From Art to Landscape

W. GARY SMITH From Art

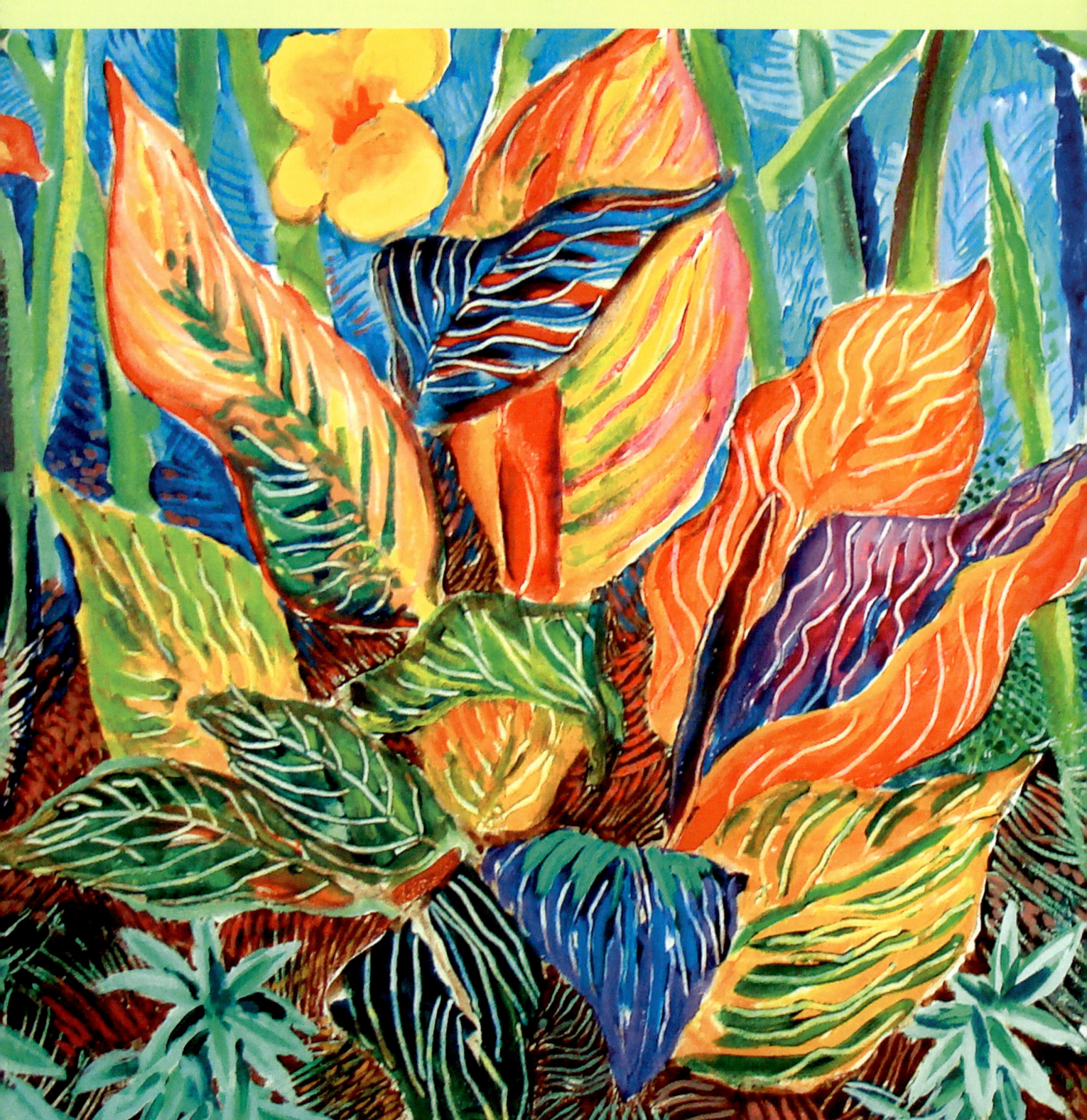

to Landscape

UNLEASHING CREATIVITY
IN GARDEN DESIGN

TIMBER PRESS/PORTLAND · LONDON

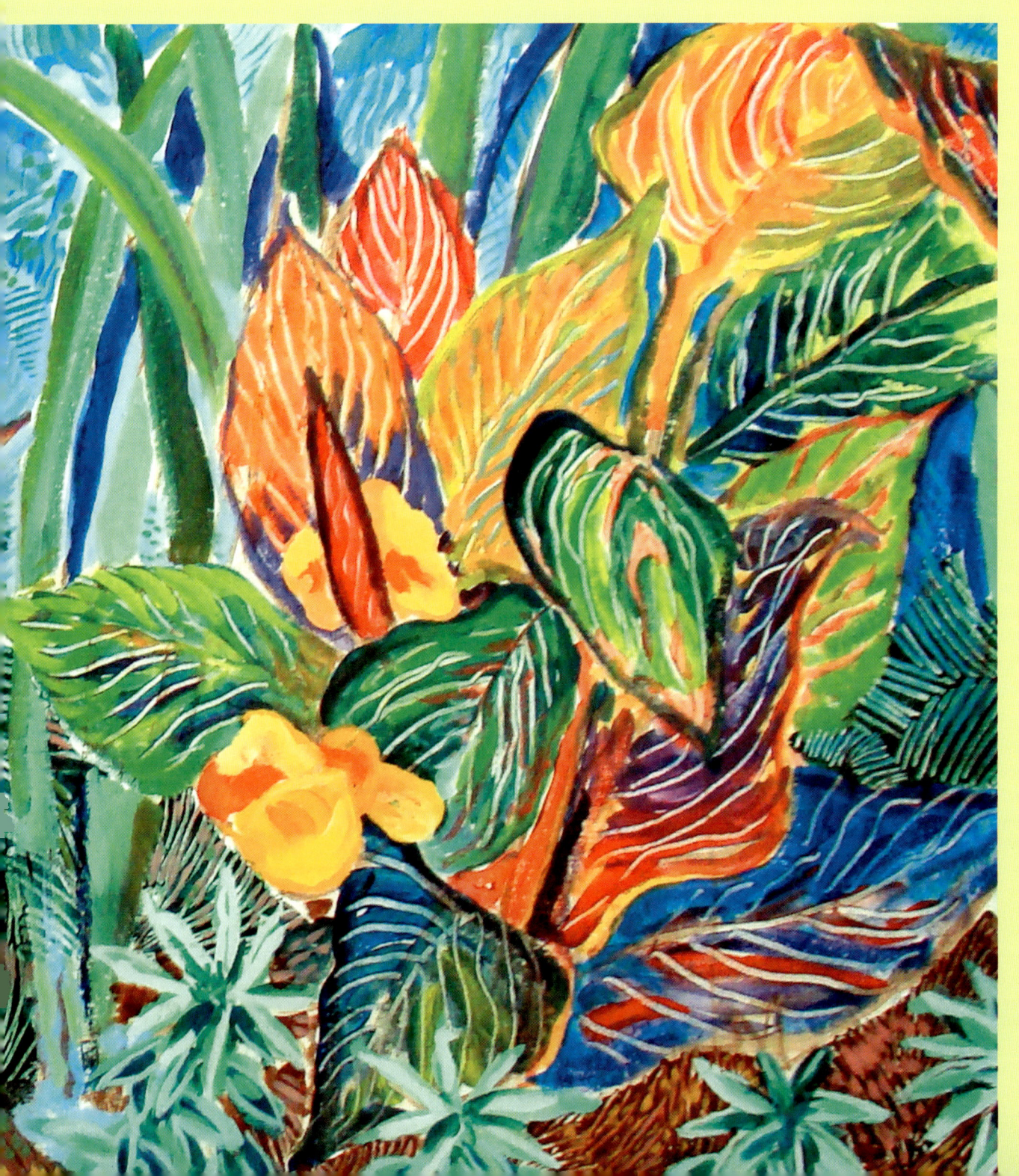

Half title (page 1): Detail from a painting of a floodplain area on the Botanic Garden of Western Pennsylvania site. Title page: After a visit to Chanticleer, I painted this fantasy version of a border planting designed by Dan Benarcik, which included *Canna* 'Tropicana' (also known as 'Phaison'), *Euphorbia characias*, and a New Zealand flax (*Phormium tenax*) in the background. This page: Working sketch of the Sunrise Border Wall in the Tropical Mosaic Garden of the Naples Botanical Garden.

All photographs and other illustrations by W. Gary Smith unless otherwise credited. Copyright © 2010 by W. Gary Smith. All rights reserved.

Published in 2010 by Timber Press, Inc.

The Haseltine Building
133 S.W. Second Avenue, Suite 450
Portland, Oregon 97204-3527
www.timberpress.com

2 The Quadrant
135 Salusbury Road
London NW6 6RJ
www.timberpress.co.uk

Printed in China
Designed by Susan Applegate

Library of Congress Cataloging-in-Publication Data
Smith, W. Gary.
 From art to landscape: unleashing creativity in garden design/W. Gary Smith.—1st ed.
 p. cm.
 Includes bibliographical references and index.
 ISBN 978-0-88192-973-7
 1. Gardens—Design. 2. Art and design. I. Title. II. Title: Unleashing creativity in garden design.
 SB472.45S65 2010
 712'.2—dc22 2010012438

A catalog record for this book is also available from the British Library.

TO SERENDIPITY

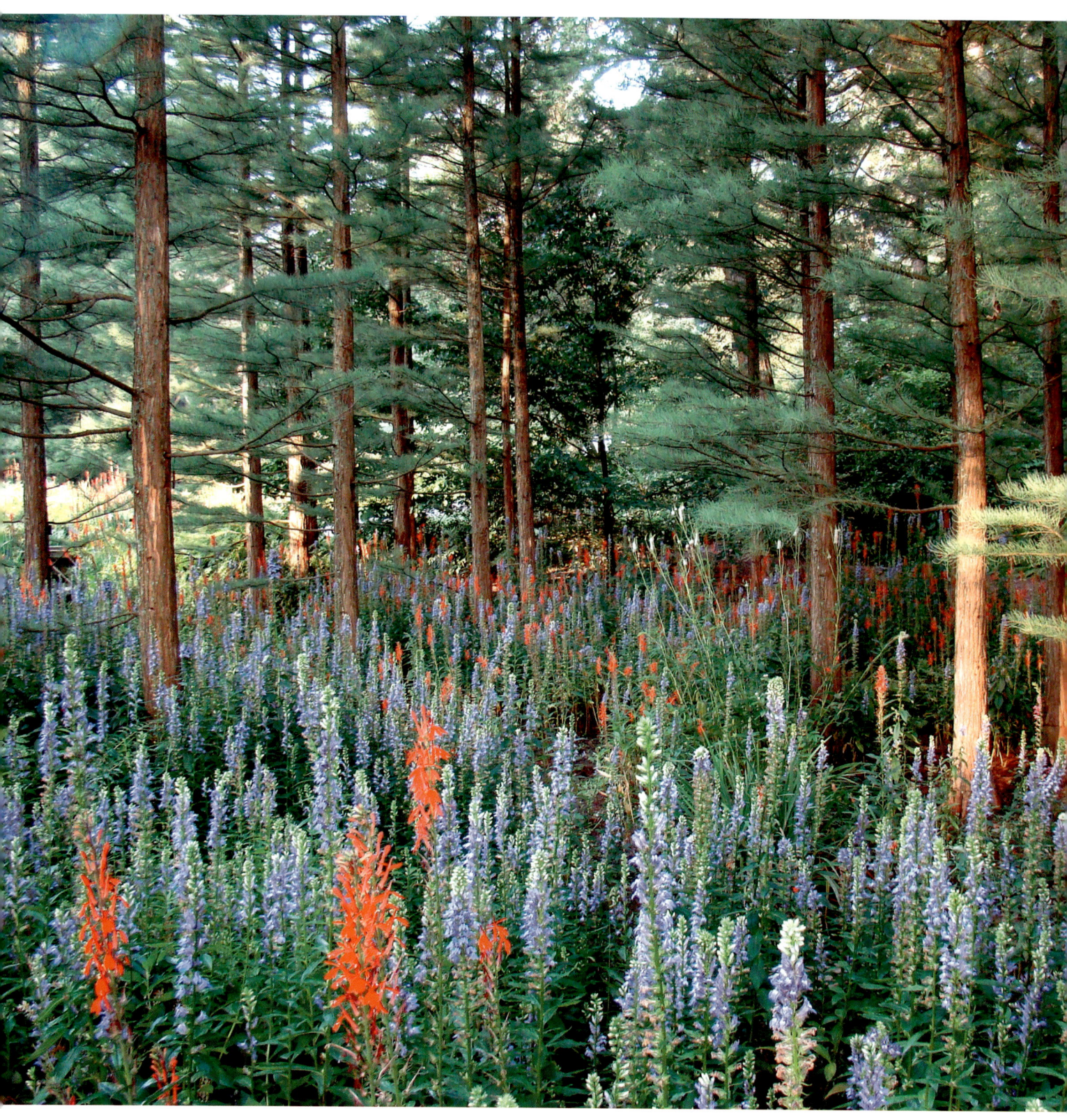

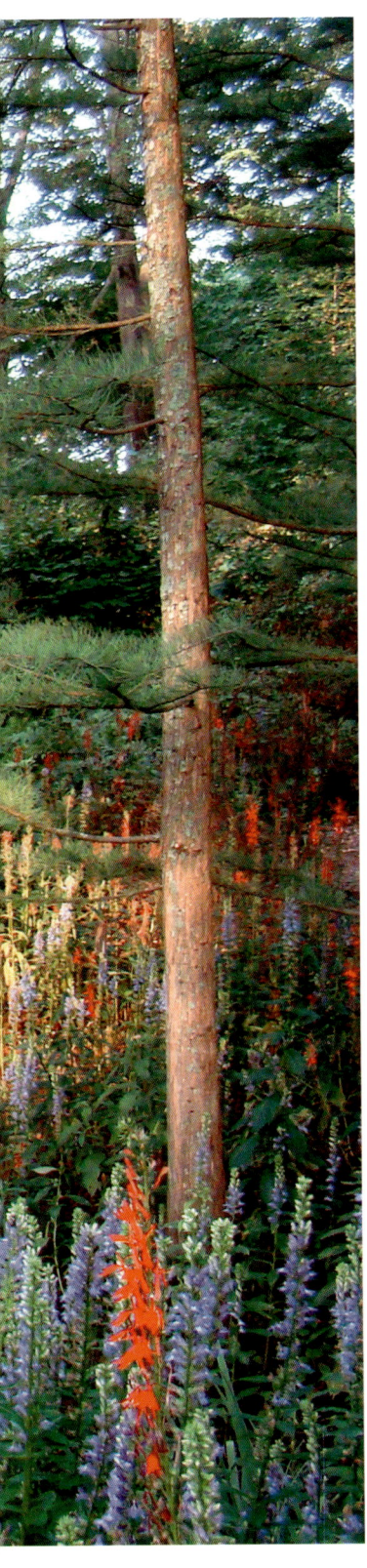

Contents

INTRODUCTION: Artists' Tools in Garden Design, 9

PART 1 Cultivating the Artist's Eye
ONE The Creative Self: Begin with Who You Are, 15
TWO Building a Visual Vocabulary: Shapes, Forms, and Patterns, 31
THREE Sketching, Painting, Drawing: Ways of Seeing, 65
FOUR Expanded Repertoire: Lessons from Artists, 97
FIVE The Garden as Fine Art: H. F. du Pont's Winterthur, 123

PART 2 Designing the Artful Garden
SIX Abstracting from Nature: Peirce's Woods at Longwood Gardens, 149
SEVEN Interpreting Sense of Place: The Tropical Mosaic Garden, 191
EIGHT Collaboration Goes Wild: The New England Wild Flower Society's Garden in the Woods, 221
NINE Fantasy and Imagination: Enchanted Woods at Winterthur, 233
TEN The Artist's Eye in the Garden, 273

BIBLIOGRAPHY, 293
ACKNOWLEDGMENTS, 294
INDEX, 295

A blend of blue lobelia (*Lobelia siphilitica*) and cardinal flower (*L. cardinalis*) flows through a grove of pond cypress (*Taxodium ascendens* 'Prairie Sentinel') in Longwood Gardens' Peirce's Woods, where a central design motif is strong vertical trunks played against horizontal sweeps of ground covers.

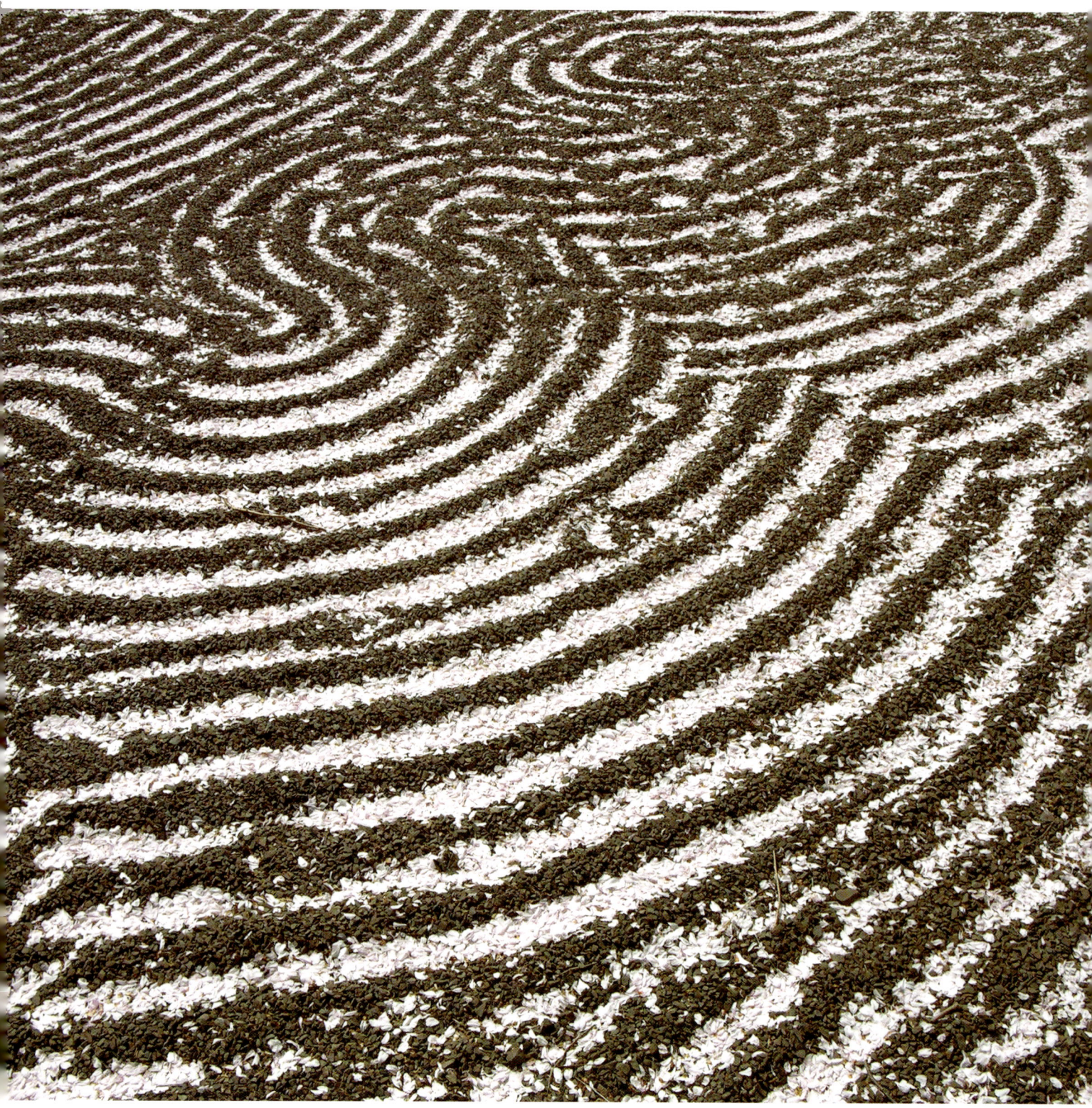

INTRODUCTION
Artists' Tools in Garden Design

THIS IS A BOOK ABOUT the creative process, exploring the tools and techniques artists use to foster personal connections with the landscape and putting these to work in enriching the art of garden design. Drawing, painting, sculptural experimentation, meditation, poetry, dance—these are a few of the media and methods artists employ to immerse themselves in a place, to discover its essential qualities. I've had many conversations and collaborations with fine artists in a variety of disciplines, and they've had a great influence on my own development as a garden designer. Horticultural designers—talented amateurs as well as professionals—continue to remind me that the garden is mostly about living plants and the inspiration and joy their beauty brings into our everyday lives.

I have discovered that artists connect with the landscape in a way different from how landscape architects tend to connect with it. My professional training was originally in ornamental horticulture at the University of Delaware, in a region historically rich with commercial nurseries and fine gardens. I studied landscape architecture with the great environmental planner and landscape architect Ian McHarg at the University of Pennsylvania, where the emphasis was firmly on ecological design. Later in my career I began to study the fine arts of painting and sculpture. I learned a lot from my artist friends, as well as from formalized study at the Pennsylvania Academy of the Fine Arts. I am continually delighted by how these creative practices deepen my work as a garden designer, though oftentimes they appear at first to be unrelated.

In my training as a landscape architect, I was taught a methodology in which the rational analysis of a site's ecological and social factors will lead to a harmonious design solution. The ego is minimized, and the existing landscape is modified to reflect what is best for its natural systems as well as its users' intended activities. Artists, on the other hand, are taught to consider the ego as a positive force. Cultivating intuition as a means of connecting to the landscape on a deep level, sensitive to the inner qualities of a place, they can create works of art that are intensely moving to themselves and others. In recent years, many artists have focused their attention on the living landscape—not

On a windy April day, fallen cherry petals found their way into the grooves of a raked gravel pattern.

just by presenting images of the landscape in their artwork but also through actually modifying the physical place. Some are more tuned in to the nuances of natural systems than others, and when landscape and artist speak in harmony, the message can be more meaningful than when either speaks alone. This is also true in landscape architecture and especially so in fine garden design. The garden is where landscape and art can come together most potently, where people can find the deepest connections with the living world.

Garden as Transformation

One spring day as I drove to Chanticleer, a public garden in Wayne, Pennsylvania, the rows of cherries and pears along Lancaster Avenue were just passing their peak of bloom and releasing their flowers. Unusually strong gusts of April wind were blowing all the petals off at once, and big white drifts of them flew across the street in front of me. With such strong winds at play, I hoped there would be some flowers left on the trees when I got to the garden. Once at Chanticleer, I met with Dan Benarcik to tour the gardens he had created for the area around the main house.

In front of the house is a circular courtyard that once was covered in asphalt, but now Dan maintains it as raked gravel. Inspired by the ancient Japanese tradition, he rakes a new pattern into the red gravel every Monday morning, and then it gradually erodes during the week under the occasional footsteps of errant children and absentminded adults. This is fine with Dan, since he knows that gardening is an ongoing process, and that people are required for the garden to fulfill its purpose. I was there on a Monday, when Chanticleer is closed to the public so the staff can garden without interruption. A couple of hours before my visit he had raked the gravel courtyard into a perfect scalloped pattern. A circle of pink-flowering cherries encloses the courtyard, and just within the short time since Dan had done the raking, they had lost almost half their flowers to the wind. In spite of the strong gusts, most of the petals had made it down to the ground at our feet, nesting securely in the crevasses of the raked gravel. When I saw it I gasped, delighted to see that Dan's scalloped pattern had come alive with fresh pink petals arrayed in thin parallel arcs.

This was one of those times my friend Bill Frederick would call a "numinous moment," a time when you are filled with awe in the presence of something beyond your own abilities. It's what brings me back to the same garden over and over again, because you never know when such a perfect moment will be offered. In this case it resulted from a convergence of weather and biology, or—more precisely—of wind and abscission. But that was just the start of this numinous experience. After the first delight of seeing the scalloped cherry-petal pattern, I noticed the wind was creating a subtle vortex within the circle of trees, and the cherry petals swirled around and around the courtyard as they fell to the ground. Fortunately, there is a hard-paved apron between the gravel and the cherry trees, so we moved in and stood closer to the center where the airborne cherry petals could pass behind us as well as in front. We were surrounded with swirling clouds of petals. It was amazing, mesmerizing, as if we'd been shrunken down to miniature size and were standing inside a snow globe. For me, total immersion in this kind of magic is what being in a garden is really all about.

Creating Gardens That Connect

This book is all about pleasure, about sharing and collaborating with others and connecting with place. It's about opening your heart to creativity and bringing personal story and imagery into your physical environment. When you use simple artists' techniques both to see and to record—for yourself—the unique qualities of a place, you will be led to a richness of expression beyond your ability to imagine. As you develop a design vocabulary that expresses your self as much as the regional landscape surrounding you, you can craft a garden to celebrate your innermost being. It's about nurturing creativity as a way of understanding your own personal history, the images and stories that have meaning for you, and bringing your own delight into the world with living trees and flowers (along with all the sculptural and architectural elements that serve and support them). It's about making a garden to share with friends and other visitors, presenting experiences and imagery in a way that has meaning for them, too. The garden can be a place where others get to explore their own stories, a setting where they might feel safe with fantasy and where their own inner self can be invited out into the world.

To me the garden is mostly about joy. The gardens that are most memorable are those that make me smile, where I can lose myself in the creative spirit of others. I want to be in a garden where I stop and say, wow, what made them do that? What made them put those things together? If I'm having that kind of response, I know I'm in a garden where my own creative spirit has been engaged, or maybe even awakened. Perhaps it's been asleep for a while and needed to be brought back to life. And then the gardens where I find myself laughing—well, those are the ones where I know transformation is taking place. Those are the ones I'll want to come back to again and again, and not just so I can check out what the gardener has thought of next, but to experience the transformation within myself at a deeper level.

Part 1 of this book presents some of the artists' techniques and tools I have learned along the way to encourage connection with the inner well of creativity and begin designing gardens as an artist might. Part 2 presents some real-life case studies of how a creative spirit and a regular artistic practice can enrich and complement the garden design process, drawn from my own experience working with others in gardens across the country. I hope you'll give yourself permission to practice some of the artists' techniques described in the pages ahead. Some are at a kindergarten level—in terms of skill as well as delight—and others are more advanced. Please remember: whichever techniques you choose, you have to practice them. The effective exercise of creativity actually does require . . . well . . . *exercise*. If you keep testing and developing various artistic techniques in various media, you will find yourself continually refreshing your regular design routine. Get into the habit of developing new habits. Above all else, keep learning about new plants and keep visiting gardens and natural areas with your artist's eye fully engaged. The personal rewards will be significant, and you'll find deeper connections to plants and nature than you might have believed possible. Your garden will reflect levels of artistic expression that continue to evolve, and your friends and family will be moved and inspired again and again.

PART 1
Cultivating the Artist's Eye

After I completed this "doodle book" sketch, it reminded me of submerged water grasses waving placidly in a slow-moving current. I computer-colorized the original black-and-white sketch to make it more evocative of nature.

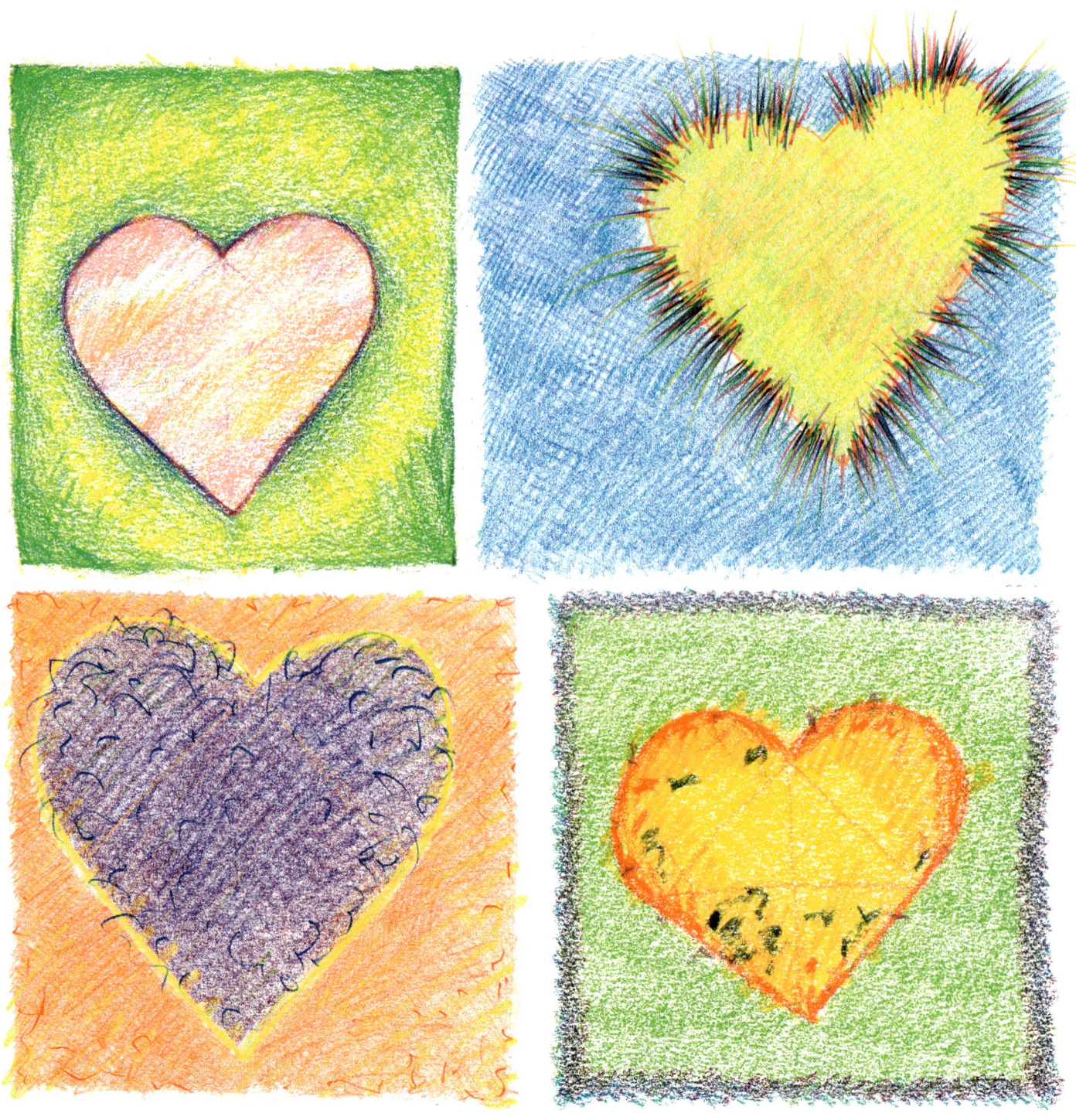

ONE

The Creative Self: Begin with Who You Are

Every work of art begins from the self. No creative act exists in a vacuum—as artists we are always engaged in a dialogue with the world and people around us—but every project, great or small, begins with the seed of an idea that originates from an inner personal knowledge. Whether it's a painting, a piece of music, a dance performance, a sculptural installation, or a garden, all creative work begins with a spark of interest, a magical moment of delight—and this is an intensely personal and private experience. It's that little voice in your head that says, "Oh, wow, wouldn't it be so cool to put a sharp green together with a flaming pink? I can't wait to try it." It's the little shiver we get when we remember a scene from childhood and long to share that memory with others. No matter how many people will later be involved in the design process and, we hope, touched by our work, inspiration is a mysterious flash of insight that calls upon our own personal wealth of experiences, observations, and relationships.

My Own Sources of Delight and Inspiration

My source of delight and inspiration in the natural world, as well as my sense of joy in the artistic process, is rooted in my earliest childhood growing up in Newark, Delaware. It might not seem like the most culturally or artistically rich of locales, but every small city has its unique pleasures, and one of mine as a kid was living just across the state border from Longwood Gardens in Kennett Square, Pennsylvania. In my high school days Longwood didn't charge admission, so occasionally we would cut school for the day and drive over there to hang out with all the flowers. I'd get lost among the brilliant colors in the floral displays, and I'd fantasize about maybe working there one day. Important moments in my teen life happened there. My first awkward kiss was on the steps of the Italian Water Garden.

Horticulture was always important to me, and in the eighth grade I joined the Greenhouse Club. We had a small production greenhouse out in the service area

Design begins by looking within, and sketching can help reveal what's in your unconscious self. I drew dozens of hearts like these when designing the Corn Heart, a work of environmental art done in collaboration with storyteller Annie Hawkins.

behind our school. Mr. Nickle, our history teacher and Greenhouse Club advisor, taught us how to grow plants from seed and from cuttings. We produced seasonal crops for all the holidays—chrysanthemums for Thanksgiving, poinsettias for Christmas, and lilies for Easter. I enjoyed the art of horticulture and was fascinated by the technology. Vermiculite was a miracle substance. We learned to excel at potting things up, watching them grow, and then coercing our parents into buying them from us.

My Aunt Betty's house had plants in every window, and she lived just down the street from my high school. My friends called her my "plant aunt." She had hundreds of houseplants, and it was my job to take care of them when she was away. Aunt Betty taught me how to grow African violets, and she gave me my first horticulture book: *Growing Plants Under Artificial Light*, by Peggie Schulz, published in 1955. "Under lights," Schulz wrote, "plants can be grown anywhere, as decoration for any room." What a concept. I could use live plants to decorate any room in the house, regardless of how much sunlight there was. By the age of fourteen, I had more than two hundred African violets growing under fluorescent lights and threatening to take over my bedroom. My mother used to worry that they'd suck up all the oxygen at night and I'd suffocate in my sleep.

Recently, a friend was reminiscing about his childhood fantasy of owning a Christmas tree farm. At age fourteen he ordered a hundred seedlings from the back of the magazine section of his local Sunday newspaper. It cost ten dollars for a hundred trees, which seemed like a fabulous deal, although my friend was disappointed at how tiny the seedlings were when they arrived at his home. He planted them anyway but soon lost interest in the project. As adults, we speculated that a few of them might have survived and grown into mature specimens, and might at this very moment be occupying a significant amount of space in his childhood backyard.

I too was a big fan of the ads in the back of magazines, and I sent away for plant catalogs, as many as I could. They were colorful and glossy, like high-quality books for free, and I'd pore over them and dream about what I could do if only I had my own garden. I wanted to grow dahlias the size of dinner plates, and melons so big I'd need a wheelbarrow to move them into the house—and I was particularly enamored of gladiolas, irresistibly attracted to all those brightly colored racemes. Only after growing up did I discover that an alternate common name for the gladiolus is sword lily, and that the genus is named for the

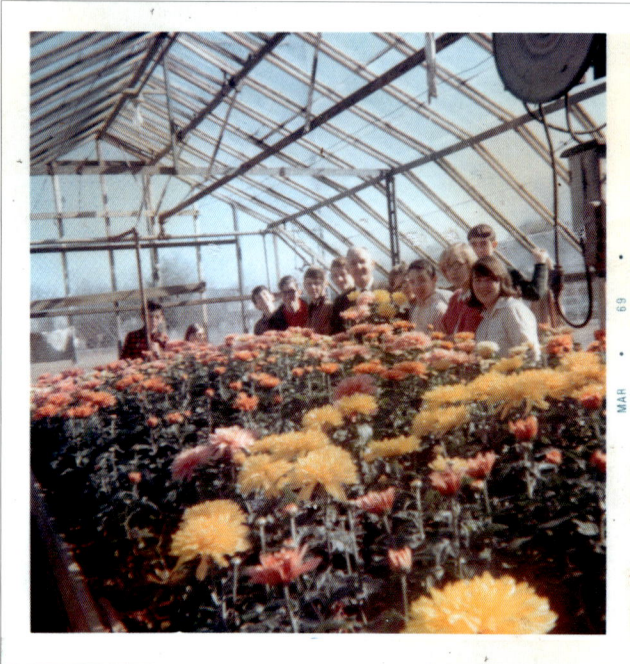

In the Greenhouse Club at my junior high school, we grew seasonal flowers for the holidays, such as these chrysanthemums for the football season.

gladius, a Roman sword. What boy in the sixties didn't love gladiator movies? We'd watch them on Saturday morning television. Victor Mature was my hero—besides, who could resist glads with cultivar names like 'Lucky Star', 'Firedance', and 'Violet Queen'? Caladiums were also appealing, and there were hundreds of varieties of irises and daylilies to dream about and hope to grow one day.

Newark Senior High School offered horticulture courses as part of the vocational/technical curriculum, and I signed up for them as free electives even though I was on the college-prep academic track. The vo-tech guys tended to be big and gruff, and somewhat threatening to a skinny flower-lover like me. Most of them wore denim jackets embroidered with the Future Farmers of America logo. I never joined the FFA but I loved the jackets, and being with those guys I did learn a lot about plants.

My other high school passions were music and art. I sang in three different choral groups, including an ensemble where we sang Elizabethan madrigals while dancing the pavane and galliard. We had embroidered jackets, too, but ours were purple silk with gilded filigree. The art room was the place where I felt most comfortable, and that was where I usually hung out with my friends. We had two art teachers. Mr. Kellechava—we called him Kelly—was an elegant older gentleman who taught the fundamentals of classical drawing and painting, while Miss Wilson was young, hip, and freewheeling. She had a mod sixties hairdo and wore very short skirts, and I swear she even wore white vinyl go-go boots on special occasions. We could fling anything onto a canvas and she'd be delighted. I didn't know it at the time, but between Kelly and Miss Wilson I was learning all about the interplay between discipline and chaos, a theme that has followed me ever since.

Finding Landscape Design

When it came time to choose a major for college, I really wanted to study music and art, but I chose horticulture because it was more practical and seemed more likely to lead to a good job. At the University of Delaware I majored in ornamental horticulture, but since the program was housed in the College of Agricultural Sciences, the curriculum was strong on science but somewhat weak on ornament. There were

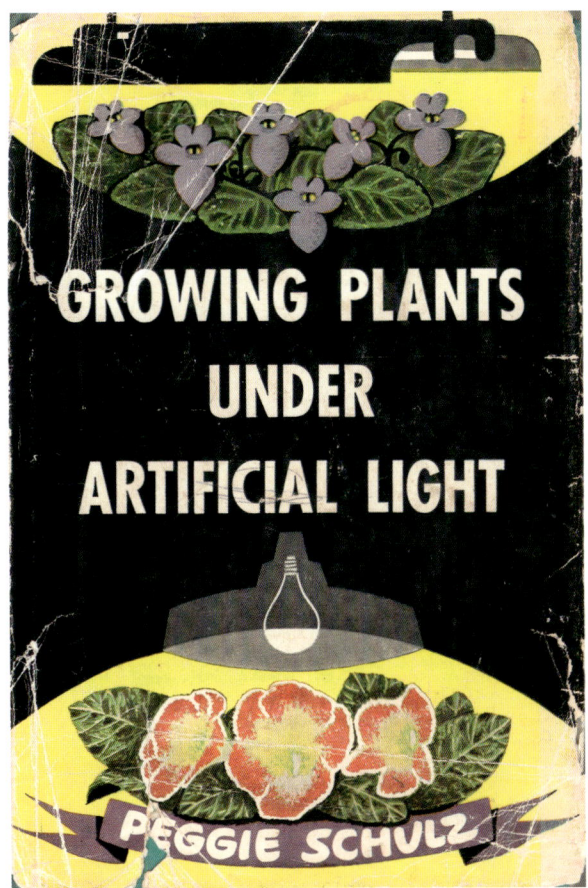

Thanks to Peggie Schulz (via my Aunt Betty), I had hundreds of African violets blooming under fluorescent lights in my bedroom when I was in the eighth grade.

lots of classes on plant biology and genetics, and a fair number on the identification and cultivation of ornamental plants, but not enough on their uses in the landscape. I was craving creativity, so I supplemented my horticultural studies with elective courses in music and fine arts. In my junior year, having taken the necessary prerequisites, I enrolled in a landscape design class. The teacher, Conrad Hamerman, finally showed me how art could be combined with plants to create gardens.

Landscape design class brought all of my interests together, and for the first time I could imagine a career that integrated everything I loved. Conrad had worked for the famed designer Roberto Burle Marx in Brazil and had become his representative in the United States. My classmates and I thrilled to photographs of Burle Marx's modernist gardens. He made living abstract paintings on a grand scale, with great sweeps of boldly contrasting color, texture, and form. His designs, which celebrated creativity and the mark of the human hand, were dramatic expressions of the garden as abstract art. Burle Marx once visited

Roberto Burle Marx designed the Carlos Somlo residence in 1952, in Teresopolis, Brazil, as a living modernist "painting" at a landscape scale. Photo by Conrad Hamerman.

our studio to critique our projects, and even though we'd all been inspired by his work, at the time we had no idea he was one of the most prominent landscape architects in the world.

In my senior year at Delaware I found another profoundly moving discipline: ecology. Armistead Browning, a local landscape architect who focused on nature rather than art, taught a short winter-session course called Environmental Analysis. There we learned about the mysteries of ecosystems and the interconnected workings of the natural world. One brisk February afternoon we stood on a hilltop in Pennsylvania's Brandywine Valley, looking at a stark winter landscape that seemed to have come right out of an Andrew Wyeth painting. Sterile brown pastures were laid on top of gently curving landforms, divided by hedgerows of naked black locust trees. A cluster of weathered farm buildings hunkered down in a cleft between two hills. Ted pointed to a small stream running along the bottom of the slope.

"There's a layer of water beneath the soil," he said, "called groundwater, and it moves slowly downhill beneath our feet. Gravity pulls this lens of water down the slope, and that stream down there marks the line where it intersects the sky."

I felt my world turn on its head. The frozen winter scene was no longer inert but was now animated by water moving beneath the surface of the ground. The whole landscape came alive on that winter afternoon, and from that moment on I felt connected to it in a whole new way.

Design with Nature

During my graduate studies at the University of Pennsylvania, I met the brilliant landscape architect A. E. Bye, a designer of gardens whose form and content were inspired by the subtleties he observed in the natural landscape. Unlike Burle Marx, Bye designed landscapes that looked untouched by human hands. When he took someone to visit one of his garden creations, where every stone and tree and blade of grass was part of his design, they'd usually look around for a while and then ask, "What part did you do?" To him this was the greatest compliment.

A. E. Bye designed this garden for the Leitzsch residence in Ridgefield, Connecticut. In Bye's book *Art into Landscape, Landscape into Art*, the caption for this photo reads, "A Chestnut Oak becomes the turning point along a grass path entering the dark forest." Photo courtesy of A. E. Bye Collection, Penn State University Archives, The Pennsylvania State University.

Bye loved exploring moods and emotions in the landscape. Ted Browning worked in Bye's office during the 1970s, and they were good friends. In the early 1980s I lived at Ted's farm in Chester County, Pennsylvania. One weekend when Bye was visiting, we played a game of driving through the natural landscape and stopping periodically so Bye could give a one-word summary of the mood of a particular scene. We'd stop beside a grove of mature beech trees and ask, "What's this one, Mr. Bye?"

"Majesty!" he'd exclaim.

Or we'd stop in front of a thicket of wiggly black locust stems. "How about this one?"

"Humor!"

One of Bye's favorite images in the landscape was trees backlit by the morning or evening sun: "Luminosity!"

These two extremes—Burle Marx's gardens like bold, colorful abstract paintings on the ground, and Bye's gardens so subtle they didn't suggest that a person was even involved in their making—were the major themes that influenced me as a student designer.

At Penn, I studied with the great ecological planner and designer Ian McHarg, who chaired the Department of Landscape Architecture and Regional Planning from 1957 to 1986. His book *Design with Nature*, published in 1969 and still in print today, revolutionized the practice of landscape architecture around the world. McHarg described a design methodology based upon careful analysis of the natural and cultural factors existing on any given site. He maintained that a rigorous, detailed, and dispassionate site analysis was all that was required for an ecologically and culturally fitting design to emerge for a particular place. McHarg said that there was no role in the design process for an artist's ego and insisted that the site always tells the designer what it wants to be. Ironically, McHarg had one of the healthiest egos in the business, but he advocated humility in listening to nature and respecting the prevailing sense of place at any given site.

Storytelling in a Wissahickon Garden

In the 1980s I shared a landscape architecture firm, South Street Design Company, with my partners Michael Nairn and Anita Toby Lager. One of our projects was to create an entry court for the downtown Philadelphia headquarters of Planned Parenthood of Southeastern Pennsylvania. Since this was to be a therapeutic garden in the middle of the city, we based its design on nearby Wissahickon Creek, which flows through Philadelphia's Fairmount Park. The Lenni Lenape, a Native American tribe, lived in the Wissahickon watershed before European settlement in the late 1600s, and since that time the creek had always been venerated as a place of spiritual sustenance. We wanted to bring some of its healing energy downtown, into central Philadelphia.

We designed the courtyard's paving pattern to reflect the creek's serpentine geometry—not only its form but also the process that generated it. In a natural stream, the meandering pattern results from the dynamics of erosion and deposition. As water flows around a curve, it moves faster on the outside edge and scours away the soil, while on the inside edge, the water has less distance to travel so it moves more slowly and the sediments drop out. Over a very long time, the stream meanders farther and farther to the left and to the right, and the curves become more and more pronounced.

We abstracted this snakelike shape and reproduced it in the tiny courtyard's paving pattern. The

ONE The Creative Self: Begin with Who You Are 21

red granite pavers throughout the garden represented the red brick of Philadelphia, while the gray ones symbolized the waters of the Wissahickon. Black pavers placed on the inside edges of the curves suggested the process of soil deposition, while the outside edges had no black stones, implying the scouring action of rapidly moving water.

Interesting things occur when you follow natural patterns and let go of your controlling ego, and this project was no exception. Through Philadelphia's Percent for Art program, artist Valerie Jaudon was chosen to create a fence for the garden. Although we worked completely independently, her finished design looks as though we had been close collaborators. The plants our team had selected were native to the region, and we arranged them as they would occur in a natural forest, with canopy, flowering understory, shrub, and ground layers. As it turned out, Jaudon's fence, designed without her ever seeing our work, also had a pattern that suggested the layers of the native forest. This amazed me at the time, but since then I've seen similar congruencies happen with a surprising degree of regularity. When you work with patterns inspired by nature, it is almost as if the garden has its own ideas and begins to design itself. I was learning that to a certain degree McHarg's philosophy is right. It's useful to find avenues to get around the ego. Still, an artist's approach was necessary to highlight the patterns and processes of nature and present them in ways that visitors could more fully appreciate.

Years after the Planned Parenthood garden was completed, when I was teaching landscape design at

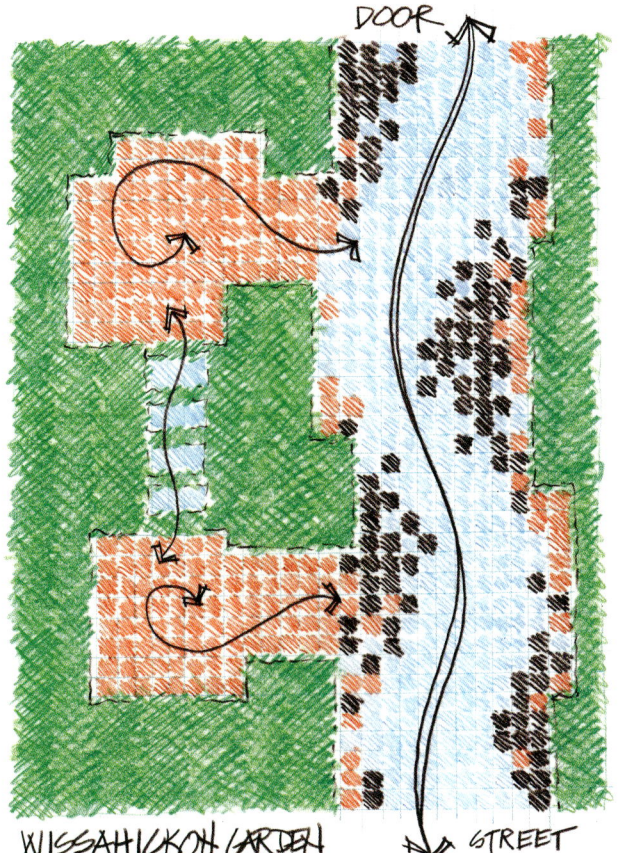

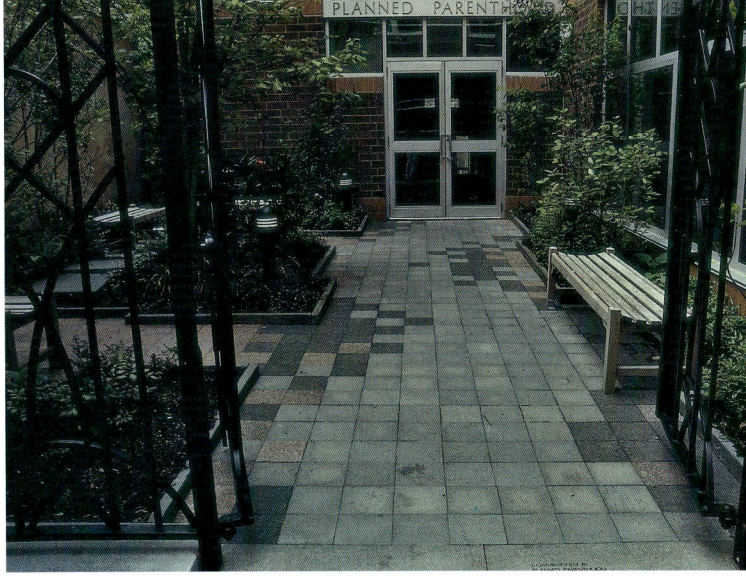

The entrance court at the downtown Philadelphia headquarters of Planned Parenthood of Southeastern Pennsylvania features a paving pattern inspired by the serpentine lines of a meandering creek, shown in this design study and in the finished garden.

the University of Delaware, I took a group of students to visit the site. We had gathered in the courtyard, and I was telling the story about how the design had come to life. I had just explained that while nature might have inspired the garden's designers, most of the people visiting the garden wouldn't know about that process. They might enjoy the garden's beauty and maybe benefit from its healing energy, but they wouldn't necessarily be familiar with the details of the whole Wissahickon story. Immediately after I made this point, the front door opened and the receptionist came out into the courtyard to ask what we were doing there. I had neglected to phone ahead to tell them we were coming, forgetting that they do get nervous at Planned Parenthood when groups of people gather spontaneously outside their front door. I apologized for arriving unannounced and explained that this was a group of landscape design students here to study the garden.

"Oh, good," she said, seeming relieved. "Did you know that this garden is all about the healing power of the Wissahickon?" I was stunned for a moment, and then we all burst out laughing. The students accused me of arranging this stunt ahead of time, but I assured them that this was no setup. I simply hadn't thought about the human component in this garden, or how storytelling is a basic part of human nature. Together we all were learning a powerful lesson, that a garden inspired by a meaningful narrative can become a place where people gather and share its story with each other. A garden is more than an artfully arranged collection of plants and other elements, more than a simple evocation of nature. It is a wellspring of human memory and emotion. It has its own sense of narrative, its own meaning, for those who live or work there as well as those who simply come to visit.

The Baby with the Rays

I started becoming a painter in the late 1980s, and Keith Haring held a special place among those whose work inspired me. I loved his bold graphic iconography, his playfulness, and his use of intense color. His imagery came from the street, from graffiti artists, but he transformed it into fine art. He was childlike and playful, and his work bridged many cultural boundaries. One of my favorites among his images is his *Radiant Baby*, showing a crouching baby in profile surrounded by lines that radiate outward in all directions. I called it "the baby with the rays." Haring derived this iconic character from the game of tag. In the nuclear age of the 1960s, you'd chase and tag another player, transferring your "radiation" to them. This image illustrates how we pass along our energy when we make meaningful connections with each other. On the Keith Haring official web site (www.haring.com), in an article entitled "Keith's Kids," Andrea Codrington quotes Haring's journal from 1986: "The reason that the 'baby' has become my logo or signature is that it is the purest and most positive experience of human existence."

Haring died of AIDS in February 1990, and when I heard about his death it hit me hard. In the spring I took our little gas-powered lawn mower out into the meadow beside our house and fired it up. The meadow grasses were about six inches tall at that time, and using the mower as if it were a paintbrush, I made a giant "radiant baby" image as a thank-you for all his inspiration. This meadow "drawing" stretched about a hundred feet from end to end, and I was surprised when it simply came out of the lawn mower almost as if some artistic force from within the meadow were guiding the whole thing. I filled the mowed lines with fresh straw to provide a stronger contrast with the

green meadow grass, and it lay there looking up into the sky until the meadow grew up around it, gradually enveloping it and taking it back into the earth.

After mowing the tribute to Haring, I started thinking again about how Roberto Burle Marx used the ground as a canvas for giant paintings, and I found myself wishing for an opportunity to do something like that in a public place. A few years later, I got a call from my friend Harriet Wentz, a garden designer and artist who at the time was also the education coordinator at the H. E. Myric Conservation Center of the Brandywine Valley Association, near where I was living in southeastern Pennsylvania. Harriet had convinced the association's leadership to consider staging a display of environmental art, and she invited me to stop by and see what we might cook up together. Another friend, Annie Hawkins, was a popular storyteller on the local art scene. Always looking for opportunities to collaborate with different kinds of artists, I suggested it might be good to bring Annie's creative energies into the mix, and Harriet agreed.

Art Can Take You Places

In the early spring of 1994, Annie, Harriet, and I created the Corn Heart, an earth art and storytelling space. The Brandywine Valley Association loaned us a sloping pasture near the nature center's parking lot, and we persuaded a neighboring farmer to plow a heart-shaped field. A colleague of mine at the University of Delaware donated the corn seed, and we enlisted a group of volunteers to plant it all by hand. I always learn something when I collaborate with artists, and Annie taught me a lot about how an artist can work in the landscape.

As an earnest landscape architect should do, I suggested we begin the creative process by conducting a

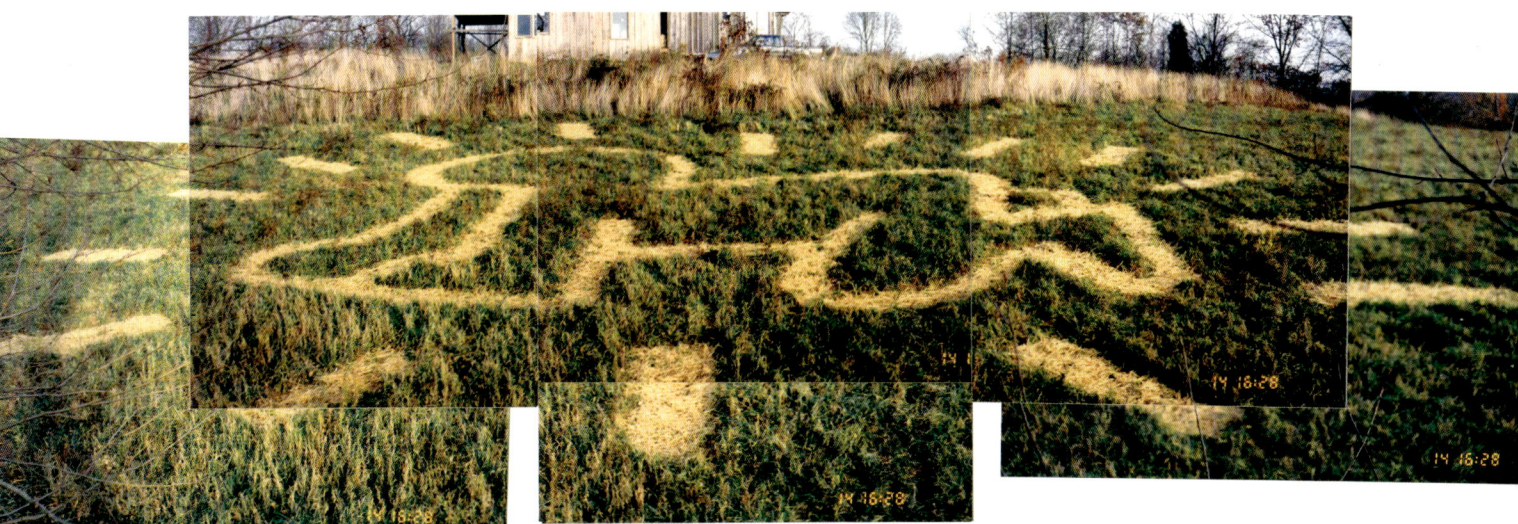

The painter Keith Haring was a great inspiration to me when I first was learning how to paint, and when he died I mowed this tribute to him in the meadow at my home in Pennsylvania. The "radiant baby" was one of his iconic images.

site analysis. Standing out on the hillside, I practiced the "layer cake" method I had learned in graduate school. At that time, I was still very much involved with Ian McHarg's methodology, in which you always begin with a careful inventory. You study the soils and hydrology, and then draw a map to record the patterns they make on the land. You map the existing vegetation, the land uses, and all the other natural and cultural factors that make up the place. Then, as the theory goes, when all these natural patterns are layered on top of each other—like the layers of a cake—a design will begin to emerge. The designer's ego has little to do with the creative process.

So I went out into the field with a base map to record all this stuff, while Annie walked around the site getting the feel of the land. I mapped the direction rainwater would move across the field, where the sun would rise and set, and how the surrounding woods and hedgerows enclosed the land. I drew some arrows to show where the school groups were going to come out of the nearby woods, and the path they would take when they walked to and from the education building. I mapped where the visitors would park their cars, and the vantage points from which they would view the field. I was deeply engrossed in studying the land as McHarg would have had me do and waiting for a design to start emerging.

Suddenly, Annie came running up to me, all out of breath, with an ecstatic look in her eyes.

"What's up?" I said.

"I got it!" she exclaimed.

"You got what?"

She was really excited, almost gasping for air. She paused, pulled herself together, and said, "I think it should be a big corn heart."

This stopped me in my tracks. Something inside me knew that she was absolutely right. Yes, it should be a big corn heart, a cornfield in the shape of a giant heart. Well, I thought to myself, so much for careful site analysis. I asked Annie where in the world she got such an amazing idea. She replied that she didn't know exactly, it had simply come to her. I wondered, how do artists do this? How do they just seem to know what to do?

We had two acres of pasture to play with, and the idea of making one giant heart was thrilling. I went back to my studio and started drawing hearts like crazy, dozens and dozens of hearts, over and over again. I drew them in different sizes, colors, and styles, throwing myself into the whole mindset of hearts. I spent several days alone in my studio, drawing hearts and pinning them up, covering the walls with brightly colored hearts. Each of them seemed to have a unique personality. Some of them were happy, some of them somber—some of them even seemed angry or aggressive. I was immersed in the experience, euphoric, like a child lost in his own fantasy world.

During all this heart drawing, I happened to look back though some old family photographs and found a picture of myself on Valentine's Day in 1968, eleven years old, holding a heart-shaped cake. My mother helped me bake the cake, and I decorated it with pink coconut. I still remember Betty Crocker's directions: you divide the batter between a square pan and a round pan. After the cakes have baked and cooled, you cut the round one in half. Then you put the square one on a serving dish with one corner pointing toward you. You place the half circles up against the two top edges of the square, and it makes a heart. I had also made a cherry Jell-O Tupperware mold with a heart pressed into the center, and a strange little silo of construction paper with hearts glued onto it.

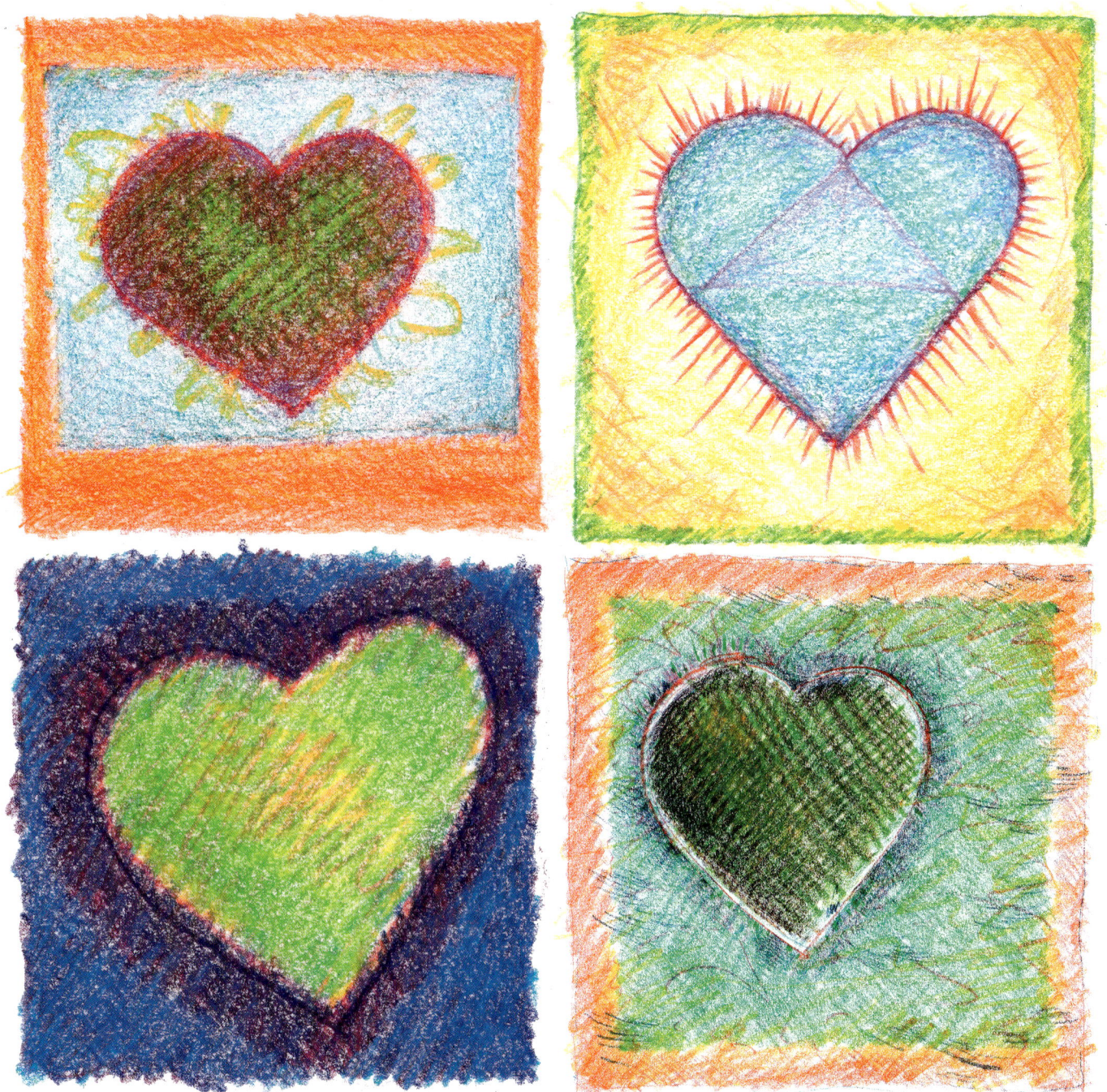

As soon as Annie came up with the corn heart concept, I got busy drawing hearts in my studio. I drew dozens and dozens of them without even stopping to think, delving into the iconography of the heart. Each one seemed to have its own unique personality.

And the look on my face in that photograph? Well, I think I knew that little boys weren't supposed to bake cakes, especially if they were shaped like hearts. I think lots of artists and designers can identify with the look on that eleven-year-old's face, the look of tremulous hope. "Do you like it?" it says. "I made it myself. Do you think it's okay?" I remembered the sugar cookies my mom would make at Christmas, and how the heart-shaped ones were my favorite out of all the shapes—and how I got teased about it. "Gary likes hearts, Gary likes hearts!" It was humiliating. But now I wasn't a little kid anymore, and by gosh, was I ever going to show them what boys who like hearts get to do when they grow up and get access to big open fields at nature centers.

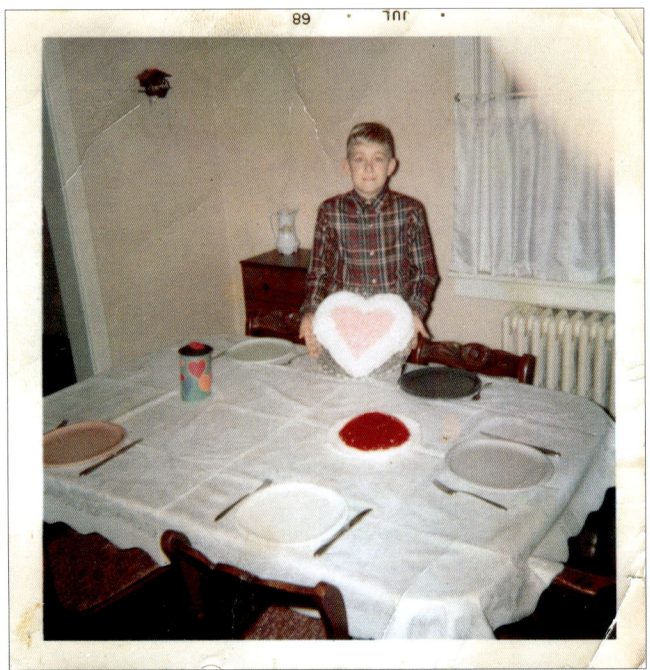

During the time when I was drawing hearts, I found this photograph taken on Valentine's Day 1968. I had made a heart-shaped cake and decorated it with pink coconut.

Annie was so taken with that photograph that she wrote an original tale to tell out loud (a "telling tale") called "The Boy Who Loved Hearts," all about the beauty of being exactly who you are. It's the story of a young prince who doesn't like weapons or hunting but loves spinning wool and sewing. One day, he stitches together a beautiful quilt of hearts. His father, the king, finds the quilt and, disturbed over this unmanly display, demands an explanation. The prince replies:

> Father, everywhere I look, I see hearts. I see them in the clouds. I see them in the ripples of the rivers. I see them in the shapes the wind makes when it blows through the tall grass. I see, Father, how all of our hearts are woven together in a great tapestry, with all the hearts that have beat before us, and all the hearts that will beat after, and through those hearts I see the boundless generosity of the world.

The king is enraged, the prince leaves the kingdom, and eventually—after the prince and the king each experience great suffering—the king and prince are reunited and everyone learns that "there are many ways of being in the world." Annie performed "The Boy Who Loved Hearts" at the Corn Heart during the autumn harvest. Even though this was many years ago, it remains one of her most popular stories.

At the beginning of the growing season, we convinced a local farmer to plow a field in the shape of a heart and then worked with a team of volunteers to sow the corn seed by hand. As our "crop" grew and matured, the Corn Heart changed dramatically through the seasons. One day that autumn, we met with a local arborist and talked him into bringing his bucket truck to the Corn Heart so we could go up

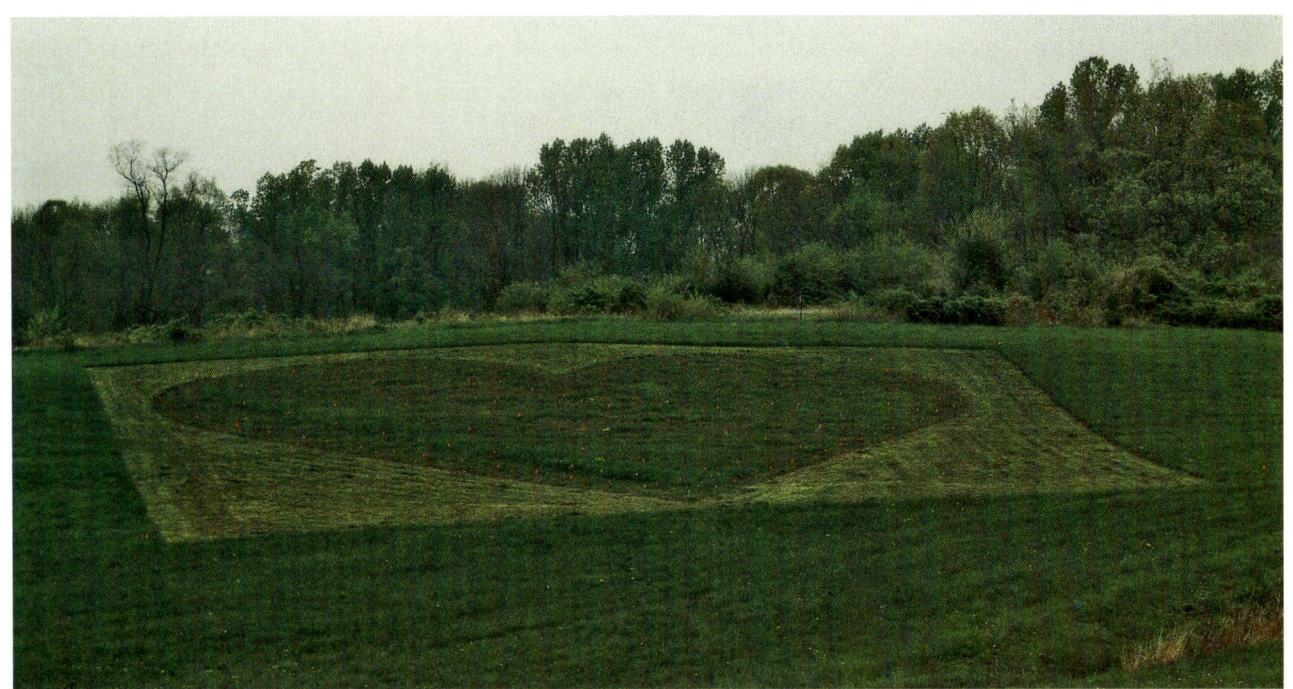

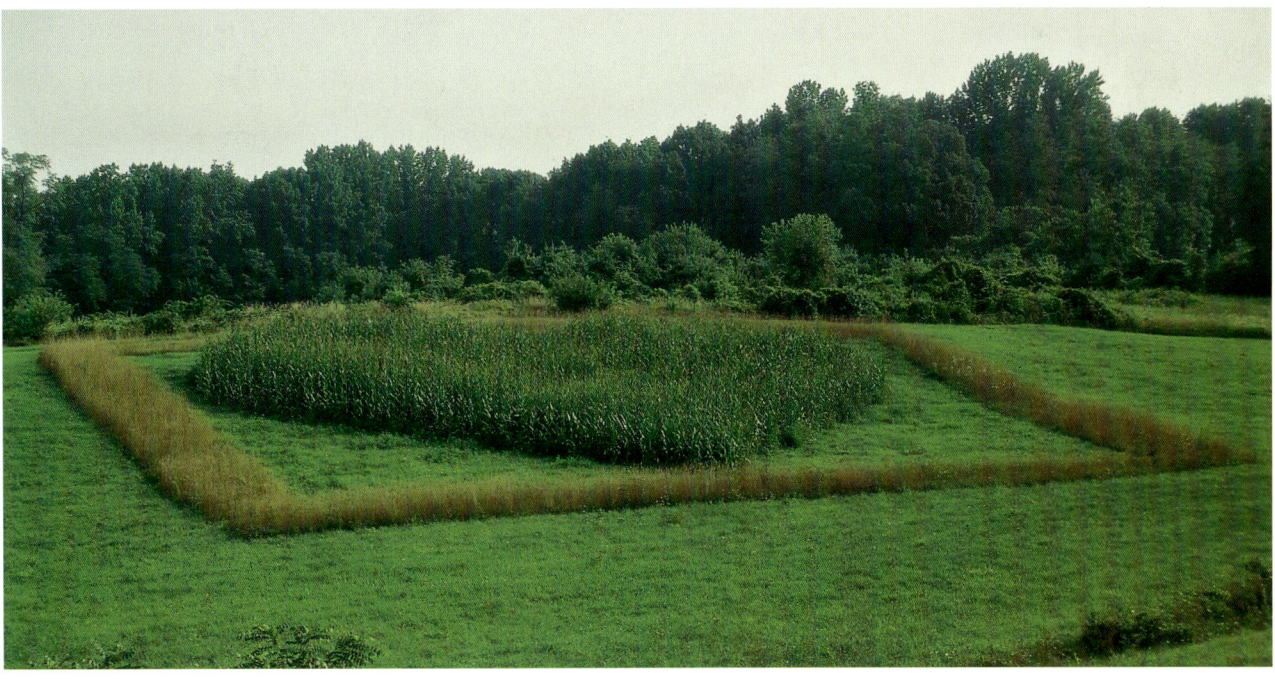

TOP We used small plastic flags to draw the giant heart full size on the site and then found a local farmer to come plow the field.

ABOVE The Corn Heart changed dramatically through the seasons. In midsummer we let the pasture grasses grow a little in the area surrounding the Corn Heart and mowed them to create a frame.

28　PART 1　Cultivating the Artist's Eye

and get a good view from above. As Annie and I were being lifted up into the sky, she turned to me and said, "See, I told you, art takes you places you never knew you'd go."

Thousands of people came to visit the Corn Heart, and it meant something different to each one. Some were reminded of a traditional Pennsylvania quilting square. Others thought of the decorative arts of the Pennsylvania Dutch, where hearts are a common motif. Some found it to be a commentary on modern industrialized agriculture. I was beginning to get some ideas about how artists work. It occurred to me that Annie grew up in Pennsylvania, and that as an artist she had absorbed much about local culture during her years of living and working there. On a beautiful spring day in that pasture at the Brandywine Valley Association, she opened up her own heart to the hillside, and everything she had ever learned about the culture of Pennsylvania came through her and out into the world.

How do artists just seem to know what to do? I think it comes with practice. You practice the art of

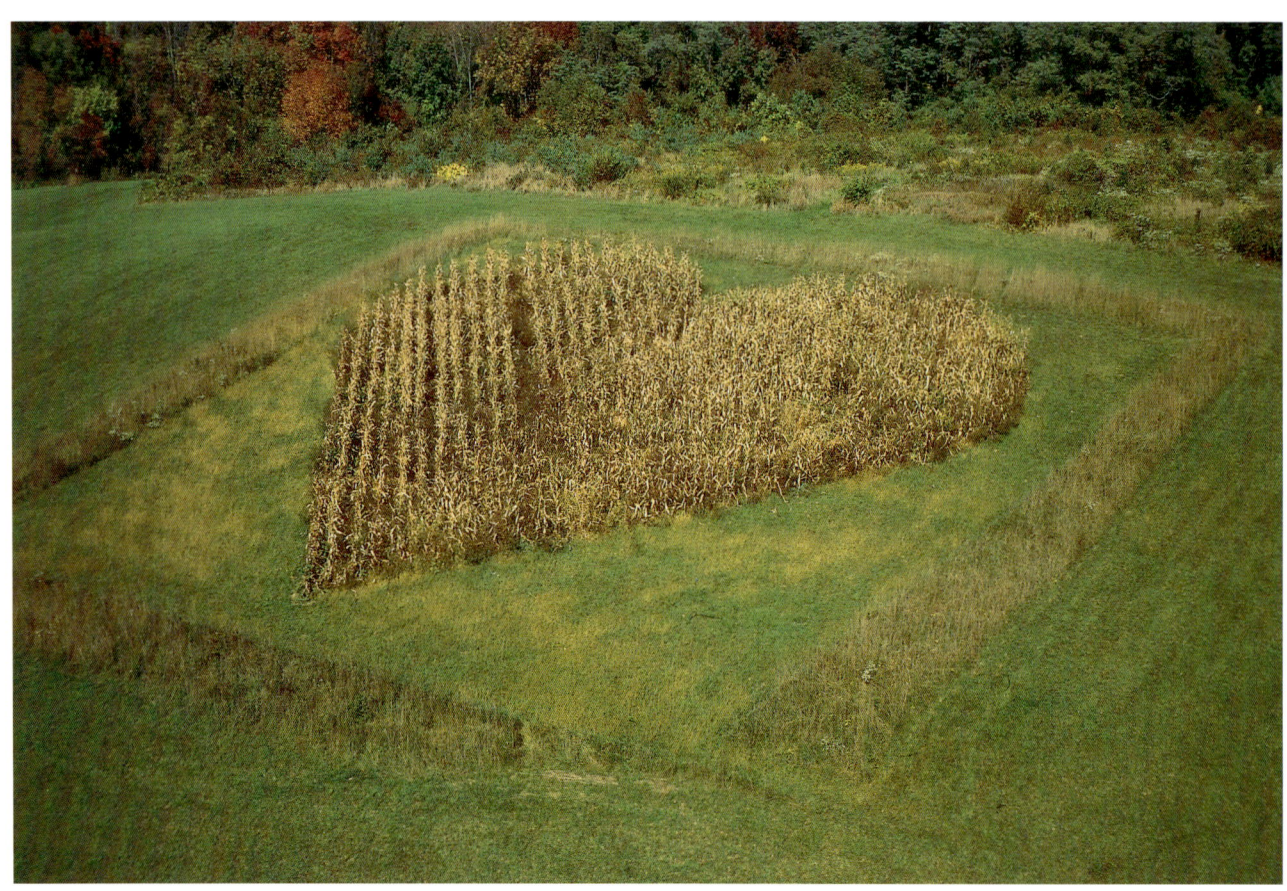

As we soared up into the air in the bucket of an arborist's Hi-Ranger, Annie turned to me and said, "See, I told you, art takes you places you never knew you'd go."

careful intuition, of trusting what's inside you. You open yourself up to what's in front of you, and you suspend your analytical mind. You allow your unconscious to have access to your whole personal history, and you notice what comes to the surface. What comes to the surface, usually, is a work of art that can be shared with others.

Nurturing the Self, Becoming an Artist

Meaningful gardens have personal value. According to garden writer Valerie Easton, "When we make personally meaningful gardens—and really, what's the point of any other kind?—we are indulging in myth making. Gardeners may think they are concentrating on the practicalities, or on the visuals, but we are really telling stories out there in the dirt, composing our autobiographies." Meaningful art does the same thing. In making art it's difficult not to involve your own history.

In *The Soul's Palette: Drawing on Art's Transformative Powers*, author Cathy Malchiodi writes:

> Art's true function is to inspire us, mirror our thoughts and embody our emotions. When words are not enough, we turn to image and symbol to speak for us. They are a conduit to all we contain within and a way of reflecting and recounting where we have been, where we are, and where we are going. Artistic expression is far more than self-expression and has much more astonishing power. Artistic creativity offers a source of inner wisdom that can provide guidance, soothe emotional pain, and revitalize your being. . . . The simple act of making art nourishes the inner self and connects us with the outer world of relationships, community, and nature.

Malchiodi also gives us license to go ahead and call ourselves artists: "An artist is not a special kind of person . . . but every person is a special kind of artist." Stay with the process, she advises. Don't be attached to any particular outcome.

I once attended a lecture by the artist Eve Larson where she talked about responding to the urge to become an artist. "Suddenly your life turns a corner," she said, "and you think, am I going to grab onto that or not? You don't have to go a traditional route to become an artist. You can just call yourself one." There's no point in debating who's an artist and who is not. Just call yourself an artist and get on with it.

TWO
Building a Visual Vocabulary:
Shapes, Forms, and Patterns

FOR THE PURPOSE of garden design, I like to think there is a rather small set of basic shapes, forms, and patterns that make up the world we live in. I haven't made an exhaustive catalog of all the shapes, patterns, and forms that exist in nature, but here I will discuss the ones that have come together in my own work over years of observation and reflection. Inarguably, the universe is much more complex and varied than can be represented by this little inventory, but for making decisions as an artist and designer I find it's good to simplify things. Pondering the full complexity of existence may be great for creating a sense of wonder and mystery, and it helps to keep you humble, but if you want to actually design something it's best to keep your visual vocabulary down to a workable subset of possibilities.

Patterns in the native landscape provide inspiration for design. This study for a tile mosaic in the children's garden at the Lady Bird Johnson Wildflower Center depicts the spiraling flower of the native Turk's cap, *Malvaviscus arboreus* var. *drummondii*.

Limiting my visual vocabulary helps me make sense of what I'm looking at. I'm interested in using artists' tools and techniques to study complex patterns in nature, finding inspiration for art and design. Artists—particularly those who work with abstraction—are concerned with seeing complex images in terms of their intrinsic form. They may be inspired by actual scenes, objects, or human figures, but rather than making a pictorial representation of a subject, they exaggerate or stylize it to convey its essential qualities. The primary goal is to convey some sort of meaning, feeling, or emotional response. In garden design, you can choose the natural landscape as your source of inspiration, abstracting its essential shapes and patterns to create a garden that—even without being particularly naturalistic in form—is just as profoundly beautiful and restorative to the human spirit as a natural ecosystem might be.

I always invite my students to embellish and add to the vocabulary I teach them, or even invent their own entirely new vocabulary, one that makes sense to them and helps them make their own visual connections to the natural world. There are many shapes, forms, and

patterns beyond the vocabulary I've developed, but here are the ones that seem to work for me.

Shapes and Forms

The three most elemental shapes are the circle, the square, and the triangle. There are also subtle variations on these, such as the oval and the rectangle, but for my purposes those two are really just simple elongations of the circle and the square. More complex geometric shapes such as the star and the hexagon can be subdivided into triangles, and an octagon is a ring of alternating triangles and squares with a square in the middle (and even a square can be reduced to triangles). In addition to these geometric shapes, organic or amoeba-like shapes are common, especially in nature.

In geometry we also talk about point, line, and plane. All the shapes just described are made of these elements. Lines form the boundaries of shapes, and those shapes with angles have lines that meet at specific points. In addition to defining shapes, various combinations of lines also make up symbols, such as asterisks, or the plus and minus signs. Along with shapes and points, they form all the alphabets of every language.

A plane is a flat surface, but the world we live in is three-dimensional. While shapes have two dimensions, forms have three. The world we move through is made of three-dimensional forms along with the spaces between them. In addition, physicists describe worlds that have four dimensions, or five, or more. Some say the fourth dimension is time, but mathematicians describe the fourth dimension as spatial, not temporal. For the purposes of this discussion we can stick to three dimensions—although the element of time is critical in designing gardens. I'll say more about that later.

If you're interested in delving into variously dimensioned worlds, I recommend Edwin A. Abbott's 1884 novella *Flatland*, a thought-provoking exploration of a world that exists in only two dimensions. A real mind-bender (but also an easy read), it challenged my perception of the world as we know it and presented an opportunity to contemplate other ways of being. It was first published anonymously, since Abbott wrote it primarily as a commentary on Victorian classism and other prejudices, but it's also a relatively easy-to-understand exploration of higher-level mathematics. In his foreword to the 1983 edition, Isaac Asimov wrote, "To this day, it is probably the best introduction one can find into the manner of perceiving dimensions. We are made to understand the way in which the inhabitants . . . are not only incapable of understanding the limitations of their view but are enraged by any attempt to enforce them to transcend those limitations." *Flatland* is a stirring condemnation of those who object to alternate ways of being in the world—an idea that is critical to consider in garden design.

Although we live in a three-dimensional world, we typically use two-dimensional images to describe it. For example, this book is full of two-dimensional drawings and photographs that do their best to describe three-dimensional places. To more fully describe the real world, you have to add the sphere, the cone, the cube, and the tetrahedron (a three-dimensional triangle) to your visual vocabulary. I don't know what the three-dimensional amoeba shape is called—a blob?—but it's very important since organic forms make up most of the garden and almost all of the natural world.

Most garden architecture, especially what often goes by the objectionable term *hardscape*, has traditionally been made using this fairly small set of geometric shapes and forms. Geometric patterns do exist in nature, but most of these occur only at a microscopic level. The natural world is largely defined by organic forms, but today—especially in gardens designed by those with architectural training—geometric forms tend to dominate the made landscape. What does this say about most designers' relationships to the natural world?

Patterns

The human brain, among its myriad functions, helps us make sense of our surroundings by sorting through chaos and recognizing patterns. Even though an average brain has roughly 100 billion memory-storing neurons and one quadrillion data-transmitting synapses, it doesn't have the capacity to store all the data we encounter in our daily lives. What we perceive must be simplified into patterns so that the data can be efficiently understood and stored. A freind has prbobaly snet you a senentce lkie tihs via emial, ilulstraitng how you can reocgnzie wodrs if olny the frist and lsat one or two lteters are in tehir prpoer palces. That's because your brain is seeing the overall pattern, not the details.

In her book *An Alchemy of Mind*, Diane Ackerman writes about the value of pattern in our lives.

> Pattern pleases us, rewards a mind seduced and yet exhausted by complexity. We crave pattern and, not surprisingly, find it all around us, in petals, sand dunes, pinecones, contrails. . . .

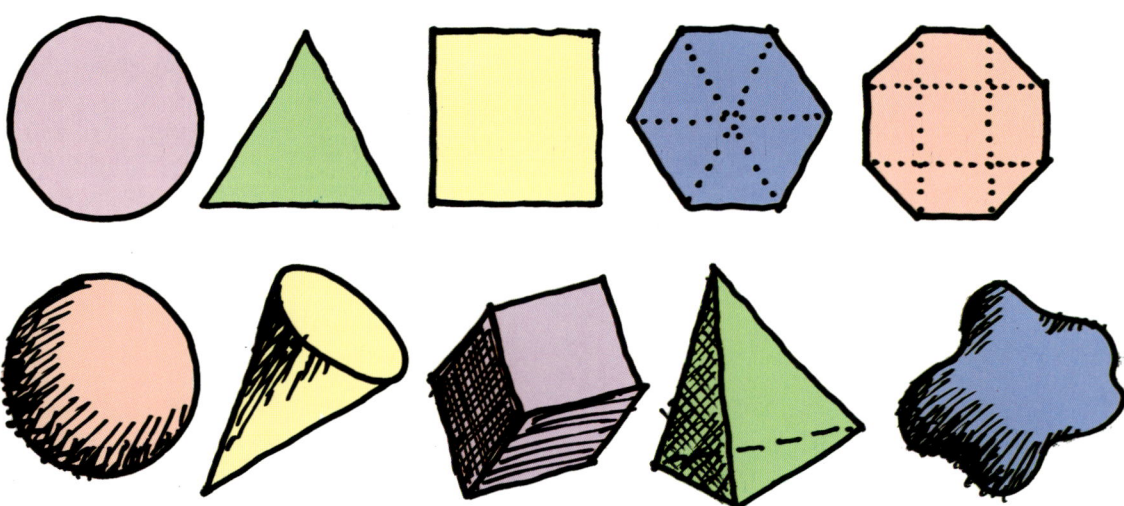

The three most basic shapes are the circle, the triangle, and the square. More complicated shapes, such as the hexagon and the octagon, can be subdivided into triangles and squares. The most basic three-dimensional forms are the sphere, the cone, the cube, the tetrahedron, and the "blob."

Our buildings, our symphonies, our clothing, our societies—all declare pattern. Even our actions. Habits, rules, rituals, daily routines, taboos, codes of honor, sports, traditions— they reassure us that life is stable, orderly, predictable.

Just as there is a relatively small set of shapes to work with, there aren't that many patterns, either. For the purpose of garden design, I suggest nine basic patterns: scattered, mosaic, naturalistic drift, serpentine, spiral, circle, radial, dendritic, and fractured. These can be used to describe almost everything that exists. Often when exploring the natural world, you'll find that two or more patterns combine to create a rich visual image. For most of us, our brains have trouble perceiving more than a couple of patterns at once, so in garden design it's usually best to limit yourself to using two, maybe three, for any particular composition.

SCATTERED

Toss a handful of marbles up into the air and watch them fall down onto the living room carpet, and you'll see the classic scattered pattern: one element repeated in apparently random order across a level field. The scattered pattern occurs in many places in the natural world, but usually the ordering is not as random as it might seem. Patterns result from processes. For example, fallen leaves make a scattered pattern on the

After the winter cold and wind strips the leaves away, the scattered pattern of buffalo gourds (*Cucurbita foetidissima*) is revealed. These are growing at the Leonora Curtin Wetland Preserve in Santa Fe, New Mexico.

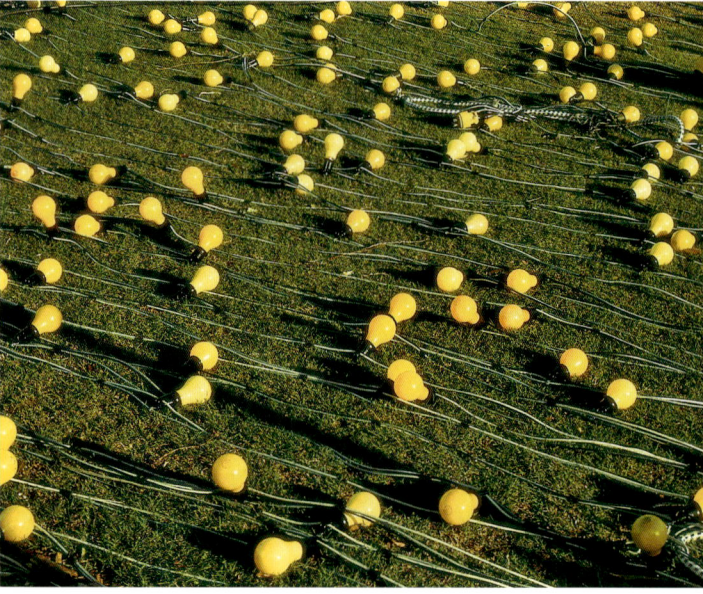

At Epcot theme park, part of Walt Disney World near Orlando, Florida, these strings of lightbulbs were laid out on a lawn before they were hung in the trees. Even though the bulbs were spaced evenly along the wires, when the strings were laid down side by side they formed an organic scattered pattern.

ground in response to a few simple factors. When the leaf has finished doing its job for the tree, an abscission layer forms to separate the leaf from the stem. Gravity pulls the leaf to the ground, and the acceleration rate of each leaf varies according to its surface area and its particular resistance to the air it falls through. Air currents affect the horizontal movement of leaves as they fall, and the taller the tree, the greater the distance its leaves have to travel before they reach the ground. Any particular scattered pattern depends on a similar set of variables.

Some of the components in a scattered pattern will be aggregated into clumps, and there will be gaps of various sizes between the clumps. This clump-and-gap pattern occurs in many places, in many different scales, as small as grains of dust on the head of a pin, or as big as the array of stars across the sky.

MOSAIC

When two or more organisms occupy the same space, a mosaic pattern results. Typically, the spaces between the clumps of one element are occupied by clumps of something else, but sometimes they blend and coexist in the same space. The clumps and gaps vary in size, so some parts of the mosaic might be dominated by one element, while other parts might have a relatively equal balance of all the elements. The clumps also vary in shape, so the overall mosaic pattern can vary widely depending upon the specific characteristics of each organism.

If you focus only on the flowers of these native bunchberries (*Cornus canadensis*), you see a scattered pattern. If you widen your scope of vision to take in all the elements—bunchberry flowers and leaves, cranberry plants, hair-cap moss, native grasses—a mosaic pattern emerges.

Leaves that fall from various mixed-woodland trees create a mosaic pattern on the forest floor.

In a typical mixed woodland, five or six different tree species may contribute scattered leaves to create a mosaic pattern on any given patch of the forest floor. Each kind of leaf will tend to have a greater concentration near its parent tree. Oak leaves are relatively heavy, so they will tend to fall nearer the tree. Maple leaves are lighter, so a breeze might spread them more widely. A gust of wind might blow most of a tree's leaves far away from their parent source. Beech trees hold most of their leaves through the winter, so the mosaic on the forest floor might contain only a few of them.

Living organisms create mosaic patterns by competing or cooperating with each other, seeking to occupy space or to consume whatever resources might be available. In an herbaceous meadow, the patchwork of wildflowers and grasses is guided by various combinations of natural factors such as soil type, availability of moisture and nutrients, and methods of seed dispersal. In plant communities where resources are abundant, species diversity is high and the mosaic pattern can be quite complex. As complexity increases, it becomes more difficult for us to discern the mosaic pattern.

In ecological communities where resources are limited, species diversity is low and the patterns are simplified. A prairie fire consumes organic matter, and over years of repeated burning the soil becomes relatively nutrient-poor. The species composition is reduced to only those that can withstand periodic burning and thrive with minimal nutrients. In other kinds of ecosystems, other factors limit the diversity of species. For example, low soil pH favors acid-loving plants, which is one reason you see vast and simplified mosaics of rhododendrons and mountain laurels near the granitic ridge tops of the Smoky Mountains. Along floodplains, wetlands have very clear mosaic patterns because the species diversity is limited to those that can withstand high levels of moisture and low levels of oxygen in the soil.

Tidal pools, such as this one in coastal Maine, offer many opportunities to explore the mosaic pattern.

In a wetland ecosystem, the limited number of species adapted to the conditions there create an especially distinct mosaic pattern. Many kinds of environmental stresses—such as extremely high or low soil pH, periodic burning, or drought—can lead to exaggerated patterns in the landscape.

The Roads Water-Smart Garden, designed by Lauren Springer Ogden, at the Denver Botanic Gardens features native and drought-tolerant plants. The mosaic pattern is exaggerated to make a dramatic display. Repetition of color, texture, and form creates strong unity within a rather complex diversity of species and cultivars.

The Laura Smith Porter Plains Garden at the Denver Botanic Gardens is a managed meadow of native perennials and grasses. The mosaic pattern is subtler than in the Roads Water-Smart Garden, more like what you would find in a naturally occurring ecosystem.

In Chicago's Millennium Park, the Lurie Garden, designed by Gustafson Guthrie Nichol Ltd, Piet Oudolf, and Robert Israel, is a bold abstraction that symbolizes the prairie meadows of the great American Midwest.

NATURALISTIC DRIFT

While a scattered pattern will occur when you drop a handful of marbles on the living room rug, tossing them sideways will create a naturalistic drift. There will be more elements nearest to the source, and fewer and fewer as distance from the source increases. Plants that spread by runners often produce this pattern—agaves and yuccas do this in the dry lands of the American Southwest—but the plants that most commonly demonstrate the naturalistic drift pattern are those with seeds dispersed by birds.

Consider a typical naturalistic drift of the common red cedar, *Juniperus virginiana*. A group of cedar waxwings will perch on a plant that is heavy with fruit and gorge themselves with berries. The waxwing's digestive system seems to work pretty quickly on the fruit to separate the pulp from the seeds, because when the bird takes off and flies to another tree it lightens its load by ejecting a small packet of seeds wrapped in a little wad of fertilizer. Within a few years that little packet will have produced another red cedar full of fruit, and a bird will land there to carry on the seed dispersal process once again. In a naturalistic drift of red cedars, I guess you could say the trees are spaced about as far apart as a bird can squirt.

This bird-dispersed pattern won't be unidirectional, as when you toss a handful of marbles across the carpet, but will expand outward in all directions. In a composition that includes a number of plants that tend to spread in a naturalistic drift, various species will intersect in various ways, creating landscapes with lots of richness and diversity. In the garden, you can work with this pattern to achieve beautiful effects.

Barnacles cling to a rock on the Maine coast, clustered more thickly near the bottom and then thinning out as they approach the high tide line.

Common red cedar (*Juniperus virginiana*) and bayberry (*Myrica pensylvanica*) are often seen together in old-field ecosystems on the mid-Atlantic coastal plain. Here the two species are blended together into one naturalistic drift pattern, with seeds that have been dispersed by birds.

In a desert grassland at the Arizona-Sonora Desert Museum outside of Tucson, a naturalistic drift of Palmer's agave (*Agave palmeri*) and desert spoon (*Dasylirion wheeleri*) fans out among wild grasses, blue grama (*Bouteloua gracilis*), and cane bluestem (*Bothriochloa barbinodis*). An Arizona rosewood (*Vauquelinia californica*) occupies the center middle ground.

ABOVE Near the entrance lane on a Texas ranch, a big sweep of century plants (*Agave americana*) and narrow-leaved Buckley's yucca (*Yucca constricta*) meanders in a carefully designed naturalistic drift alongside a stone wall and hedgerow of Texas red oaks (*Quercus buckleyi*).

RIGHT At the Chanticleer Garden in Wayne, Pennsylvania, where a bluestone walkway meets an asphalt path, a naturalistic drift pattern integrates the paving stones with the asphalt.

TWO Building a Visual Vocabulary: Shapes, Forms, and Patterns 45

SERPENTINE

The snake, one of the most ancient and symbolically potent icons in human culture, finds myriad expressions in the natural landscape. It is among nature's most common forms, showing up in everything from reptiles to rivers, from the edge between forest and wetland to the knifelike ridge along the tops of sand dunes. In North America, the jet stream pushes weather systems across the continent in a constantly shifting serpentine path. The yin-yang symbol is a circle bisected with a simple serpentine line, representing elemental forces that oppose but also complement each other, each actually requiring the other for its own existence in the natural world. The serpentine line is what the nineteenth-century British painter and aesthetician William Hogarth called the "line of beauty," and it's one of the patterns most pleasing to the human eye.

When I first visited Wayne and Beth Gibbens at Innisfree, their farm in the Piedmont hunt country of central Virginia, I knew I had found kindred spirits when I saw their serpentine fences winding through the fields and paddocks. Most of the fences in their region run perpendicular to the property lines, so the pastures tend to be rectangular. Unlike their neighbors, Wayne and Beth had laid their fences out in serpentine lines to emphasize the beauty of the native landforms. Continuing to play with the curving line, we created a master plan for their farm that includes what they call "the daily jaunt," a walking trail that moves through the property in a serpentine line.

In laying out the pathways that made up the daily jaunt, I would map out a route by placing little flags in lines that curved along the edges of the pastures, and then Wayne would follow with the tractor mower to

The snake, one example of which is seen here on my driveway, is the namesake of the serpentine form.

This aerial view of a Mississippi River tributary illustrates the serpentine form occurring naturally on a vastly different scale.

ABOVE Seeing the serpentine fences that enclosed their fields and paddocks, I knew I had found kindred spirits when I first visited Wayne and Beth Gibbens at Innisfree, their farm in the Piedmont hunt country of central Virginia.

RIGHT Laying out the pathways for "the daily jaunt," I'd place little flags in the ground to map out serpentine lines, and then Wayne would follow along with the tractor mower.

When the pasture grasses grew up, the serpentine lines of the pathways were quite dramatic. One of the beauties of this technique is that it's easy to change the layout from year to year.

ABOVE The serpentine line, as seen here at the Huntington Botanical Gardens in San Marino, California, was referred to by nineteenth-century British painter and aesthetician William Hogarth as the "line of beauty."

RIGHT In this public park in San Diego, California, the pathway moves through a simple grid of turf mounds, creating a serpentine pattern. Design by Martha Schwartz Partners.

TWO Building a Visual Vocabulary: Shapes, Forms, and Patterns 49

etch the route more permanently into the landscape. It was like painting lines on the land with a giant brush. The best thing about making such simple pathways is that they are easy to change from year to year, and without a lot of expense and effort you can experiment and modify them until you've got the pattern just right.

SPIRAL

Another one of the oldest and most venerated of human symbols, the spiral is significant in cultural iconography around the world. There's a lot of scholarly discussion about the meaning of spirals in ancient cultures, where they might have symbolized the energy of the sun, the female life force, the cycles

of the seasons, evolution, and change. In our day, spirals continue to be loaded with meaning, profound as well as frivolous. In animated cartoons and movies you'll see rotating spirals used to represent dizziness or other altered states of consciousness. Alfred Hitchcock frequently used the spiral to enhance a feeling of suspense or terror—most famously in the movie *Vertigo*, with the spiral motif even appearing on the movie poster.

Spirals are everywhere in nature, showing up in seashells, sunflowers, river eddies, and the fiddleheads of ferns. A helix is a three-dimensional spiral like those found in tornadoes, spiral staircases, and carpenter's screws. The major bones in our arms and legs spiral slightly from end to end, as do the trunks and limbs of many trees—it's one of the ways we humans are connected to the trees. The double helix lives inside our DNA, carrying information that determines our hair color and body type, and the pattern of our fingerprints. Many plants have leaves and flowers that spiral around a central stem.

For the new children's garden at the Lady Bird Johnson Wildflower Center in Austin, Texas, I was asked to design a setting for a collection of native plants with spiraling plant parts or spiraling form. Lots of school groups visit the Wildflower Center, and since the education staff wanted to teach about the widest possible range of topics, we decided to include mathematics in the lesson plan. I proposed a spiraling stone wall, low and wide enough to walk on, that wrapped around and through the spiraling plants. The wall will be covered with colorful broken-tile mosaics depicting leaves and flowers, including those that aren't present during the school year, as well as symbols and mathematical equations related to the spiraling form. The serpentine collection even includes a hopscotch game

A double spiral rill is part of the central water feature in the historic 1920s garden of Amelia Elizabeth White and Martha Root White in Santa Fe, New Mexico.

In a contemporary New Mexico garden, a spiral form is used at the top of a handrail.

LEFT Many plants have a spiral form, including this huachuca agave (*Agave parryi* var. *huachucensis*).

BELOW For the children's garden at the Lady Bird Johnson Wildflower Center in Austin, Texas, a spiraling wall will enclose a collection of native plants that have spiraling leaves, stems, flowers, and/or fruits.

52 PART 1 Cultivating the Artist's Eye

with numbers progressing in a Fibonacci sequence, named for the thirteenth-century Italian mathematician Leonardo Fibonacci, where each number is the sum of the two preceding numbers (1, 1, 2, 3, 5, 8, 13, 21, 34, 55, and so on). A Fibonacci spiral, mathematically related to the sequence, is found in the arrangement of leaves, seeds, and flowers in many plants.

CIRCLE

When you drop a pebble into still water, ripples move outward in a series of perfect concentric circles. The planets in our solar system move around the sun in nearly circular rings. The circle appears frequently in ancient as well as modern art and is associated with many different meanings across many cultures. Concentric circles symbolize creation, centrifugal

In Australian aboriginal dot paintings, such as *Love Dreaming* by Maggie Napaljarri Ross (a detail of which is shown here), concentric circles signify sacred places in the landscape.

This paving at Kykuit, the historic Rockefeller estate in New York's Hudson River valley, has concentric circles arrayed in a scattered pattern. With sophisticated subtlety, the circles are made with pebbles exactly the same shape and size as those in the background. The circular form provides interest while the texture provides continuity.

Although ferns tend to grow in a radial pattern, the leaflets of this one form a sequence of concentric circles when you look directly down on the plant from above.

TWO Building a Visual Vocabulary: Shapes, Forms, and Patterns 53

force, and outward expansion. In Australian aboriginal art, concentric circles represent waterholes or other sacred places in the landscape. In central Australia, Kukatja women perform a ceremony where they gather and move in circular motion, scuffing the ground with their feet. Literally referred to as "piercing the ground," this action is thought to raise the ancestor spirits and bring them out into the physical world through the women's bodies.

The single circle is an even more common cultural icon, symbolizing unity, divinity, and wholeness. Throughout Europe and northern Africa, prehistoric stone circles have inspired much debate on their exact meaning and origin, but when you visit them you don't need any prior knowledge to experience their transformative power. Jens Jensen, the Danish-born American landscape architect, popularized the "council ring" in the public parks he created in the early 1900s throughout the midwestern United States. A circular stone bench, the council ring is a democratic gathering place where everyone can have equal status. Fairy circles—rings of mushrooms typically found in forests but also in open pastureland—are common in European folklore. They serve as portals into the fairy kingdom, or as places where the little people gather to dance and sing.

Here are two contrasting examples of the circular form in the landscape. Big sweeps of Porter's sunflower surround circular clearings in the granite outcrop at Arabia Mountain State Park in Stockbridge, Georgia (left). The inverse occurs in a pond at Baxter State Park in Millinocket, Maine, where water surrounds circular islands of marsh grasses (right).

RADIAL

Straight lines emanating from a central point form a radial pattern, like the lines of energy moving outward in Keith Haring's *Radiant Baby*. It is an efficient way of moving materials through a living system. In plants, radial arrangements of leaves or stems are common, including the leaves of the desert sotol, the spines of a cactus, and the umbels in a milkweed flower. In the nonplant world, fireworks, wagon wheels, and sea urchins also have a radial form. I once saw an aerial photo of medieval farm fields in northern Europe, with long narrow strips of cropland radiating out from a central point like a giant starburst. This geometry resulted from the invention of the deep plow, which required as many as eight oxen to pull it through the heavy soils. Turning such a large team required a wide radius, so the fields were arranged in long narrow strips to minimize the amount of land devoted to turning the plow. Patterns almost always result from a particular process or processes, cultural as well as natural.

DENDRITIC

The dendritic pattern is another efficient way of moving energy through a system, and it highlights another intimate connection between humans and trees. Life-sustaining substances move through the branches and roots of a tree in the same pattern as blood circulating through our arms and legs. The drainage system in a typical watershed has a dendritic arrangement of rivulets, streams, and rivers. In a thunderstorm, electrical currents flash through the sky in a dendritic pattern. Our own personal electrical supply, the central nervous system, is also dendritic. Ongoing neurological

Alliums have a radial flower structure, as illustrated by this *Allium christophii* growing with a *Sedum telephium* 'Matrona' at the Toronto Botanical Garden.

In my own garden, pressing a doll's head into the center of this blue fescue, *Festuca glauca* 'Elija Blue', dramatized the radial pattern typical of ornamental grasses.

ABOVE The branches of a Monterey cypress (*Cupressus macrocarpa*) growing along the Pacific coast in San Francisco's Golden Gate Park illustrate the dendritic pattern.

LEFT So do the exposed roots of an old dead tree in the mountains of Maine.

RIGHT The Green Man is one of the oldest symbols in the arts, occurring in a variety of forms in many cultures and dating back more than a thousand years. In my pastel drawing called "Tree Man," the arms of a man branch in a dendritic pattern, symbolizing the union between humans and trees.

BELOW Watershed drainage typically expresses a dendritic pattern, such as here at the Borrego Badlands in southern California. Photo by Bruce Perry.

health and development uses a process called dendritic arborization, literally "branching tree process," and good neurological development requires continual growth of this system—which, by the way, is stimulated by constant exposure to new ideas and activities, so I hope you are experiencing at least a small degree of dendritic arborization as you read this.

FRACTURED

A fractured pattern occurs when a force such as pressure, expansion, or shrinking is evenly applied over a uniform field, as when a flat layer of mud dries. When a tree grows and its trunk expands, the bark can split in a fractured pattern. In Raku pottery, crackled or "crazed" glazes result from removing pots from the kiln at their highest temperature. Quick cooling and the resulting thermal shock cause the glaze to shrink rapidly, creating a beautiful fractured pattern. In a patio, closely fitted irregular stones create a fractured pattern. Some of my most enjoyable moments in the garden have been making colorful mosaics with fractured tiles.

ABOVE Some of these lichens, growing on the rocky New England coast, have been fractured by expansion and contraction of individual patches. Different species interact to also form a mosaic.

RIGHT The bark of this persimmon tree (*Diospyrus virginiana*) becomes ever more deeply fractured as the trunk expands over the years.

Bringing Patterns into Design

When you are using these patterns in garden design, remember that in nature they result from specific processes that operate over a period of time. They don't just show up without reason. In plants, dendritic patterns evolve from the growth and branching of stems, and in a river, the serpentine pattern comes from erosion and deposition of soils. Patterns will seem to make the most sense in your garden if they're used for a logical reason or to suggest a particular process. Using patterns that occur in local ecosystems is one way to connect your design to a local sense of place. However, there's nothing wrong with whimsy, as long as you're conscious of your own capriciousness and exercise some restraint in how many patterns you use in one design composition.

Since we can only process a certain amount of visual information at once, we tend to find greater satisfaction in designs that are relatively simple. The fewer species there are, the simpler the patterns and the more beautiful the composition. We find satisfaction in scenes that have a balance of unity and

A fungus spreads in a mosaic pattern on the pad of a prickly pear cactus (*Opuntia* sp., above). The spines of the cactus occupy the same territory in a near-perfect grid (above right). When the skin of a prickly pear pad erodes away completely, a dendritic network is revealed in the structure beneath (right).

diversity. Variety creates interest, and order makes it easier for us to perceive the overall patterns. A basic principle of garden design might be: beauty equals unity plus diversity.

However, plant lovers just can't help themselves when it comes to species diversity. They've just got to have lots and lots of different plants, including the latest varieties and cultivars. But let's face it, how many different heucheras does your garden really need? I'm glad there are so many fabulous ones to choose from, but unless you are a heuchera collector, in which case you can't prevent yourself from collecting as many as

This arrangement of golden barrel cactus (*Echinocactus grusonii*) at the Huntington Botanical Gardens illustrates both the naturalistic drift and serpentine patterns.

Isabelle Greene designed the Silver Garden at Longwood Gardens in Kennett Square, Pennsylvania, to display silver-leaved plants that are adapted to Mediterranean and dry climates. A naturalistic drift pattern, along with repetition of plants with a radial form and silvery color, provides strong design unity to a diverse collection.

ABOVE At the Chanticleer garden in Wayne, Pennsylvania, a scattered pattern of *Allium* 'Purple Sensation' sweeps through the Tennis Court Garden in late spring.

LEFT In my container garden in Toronto, Ontario, a mosaic of various silver-foliaged plants is unified by a naturalistic drift of blue and turquoise globes.

possible, your garden design will be much more successful if you can limit the palette to a few well-chosen varieties. When a plant lover makes a garden from scratch in a finite amount of space, it's hard to exercise restraint even in how many different species to include, let alone cultivars. It's easy to end up with something that looks like a big bowl of M&Ms—or even worse, a bowl of M&Ms with Smarties, Jujifruits, Goobers, *and* Raisinets. That's not a mosaic design, it's a scattered pattern gone insane.

In a naturally occurring ecosystem, the patterns are simplified by the site's particular environmental conditions. You can apply the same principle to a garden by choosing only those plants that will thrive without heroic efforts to modify the site. For example, use drought-tolerant plants on a dry site and moisture-loving plants where the drainage is poor. If the site has no limiting environmental factors, you might need to create your own set of rules. You could choose to emphasize native plants, or seasonal change, or plants that conform to specific design themes such as color or textural combinations. Find some basic limiting factors and try to stay within those when choosing plants, and you'll find a greater sense of unity, and beauty, in your garden.

A diverse mosaic of desert plants at Kendrick Lake Park in Denver, Colorado, is given structure by the smooth contours of a natural rock (left). Similarly, a sheared evergreen hedge brings structure to a grass meadow at Le Jardin Plume in Normandy, France (right). The steady, solid hedge enriches the kinetic interplay of windblown grasses.

The "new-wave" planting style of Dutch garden designer Piet Oudolf is based on a mosaic of strong masses, including a variety of perennials, bulbs, and grasses—as seen at the entrance to the Toronto Botanical Garden in Ontario.

THREE
Sketching, Painting, Drawing:
Ways of Seeing

WHEN I TAUGHT DESIGN at the undergraduate level, I was disheartened to learn that some of my students associated being creative with being high on drugs. After pondering this problem for a while, I came to think that part of this association had to do with drugs being illegal. In our culture, being freely creative feels so self-indulgent, it's almost like you're getting away with something you shouldn't be allowed to do. Following our artistic impulses, and enjoying them, can have a sense of guilt associated with it, and that makes it difficult for the design process to really flow. In the teaching studio, most of what I tried to do was to make a safe place for creativity to happen. Once the students tried it and found there weren't any negative consequences, they'd get more comfortable with the sensation of being creative, and the ideas would begin to pour out. It's important to find your own personal way to make creativity feel safe so you can really indulge yourself in it.

The Creative Flow

Creative energy flows most freely when you can let your ego fly. Ego can be a useful and productive thing, not the least bit harmful as long as you're keeping an eye on it. I once had an employer who used to call me over to his desk to admire his work. It was part of my job. I remember one day he had completely papered the wall in front of his desk with dozens of sketches he had drawn on a recent trip to Europe.

"Look at this," he swept his hands widely. "There they all are, and they're all me."

What arrogance, I thought, but at the time I also felt that my job was to agree. "Yes," I sighed, "this couldn't possibly be more you."

But now when I look back on this event, I think about it differently. I recognize the feeling he was having. There in his office he had made a space where he could totally indulge himself, nurturing his own creativity. It was delightfully self-indulgent, and he

The open meadow at Tyler Arboretum in Media, Pennsylvania, offered a subject I could paint without thinking too much about accuracy or detail. I used fairly large brushes to apply simple daubs of color, seeking to capture a general feeling or mood.

Normandy 8/13/09 WGS

 Waiting for a friend in the courtyard outside a château in Normandy, I made this small oil pastel sketch on paper, recording the patterns in a grove of linden trees. The sketch required ten or twelve minutes of focused looking, giving me time to explore the subtle variations in the vertical lines of the trunks—and to notice that some of the trees, which had been planted in a regular grid, had died over the years, eroding the grid into a more organic pattern.

THREE Sketching, Painting, Drawing: Ways of Seeing 67

wanted to share the experience with me. Now that I have a fuller understanding of the role of ego in the design process, I don't think he was being the least bit arrogant, and I'm grateful he chose to invite me into that moment.

My artwork serves me that way. Most of it doesn't ever get shared with others, but I find it important to nurture myself with artistic pursuits that simply make me feel good. I love the physicality of materials, the feel of good pencils, paints and papers, fine pigments and well-crafted tools, and I allow myself to play with them, much like a child with a favorite box of crayons. As long as I continue to enjoy the experience of making art, not worrying about its commercial value, the creative flow stays in high gear and has a very positive influence on my work as a garden designer.

I painted this study of trees in Austin's Shoal Creek Greenbelt with acrylics on a piece of plywood coated with a layer of white gesso that had some sandy soil from the creek bed mixed into it.

68 PART 1 Cultivating the Artist's Eye

A student makes a collage to represent the pattern in a native meadow.

The student who made this collage needed an extra color, and since she only had been given four colors of construction paper, she used some newspaper that she happened to have handy—exactly the kind of spontaneous creativity an exercise like this is designed to promote.

One time I painted a study of trees in Austin's Shoal Creek Greenbelt with acrylics on a piece of plywood coated with a layer of white gesso that had some sandy soil from the creek bed mixed into it. I'd never done a painting on a sandy board before, so the novelty took some of the seriousness out of the enterprise, and the rough surface invited some fairly coarse and expressive brushstrokes. I find that anything I can do to keep the painting experience fresh and unpredictable will prevent me from getting too concerned about painting realistically. For me, the whole point of painting is to keep the creativity flowing, not getting bogged down in exact representation, allowing the painting to teach me new and unexpected ways of seeing the landscape.

I once read an interview with singer-songwriter Joni Mitchell in which she talked about her work as a painter. She said the money from her music had allowed her to paint outside the constraints of the commercial art world. She didn't have to worry about how well her paintings were selling, and the music and the painting fed each other. That's how I feel about painting and garden design. Since my profession is garden design, I don't have to worry about being marketable as an artist, and the creative energy generated by the painting feeds and stimulates my work as a designer.

Kindergarten Materials

If you have difficulty thinking of yourself as an artist and you're intimidated by the materials and techniques artists use, you can pretend you are a child. Play. Have fun. Use the kinds of supplies they use in kindergarten. One easy way to record patterns in nature is to make a collage with cheap construction paper and a glue stick. Assemble the following: a ten-

In a design workshop held at the University of Utah's Red Butte Garden in Salt Lake City, sponsored by the APLD, we made small soft pastel sketches to abstract the patterns in a native meadow. I assembled twelve of them in a grid. Laying a piece of tracing paper over the twelve sketches, I began to draw shapes that tied together the various shapes in the individual sketches.

inch square of cardboard, five colors of construction paper, a glue stick, and at least forty feet of string. Go out into a meadow and use the string to mark out a square, ten feet by ten feet. Pretend you are hovering above the square and looking down. Make a visual recording of the mosaic pattern by tearing pieces of construction paper with your fingers and attaching them to the cardboard with the glue stick. You're making a map of the meadow, a plan view. Don't use more than five colors, even though the meadow may have more than five species of plants. The idea is to make an abstraction of the mosaic pattern, not to record it in all its detail. This is an exercise in whittling down all the information into a simple pattern.

I've done this activity with undergraduates in introductory landscape design classes as well as with advanced designers at professional workshops. At an Association of Professional Landscape Designers (APLD) conference we did a similar exercise, drawing with soft pastels rather than collaging with paper. We placed all the finished drawings side by side on a tabletop, covered them with a sheet of tracing paper, and then abstracted the mosaic patterns by tracing them again and again, each time simplifying the patterns. Then we used the abstracted patterns to develop a garden plan.

In collage, there is a fast interplay between control and serendipity. You select what colors to use but don't spend much time thinking about it. On paper, you can easily move things around. Out in the actual garden, working with real plants and other materials, experimentation takes more time and effort. The physical supplies are usually more expensive than paper and glue, but even after a garden is completed, the materials aren't fixed in place—especially not the plants. You can dig them up and move them around, even though it might take some effort.

The garden of my friend Mary Shea illustrates this beautifully. Mary is known for her interior decorating talent as well as her gardening skill. Inside the house, she is expert at combining colors and textures, and she has a knack for painting walls and trim in unusual color combinations that appear just right. She told me she sometimes has to repaint a room two or three times before she's satisfied. In the garden, her combinations of herbaceous plants are unusual and exquisite. I asked her how she gets such daring juxtapositions of colors and textures to look so great, and she said she moves plants around when fully grown, in full bloom. She is collaging with mature plants.

Once you get the hang of doing paper collages, you can move into painting. I recommend acrylics rather than oil paint. While there are certain advantages to using oil if you are producing works of fine art, I think acrylic paint works best for generating fast design studies. It's easy to clean up and it dries quickly, which makes it seem much less intimidating to use. The paintings pile up in my studio because I do them rapidly and cheaply on paper. Mistakes don't cost much—and I keep almost everything, even if it looks like a mistake. If I do something that doesn't seem right, I set it aside and move on to something else. I pin the paintings to the wall in various combinations and look at them from time to time, learning things, noticing details or recurring themes. I cut up the ones that don't seem to hold together on their own and move the pieces around, collaging them together with pieces cut from other paintings.

LEFT In Mary Shea's garden, this collage includes *Itea virginica* 'Henry's Garnet', blue myrtle spurge (*Euphorbia myrsinites*), *Spiraea japonica* 'Magic Carpet', and the star of Persia (*Allium christophii*). A unifying hint of blue in the euphorbia foliage and in both the spiraea and allium flowers helps to hold the composition together.

BELOW Three plants in this composition—Midnight Wine weigela (*Weigela florida* 'Elvera'), *Heuchera villosa* 'Caramel', and a culinary sage (*Salvia officinalis* 'Purpurascens')—are brought together by varying degrees of purple in their foliage (even the caramel-colored heuchera has subtle overtones of purple in its leaves). *Filipendula ulmaria* 'Aurea', or golden meadowsweet, provides a counterpoint with a jolt of contrasting chartreuse.

THREE Sketching, Painting, Drawing: Ways of Seeing

This is similar in some ways to cutting and pasting on the computer, but it's fundamentally different from using a graphics program such as Photoshop. Sure, computer editing is fast, but although it can be thrilling, it's not terribly thoughtful. Most important, it's not tactile. You don't get paint on your hands, and getting paint on my hands is part of the sensory experience of painting that I enjoy. There's something deeply nourishing about working with your fingers on real paper with real pigments. I attended a lecture at the Haystack Mountain School of Crafts by Marjorie Simon, a metal artist from Philadelphia, and she seemed to agree. "If you do it with your hands," she said, "eventually it will get to your brain."

Repetition is an important tool. Do an exercise once and then find a way to do it differently a second time, and then a third, and a fourth. With each successive variation your confidence increases. When you make things in a series, over and over, it's freeing, not daunting or serious, and you can allow yourself to make mistakes—a very important part of the creative process. If you allow yourself to screw things up, it will release your inhibitions, and your creativity will lead you in directions you might not have predicted.

Visual Note Taking

To really get to know a place, I find sketching is better than photographing. Photographs are good for recording the maximum amount of detail in a scene, but sketching is better for capturing its essence. It slows me down and causes me to spend time with a place. Sometimes if I'm photographing and not sketching, when I finally get around to looking at the photos I forget why I took them. This just doesn't happen with drawing. It's a way of really seeing a place, of making a connection with it.

People say that practice makes perfect, but I do everything I can to forget about that. Sketching isn't about seeking perfection as a visual artist. It's simply about practicing the art of seeing. Ecological designer

OPPOSITE TOP The creamy tones of *Hosta* 'Orange Marmalade' contrast with the cool greens in *Hosta* 'Touch of Class'. Mary uses 'Caramel' heuchera throughout the border for continuity.

LEFT Pieces were cut from paintings (acrylic on paper) and arranged—and then rearranged—into three different collages, with shapes abstracted and drawn in bright yellow lines.

ABOVE Fingerpainting is a good way to relieve some of the anxiety that might be associated with painting, get your thinking self out of the way, and have some fun. This one was from the dock of a friend's cabin in Maine, painted in around thirty minutes without worrying about the outcome—what a pleasant surprise.

RIGHT Limiting yourself to a single color like purple or blue, mixed with white, is one way to get the urge for realism out of the way and learn something about light and shadow.

THREE Sketching, Painting, Drawing: Ways of Seeing 75

Darrel Morrison agrees. He describes his beautiful watercolor sketches as "not great works of art, but note taking." For me sketching in the natural landscape is all about vivifying natural process, about bringing nature intensely alive and finding profound inspiration for landscape design. Although sketching may seem daunting at first, I really believe it's something everyone can do. Think about writing. Everyone knows how to take notes, to put down a couple of words. Just because you're not skilled at writing novels or poetry doesn't mean you can't keep a journal. In learning to sketch and draw, the goal is not to reach perfection but simply to become more comfortable with the materials. And who knows? Once you stop worrying about making lovely drawings and simply practice jotting down visual information, you may eventually discover that your sketches have a certain beauty about them. You might actually find yourself producing works of art.

However, it's important to resist the urge to strive for beauty while sketching, as this only gets in the way and stifles the flow of the pen to the page. One way of removing the temptation to make beautiful drawings is to use inexpensive materials. When visiting a

Here's a monoprint showing a grove of yellow birch in Peirce's Woods at Longwood Gardens. I added the evergreen shrub masses to give definition to the space.

Another version of the sweet birch grove, in acrylic paint on paper, suggested yellow-flowering native azaleas in the shrub layer.

A third version of the same scene, also acrylic on paper, made no attempt at realism in the color scheme. Repetition of this exercise helped me internalize the basic design theme in Peirce's Woods: strong verticals rising through horizontal planes of various shrubs and ground covers.

In addition to camping overnight on the Lady Bird Johnson Wildflower Center site before beginning its design, Darrel Morrison studied its subtle nuances by preparing a series of watercolors. He painted this one on his first visit to the site, in February 1992. Painting and photo by Darrel Morrison.

site for the first time, I bring along the cheapest pad of paper I can find, and I sketch with an ordinary felt-tip pen. I suggest avoiding pencils, because they carry with them the irresistible urge to erase, which invites you to become too fussy and concerned about your performance as an artist. Use a felt-tip pen, make lots of mistakes, and then turn the page and draw again. Remember, these drawings are just for you, just to make you slow down and absorb what's in front of you.

I write notes directly on my sketches. It helps to keep the drawings from becoming too precious, and when I refer back to them later, it helps me remember what I was recording. I use different pens in the same sketch, some with fine tips and some with thick. I use different colors, but I often intentionally use colors that are not in the landscape I'm drawing. When looking at a green landscape, I might use a purple pen. This helps me avoid the temptation to create a sense

THREE Sketching, Painting, Drawing: Ways of Seeing 81

of realism and become distracted from the task at hand. During a visit to the Georgia O'Keeffe Museum in Santa Fe, I found a quotation from the artist written on a wall: "Nothing is less real than realism. . . . Details are confusing. It is only by selection, by elimination, by emphasis, that we get at the real meaning of things." To me, this is what sketching in the field is all about, especially if the goal is to inspire meaningful design. Once you begin to eliminate details, you begin to gain access to the real meaning within a place.

When you are studying a landscape, if you like the looks of something, stop and ask yourself why. Why do things look good to you? Identify what is capturing your interest. Make a diagram to explain what's intriguing to you, just a simple sketch to record whatever information is relevant to what you are experiencing. You might be surprised to see where these

Spending about two hours on this watercolor at the Lady Bird Johnson Wildflower Center in Austin, Texas, gave me time to pay careful attention to the quality of dappled light that is common in the woodlands of central Texas. This "sense of place" study was part of a series of exercises leading up to the design of their new children's garden.

quick visual impressions can take you and how useful they can be later on down the road.

Sketching to Connect with a Place

I had an opportunity to practice making bold design statements with native plants in a native forest high in the mountains of western North Carolina. On my first visit to the Southern Highlands Reserve, I spent the morning touring the site with the director, John Turner, but in the afternoon he left me alone so I could sketch. When I begin a new relationship with a site, it's best if I'm not influenced too much by the perceptions of those who already know it really well. Preconceptions hinder openmindedness. After I'd walked a short distance into the woods, I got out my sketchbook and began by dividing the page into a grid of roughly two-inch squares, drawing them freehand, without measuring. Precision isn't necessary—besides, beginning with rulers and being meticulous is not exactly the best way to coax yourself into a creative frame of mind.

Looking around randomly, I started filling the little squares with sketches of anything that caught my eye. Each image took only two to three minutes to draw, and then I jotted down a word or two beneath the sketch to summarize what I was seeing. As soon as I finished one sketch I'd begin another. I didn't want to pause, even briefly, because pausing can break the creative flow and allow you to think too much about what you're doing. If you keep yourself in a creative groove,

These first-impression sketches of the Southern Highlands Reserve site in western North Carolina were done quickly on a two-inch grid, with a brief descriptive note jotted beneath each sketch.

Reserve "core area" studies — W.G.Smith 8/17-8/03

snag-sculpture | scrim - foreground trees | ~ a rare row | shifting slopes.

implied circle of trees | big tree trunks mixed with little wispy ones

...lawn... | ...lawn... | ...lawn... | ...lawn...

view into clearing from lower edge - open sky above | "mosaic carpet" meadow pattern

you can get thoroughly immersed in being where you are, and you have an opportunity to connect at a deep level with the place surrounding you.

After an hour or so, what emerged was a catalog of first impressions, a visual record of the beginnings of my relationship with this particular place. But more important than just recording these observations, the sketching was the actual means through which I was seeing the place. I wasn't looking first and then making a drawing to record what I saw. Sketching and looking were happening simultaneously. The time spent making each sketch was time spent laying the foundation for a relationship with a particular place that would last for many years to come.

After that first afternoon, I decided to vary the sketching technique the following day. This time I walked quickly through the woods, stopping every fifty paces and jotting down what was directly in front of me. Again, this was done without thinking too much and without pausing in the middle of each sketch. I wrote a short descriptive statement under each sketch, just a few words. What developed was a perception of the place that differed slightly from the day before, this time including elements that might

After spending an afternoon with the first-impression sketches, the next day I walked through the Southern Highlands Reserve site again, pausing every fifty paces to sketch what was immediately in front of me. Again, I added a brief descriptive note under each sketch.

THREE Sketching, Painting, Drawing: Ways of Seeing 85

not have caught my eye if I had simply looked around and sketched whatever I found attractive. I was learning to let the site speak to me directly while I simply shut up and listened to it.

Jotting down a brief note is as important as making the sketch, especially since these sketches are made very quickly and sometimes it's hard to remember the main point of each one. Some of these observations can lead to specific design ideas. "Big tree trunks mixed with little wiggly stems" might lead to taking an existing grove of trees with strong upright trunks and adding some shrubs that will develop wispy stems, contrasting with the existing trunks and accentuating their character. "Focal point: stump and fallen log" or "outcrop with quartzite" could suggest a place to install a bench, inviting you to sit and contemplate a natural sculpture that appears to have been placed in front of you. "Steep high banks" could be where you plant wildflowers such as certain species of trillium, those with nodding flowers that are best viewed from below, or maybe very small plants like dwarf crested iris so you can get close to them without having to bend down very far.

Many of these sketches won't lead directly to particular design ideas, but all of them taken together will help you find a sense of place. I like to think of sketching as a form of active meditation, stilling the chatter of daily life for the moment and sharpening your focus on what's in front of you. Once you've practiced this kind of sketching enough to become comfortable with it, you can actually use it as a form of meditation to quiet your mind and bring a level of relief from everyday stress. The design process is about more than making beautiful gardens, it's also about cultivating a meaningful relationship to place—and to your inner self.

As part of analyzing the existing site for the entrance corridor at the new Botanic Garden of Western Pennsylvania in Pittsburgh, I made these small charcoal sketches at various places along the road.

TOP LEFT Formal drawings like this one describe the finished design for the entrance corridor at the Botanic Garden of Western Pennsylvania. This level of precision is good for conveying specific details about design intent, but I think the preliminary charcoal sketches give a better sense of the overall feeling of the place.

LEFT As part of the design for the new Santa Fe Botanical Garden, I made a sequence of studies of existing gardens in and around the city, helping me define the unique architectural vocabulary of Santa Fe. This sketch, done with a black felt-tip pen on paper, shows the eccentric geometry, massing, and variety of materials in stone and adobe walls.

ABOVE An acrylic painting on canvas depicts a floodplain area on the Botanic Garden of Western Pennsylvania site. Working in a variety of media keeps me from getting too comfortable with any one technique and keeps the creativity flowing during the site analysis phase of the project.

TOP LEFT Developing a theme for a children's project in a New York City park, I took a visual inventory of architectural details in the neighborhood. In the waiting room of a nearby building from the early 1900s, I photographed the animal decorations carved into the heavy oak furniture, and then back in the studio I made these quick pencil studies.

LEFT One building in another part of Manhattan had a lobby decorated with metal tablets depicting various modes of transportation. Even though none of these images made it into the final design for the project, they helped me understand the richness of architectural detail in the public spaces of old New York.

ABOVE A couple of blocks away from the site, the façade of one building was decorated with bronze plaques depicting life in a fantasy undersea world. I photographed them and back in the studio simplified them with pen-and-ink drawings, and then colorized them using Photoshop.

When I was with a group kayaking in a mangrove swamp in Costa Rica, I was taken with the circular shapes made by the mangroves' prop roots reflected in the still water. It was a beautiful pattern, and I felt like I was drifting inside a Burle Marx painting. Mangroves grow in soil that is totally saturated with water, and the prop roots help to keep the main trunk plumb by providing a broader base of support in the soft mud. Each prop root extends from the central stem, from a point as much as four or five feet above the water's surface, and curves down to the water in a smooth arc. Mirrored in the water, the curving stems make almost-perfect circles. The canopy above is fairly dense, but flecks of sunlight come through to animate the scene. Although the water is almost totally still, there is a light breeze in the canopy, so the specks of light are constantly in motion. The light show is mesmerizing—and something about the curves and the reflections makes the lights swirl around in circles like disco lights on a dance floor.

I didn't have a camera with me, but I wanted to record this experience graphically. I didn't have my regular sketching supplies with me, either, just a little pocket notebook and a pencil, so I couldn't make a very elaborate drawing. I made a couple of simple diagrams to record the shapes and added a few notes to further describe what I was seeing. After a month or so, back in the studio, I took out the little diagrams and used them as the basis for an abstract painting. The bright reds and purples in the painting are totally unrealistic (the actual mangrove swamp was mostly greens and grays), and the shapes and textures in the painting are much less complex than they were in reality. Yet somehow the painting not only captures the experience of the mangrove swamp, it also seems to sum up much of the tropical beauty I encountered during my

These notes and small pencil studies, each no more than four inches wide, were all I had to help me remember the experience of kayaking in the mangrove swamp, but they were enough to work from in producing the finished painting.

I painted this abstraction of mangroves in Costa Rica more than a month after I returned from a study tour of tropical ecosystems. While the actual colors in the mangrove swamp were muted greens and shades of gray, the imaginary colors in the finished painting captured something of the beauty I found throughout Costa Rica.

entire trip to Costa Rica. If I had not sketched those two little diagrams while floating there in the kayak, I wouldn't have been able to make the painting later.

What does this have to do with landscape design? Well, I haven't yet been invited to design a garden in a mangrove swamp, although I suppose the opportunity could turn up one day. The encounter with the mangroves taught me something about pattern and reflection, something that might be useful to think about the next time I work with a mirror pool. Mostly, the value of this exercise for landscape design is that it was one more opportunity to develop my observation skills. It taught me that making even the simplest of diagrams, distilling a natural landscape down to its most essential pattern and form, can greatly enrich a person's experience and memory of a place.

Doodling the Inner Landscape

I spend a lot of time on airplanes or waiting for them in airports. Most people use this time for reading or working on their laptops or texting their friends, but I keep a small sketchbook handy and I doodle in it to pass the time. I like to play with shapes and explore the many ways they can be assembled into patterns, and doodling is a good way to keep visually active. It fills the bits of time between the various other pursuits of life, and it allows some very interesting patterns to emerge. Doodling involves suspending the thinking side of your brain, giving the more intuitive side full rein to lead you where it may. There are no consequences, because it's only meaningless scratchings on paper, so there's no need to be fearful of what you might create.

A mathematical algorithm played out over a grid of tiny dots led to this mosaic pattern.

Unlike the cheap sketchbooks I take into the field with me, my doodle books are made of high-quality paper. I use Moleskine sketchbooks, each with a hundred pages of heavy acid-free paper, with a plain black cover and sewn binding. These, says the Moleskine company, were the sketchbooks of van Gogh, Picasso, and Ernest Hemingway. Originally produced by small-scale bookbinders in Paris, today they are manufactured in Milan. At close to twenty dollars each, they're a bit extravagant. But, I rationalize, I have one in my hands at least a couple of times a week, so it's a simple luxury I afford myself. I don't splurge on expensive pens, however, because I lose pens all the time. I use an ordinary cheap rolling-ball pen like you can buy in any office supply store.

Doodling is not unlike field sketching, except the subject matter is not the landscape surrounding me, it's the landscape inside my head. It's amazing how unlimited the permutations and variations can be. Sometimes, when I'm really in a groove, I'm surprised by what shows up on the page. Mostly I draw abstract shapes and patterns, not thinking about any particular garden design projects I might be working on. But months later, when I look back on my doodles and think about what gardens I was designing at the same time, I sometimes see connections. I try not to think about this while I'm moving the pen, preferring to stay as much as possible in the unconscious mind.

Doodles often begin by establishing a set of rules or setting up an algorithm, a procedure that repeats over and over until a certain end point is reached. I might first cover the page with a grid of tiny dots, and

Some doodles are derived from the artworks of others—such as this one, sketched after studying pottery at the Museum of Indian Arts and Culture in Santa Fe. In collaboration with a local Native American artist, I plan to transform patterns such as these into tile mosaics on garden walls.

then, starting in the upper left-hand corner, insert an asterisk at every third dot. Then, starting at the beginning again, I'll put a small circle at every fourth dot, superimposing a circle on an asterisk where they coincide. Then I'll place a star at every fifth dot, a square at every sixth dot, and so on until every dot has at least one symbol superimposed over it. If I draw lines to connect the squares or the stars, unpredictable shapes and patterns arise. It's good practice in mindless drawing or letting go of control and just seeing what shows up on the page. Often it leads to some surprising results and helps me maintain my faith in serendipity.

This one was a real surprise. I began by making a triangle and then inside of it rotated a smaller triangle, and then a smaller one, and so on until the whole first triangle was filled with rotated triangles (look at the colored one in the lower right corner). Then I did a similar triangle adjacent to the first one, and another beside that one, and so on. A totally unpredicted pattern emerged. Try this with squares and you'll be amazed.

Here's when you know you're in a really good groove. I drew the doodle at left with a scalloped pattern, not thinking about anything out there in the real world. A year or so later I was hiking in the woods and came upon a fungus with the same pattern (left below), and then a year after that found the scalloped water feature below in the gardens at Château de Villandry, in France. Once you've begun to develop a vocabulary of shapes, patterns, and forms, you begin to see them everywhere.

FOUR
Expanded Repertoire: Lessons from Artists

ONE OF THE MOST joyful aspects of my work is the immense opportunity it offers for collaboration across the arts, and I've been fortunate to count all kinds of artists and designers among my friends and colleagues. Studying and appreciating the work of other artists, and exploring how they connect to the natural landscape, is a vital part of my own creative process. No matter what the discipline—painting, sculpture, music, or dance—I always seem to learn something from their practice, even if at first glance it seems completely different from my own work as a landscape designer. I encourage you to expand your own creative repertoire and to develop and deepen your own connections to a variety of artistic media—it's all a part of learning to think like an artist and bringing that vibrant creativity and sense of connection into the garden.

I cut pieces from old acrylic paintings and collaged them into this Fantasy Forest. This is not about capturing an image from the landscape but having creative experiences with paint, memory, and imagination.

Artists Depicting Nature

Nature is a wellspring that feeds the human spirit, and arts that connect humans and nature have been practiced since the beginning of human civilization. The simple act of making art connects you to a chain of creation stretching back through many thousands of years. Artists have always looked to nature for ideas and inspiration, and the way they represent nature in their work reflects the prevailing cultural attitudes about nature in their time.

The first internationally recognized American art movement, the Hudson River school, reflected American attitudes about humans and nature in the mid-1800s. Painters such as Thomas Cole and Asher B. Durand depicted the dramatic natural landscapes of the Hudson River valley just north of New York City. They painted on huge canvases, giant romantic scenes that included tiny images of people and small expressions of industry living in peaceful harmony with nature. The Hudson River school artists were wildly popular in their day, many achieving celebrity status, and spectators would line up in front of New York City galleries, waiting for hours to watch as the

latest paintings were unveiled. This was the time of the great American westward expansion based on the idea of Manifest Destiny, and the public found comfort in the myth of industry and technology as benign intrusions into the untamed landscapes of America.

Paintings depicting romanticized visions of the natural environment continued to be popular throughout the twentieth century. While various twentieth-century art movements such as abstract expressionism, surrealism, and pop art began to broaden artists' subject matter, paintings of naturalistic scenery retained their hold on our imaginations. In Canada, the Group of Seven painters explored the landscapes of Ontario's northern wilderness, and while they were most active in the 1920s and '30s, their work remains among the most beloved in Canada today. Recent studies in the United States have shown that naturalistic painting is still the most popular style with the American public, reflecting our continuing need to feel in balance with nature.

Environmental Art: Landscape as Creative Medium

In the late 1960s, a group of radical artists began a new movement in the United States and Europe. Rather that making paintings or other representations of nature that could be shown in museums and galleries, they began using the landscape itself as a medium for creative expression. The environmental art movement has continued to evolve and is still very much alive today. It goes by a variety of names, including land art, eco-art, green art, and most recently, sustainable art, and it encompasses social and political themes as diverse as environmental activism, feminism, ecological restoration, recycling, and even urban community gardening.

Many environmental artists seek to reveal the beauty and wonder of nature, working with the complexities offered by plants, geology, soils, wind, water, sound, and light. Stacy Levy, an environmental artist based in Spring Mills, Pennsylvania, bridges science

FOUR Expanded Repertoire: Lessons from Artists 99

and art, creating both permanent and temporary works. She says her work serves as "a vehicle for translating the patterns and processes of the natural world into the language of human understanding." Her *River Eyelash*, an installation at the 2005 Three Rivers Arts Festival in Pittsburgh, consisted of floating strands of more than four thousand painted buoys that radiated into the river from Point State Park, where the Allegheny and the Monongahela rivers converge to form the Ohio River. The "eyelash" swayed back and forth in response to the movements of wind and water, drawing observers' attention to these dynamics in the natural landscape.

In the late 1980s, "heartist" Dominique Mazeaud created another river-based project, *The Great Cleansing of the Rio Grande River*, about her connection to a particular landscape. This piece was significant in the history of environmental art because it did not produce a physically tangible artifact. Mazeaud performed a seven-year ritual where once each month she visited the Rio Grande River in New Mexico, removing trash and other debris. *The Great Cleansing* was a performance piece without an audience, except those who would read about it in the media. Recording the process only in her personal journals—no photographs, no drawings—Dominique made the work an extended meditation on her relationship to the river. Artist and author Suzi Gablik discussed Mazeaud's *Great Cleansing* in her 1991 book, *The Reenchantment of Art*:

> In 1917 Marcel Duchamp exhibited a urinal and called it art, although at the time there wasn't any concept yet in place to explain such an act of transgression. Today, Mazeaud's project is equally startling because it isn't based on a transgression of the aesthetic codes at all. It comes from another integrating myth entirely: Compassion. Carlos Castaneda calls it the "path with heart."

River Eyelash, by environmental artist Stacy Levy, dramatized the movement of wind and water where Pittsburgh's three rivers converge. The piece included more than four thousand painted buoys, threaded onto ropes and tethered to the shore. Copyright 2005 Stacy Levy. Photos by Stacy Levy (left) and Larry Rippel (right).

Mazeaud also collects Y-shaped sticks, which remind her of a human form with upstretched arms. She calls them "arms raised in prayers, doubling as dousing rods to search for new waters." Physically reaching above and below at the same time, she's placing herself between heaven and earth. The Y-shaped stick is such an ordinary object, such a simple image. We encounter them all the time and don't really think about them, but Mazeaud recognizes them as something meaningful.

A museum installation, *One Thousand Arms of Compassion* is one of several works in a larger piece Mazeaud calls *Chanting the Alphabet/The Letter Y: A Prayer for the Land Holy....* The work consists of one thousand forked branches picked up on her hikes in the Sangre de Cristo Mountains of New Mexico. It was inspired by the Tibetan Bodhisattva of compassion, who is sometimes represented by one thousand arms. Mazeaud sees this as "a collaboration with 'Earth' who supplies invariably perfect Ys." By collecting and using a natural material that doubles as a universal expression of prayer, she strengthens our connection to the metaphysical and poetic side of life, as well as our connection to nature.

This is one of the important offerings artists make in human culture, finding meaning in the commonplace and then crafting a way to share that significance with the rest of us. On her Web site, Mazeaud quotes performance artist Marina Abramovic, who said, "Art, it's not about doing, it's about being" (www.earthheartist.com/other.html). Mazeaud notes that years later, the performance artist known as Ulay suggested a modification: "Art, it's not about doing, it's about becoming," implying that our relationships to nature, like our relationships with each other, are ongoing processes that never fully come to an end.

Balancing Control and Serendipity

At the Philadelphia Museum of Art, I once saw a large drawing by the British artist Richard Long, made of a big circle of dried mud footprints on a huge sheet of paper, mounted on a board and hung on the wall. Long collected the mud from the River Avon in England and applied it to the paper entirely with his bare feet—there were no signs of other tools. He takes walks in the natural landscape and records them in drawings and sculptural installations, using materials collected from the places he explores. This particular mud drawing was a sequence of concentric circles,

This maquette for *One Thousand Arms of Compassion*, a museum installation by Dominique Mazeaud, consists of concentric rings of Y-shaped sticks found on her hikes in New Mexico's Sangre de Cristo Mountains. Copyright 2009 by Dominique Mazeaud.

recording a walk along the river. What I found most engaging about it was its combination of spontaneity and control.

It's a simple idea, to take mud from a walk along a river and apply it to paper with your bare feet. The circle is an elemental form, connecting back to ancient expressions such as the stone circles that can be found all over England. Choosing to make a circle with your muddy feet is an intentional decision, exercising a degree of control. Yet while Long applied his footprints to the paper with precision, slight variations in each footprint were beyond his influence. To me, the tension between control and spontaneity is one aspect of the work that makes it memorable. It's a brilliant representation of our relationship to nature. We can decide to take a walk along a river—or in the woods—and we can choose our direction, our pace, but we can't control everything about our experience. The nuances of the natural landscape will have something to say about that.

Sometimes I think about this image when I'm designing a garden or making an artwork in the landscape. The most beautiful compositions are those with a simple form, executed with a certain degree of care and control but allowing the site and the materials to contribute their own unique qualities to the final artistic expression. It's a challenge to manage this tension between the self and the materials, or between you and the site, to create a work of beauty without the final result appearing overmanaged or too premeditated. I think the key to success lies in inventing a guiding set of rules and then allowing them to play themselves out over time, keeping your ego as much out of the way as you can. If you don't exercise some restraint, the result can be messy, not beautiful. On the other hand, if you are too controlling, too fussy, the end result can look sterile or contrived. In the film *Rivers and Tides*, land artist Andy Goldsworthy says, "Total control can be the death of the work."

It takes a lot of practice to learn how to balance control and serendipity, and I like to practice by playing in the garden from time to time. For example, one day I was pulling weeds in the meadow—big stems of aggressively spreading goldenrod that threatened to destroy the natural mosaic of various wildflowers and grasses. I pulled them out by the roots and tossed them onto the mowed lawn beside the meadow. It was a windy day, and I noticed that when I tossed the goldenrod stems they tended to fall to the ground with their tops facing downwind. The bottom end was heavier, with clods of soil clinging to the roots, and the flowering heads were lighter and getting caught in the wind, so the plants tended to fall in more or less the same orientation.

Once I caught on to what the wind was doing, I started to cooperate and toss the goldenrod plants so the wind could catch them more easily. What emerged was a beautiful pattern that had the straight goldenrod stems mostly parallel to each other, but with minor directional shifts of line that reflected subtle changes in wind direction, along with the variations in the size and shape of each plant. Eventually I finished weeding the goldenrods out of the meadow, raked them all up, and took them to the compost heap. But before carting them away, I stood there for a brief time and admired the beautiful abstract pattern on the lawn, taking satisfaction in this graphic record of the relationship between my will to weed the meadow and the particular qualities of the goldenrods and the wind.

Another time when I was out working in the meadow, I came upon a large colony of mature poke

weed. The bright red stems were too rich a resource to pass up, so I harvested the plants, cut off all the leaves and fruits, and made a pile of the stems. Earlier that week I had begun a garden project involving a small circular mound of soil covered with neatly clipped turfgrass. The red poke weed stems made a brilliant wreath around the mound. The bright red circle was a focal point in the garden from the end of that summer through the fall. Toward winter the color began to fade, and by spring the sun had bleached the stems to pale tan. In early spring I refreshed the wreath with a ring of native broomsedge. The grasses still had their rusty-orange winter color, which held fast through much of the following summer. None of this was premeditated, and the ongoing evolution of this sculptural piece felt a lot like gardening: things would change as the weeks and months passed, and further embellishments would be added from time to time.

How Design and Art Differ

I think that a basic difference between art and design is that design solves problems, while art raises questions. Designers are given a particular site to work with, a specific set of uses or activities to accommodate, and a budget to stay within. A typical assignment might be "In the space between the garage and the kitchen, plan a garden for roses and herbs, and keep the cost under five thousand dollars." Designers work by testing a number of possible scenarios and eliminating options, ultimately focusing down to what some textbooks call a design solution. They use knowledge, skill, and creativity to arrive at the best outcome: one that is well suited to its site, is comfortable and safe to use, and is economical and beautiful to behold. It feels right, the client is happy, and the whole thing makes good sense.

Artists, by contrast, sometimes seem to be speaking in tongues, often raising more questions than they

answer, inventing whole new languages that can be challenging and difficult to understand. Sometimes they find themselves working in a code that they themselves might not fully comprehend. If you're cranking out hundreds of sketches and studies, drawings, prints, paintings, or collages every year, you don't have much time to spend trying to understand each one of them, and the meaning of what you're doing might take years to emerge—if it ever does. I enjoy taking out work from a year or two ago, preliminary studies along with finished artworks, pinning them up together in my studio, and then just hanging out and looking. I always see new things, new connections. Or if I take out older things and hang them up beside current work, I can see new relationships that I hadn't been aware of, leading to still more questions and possibilities.

Artists begin with their own perspective, their own personal experience of the world, and then attempt to communicate something about that perspective to others. How do artists convey meaning in their work? Many believe that the meaning of a particular artwork should have some sort of shared value before it can be considered valid. Making art about a specific personal event is not enough, unless it also triggers something in the viewer beyond the artist's personal memory. Some artists, when asked about meaning in their work, would say it's not their job to tell you. Others might simply claim that their work means nothing. Some work is open to various interpretations, meaning different things to different people. There can be layers of meaning, and numerous associations can be suggested. To me, art seems most valid when it causes some sort of response in the viewer or invites some sort of relationship to form between the viewer and the artwork.

In late summer I cut these brilliant magenta stems of poke weed from my meadow at home and arranged them in a wreath around a small turf mound in the garden. Through the winter the sun faded them to almost white, and in the spring I added a second wreath of orange broomsedge to extend the color interest into the following fall.

Connecting Design with Painting

I've learned a lot about the relationship between art and design from my friend William H. Frederick, Jr., author of *The Exuberant Garden and the Controlling Hand* and an inspiring horticulturist and garden designer. Of the many lessons I've learned from Bill, the most significant involve the use of color in the garden. "Color," he wrote in *The Exuberant Garden*, "is a very personal and emotional matter." He goes on:

> I, for one, am not interested in it simply as a decorative element. For me it is a biological necessity and a prime reason for gardening. As enjoyable as the native landscape is (and my life would be diminished in a major way without it), the emotional richness provided by color as produced in a designed garden is essential. It is here that the full palette of plants now available to us from all over the world can be tapped, arranged to please our eye, suit our site, and create the moods and atmospheres that strengthen our lives.

Bill and I took some painting classes together at the Pennsylvania Academy of Fine Arts, and driving to and from Philadelphia each week gave us time to discuss what we were learning about painting and how it all related to garden design. That's where we met Patrick Ross Arnold, a painter and teacher skilled at connecting the art of design with the art of painting. Bill invited Patrick to give a class at his home garden, Ashland Hollow, and the experience there totally changed the way I look at gardens everywhere.

Patrick told us, make yourself naïve in front of the landscape and open yourself up to it. Imagine your body physically opening up. Engage your visual mind rather than your logical mind. Trick yourself into that state, don't poke along or drift, but throw yourself into it through intense activity. Stay with the act of doing, of making. There's a physical growth that happens in the brain when you do this with some regularity—a part of your brain actually gets more developed. Don't worry about finishing a painting, just stay in the act of making. It's not about constructing the image precisely as you see it. It's not drafting. You want to be inside the work, just feeling, not thinking. When you start thinking about what you are doing, stop—and then start another painting. This is how you can avoid making work that's self-conscious.

The American Buddhist nun Pema Chödrön, in a number of her books including *Start Where You Are*, gives similar advice on practicing the art of meditation through exercising the breath. When thoughts enter your mind, she advises, simply label them "thinking" and return to the breath. "When you realize you've been thinking," she writes, "you label it 'thinking.' When your mind wanders off, you say to yourself, 'Thinking'. . . and do that with honesty and gentleness." Then you simply return to the breath. The same practice works with painting and drawing. As soon as you find yourself thinking, simply stop, and then return to the canvas.

Patrick talked about the difference between being an artist and a hobbyist. Being an artist involves a continual process of teaching yourself how to paint. Are you a tourist painter, or are you a painter? Tourist or hobbyist painters have a standard kit of techniques, and they go to a beautiful site to capture a new image. It's collecting pictures, but it's not being an artist. Painting is not capturing images but having experiences. "Painting is process," Patrick says. "It is a game of color relationships, and getting inside the painting is the goal. The real work in painting is letting

go of expectations and allowing the experience to be paint-driven." Familiarity with certain techniques does help the work to flow, but the experience has to remain open and mutable. Painting involves always taking risks, making yourself vulnerable to what's in front of you. "Painting is the scariest thing I can do without hurting myself," Patrick says.

Finnish architect Alvar Aalto would probably agree. Aalto was one of the most influential twentieth-century modernist architects, and he also designed furniture and textiles. At the Alvar Aalto museum in Finland, I saw an exhibition where he quoted the French fauvist painter Georges Braque: "The greatest delight in painting is that one never knows what will

BELOW I sketched this oil pastel in the meadow at Ashland Hollow to capture two patterns found in local nature. The stepped path follows a serpentine line that leads through a grove of columnar yews. The yews, while not native to the region around the garden, are arrayed in a naturalistic drift pattern reminiscent of locally native red cedars.

ABOVE I've always been inspired by Bill Frederick's use of bold color combinations to create strong emotional impact in his garden at Ashland Hollow.

happen. One starts something and this grows, and the result is quite different from what one had expected." When I find myself being surprised by what's happening in a painting or a drawing, that's when I know I'm in a good groove.

I was having a great time painting with Patrick, learning a lot, but it wasn't always easy. During the time I was studying with him, my journals record a lot of this conflict:

> This painting class, I think it's going to drive me crazy. I'm struggling. It's not coming easily to me. But it's already beginning to affect the way I see the landscape. I've started breaking things down into shapes of color and light. This might be the beginning of a significant shift . . .
>
> Spent the day painting stupid little paintings. I'm just trying to learn how to smear the stuff on the page. Frustrating but very absorbing.
>
> This painting thing, I haven't been this challenged in years. I wonder what's going to happen, where will all this lead?

Inspirations from a Painter

I've learned a lot about creativity from Naomi Schlinke, a painter friend in Austin, Texas. "The work," she told me, "connects you to all that exists." Yikes, I thought, this sounds frighteningly serious. But she's right. Our work does connect us to what's around us, to our immediate community, and then beyond that to the larger world. There's nothing scary about that; in fact, it's comforting to feel that we can make such a simple connection beyond our selves to the rest of existence.

Naomi works with colored inks on very smooth white boards. She applies inks to one board with a variety of tools, presses another board against it, and then pulls the two of them apart, revealing imagery remarkably evocative of the patterns, shapes, and textures you find in nature. When the ink dries she sands and scrapes some of it away, leaving varying amounts, and then applies more inks and repeats the process. After a number of iterations a painting becomes a palimpsest, with layers of images revealing what's beneath to varying degrees. *Webster's* defines a

palimpsest as "having besides its present writing one or two earlier erased writings." In the ancient past, parchment or papyrus was expensive, so an older text would be scraped away and a new one written over it, sometimes leaving a ghost of the old writing visible on the page. Natural ecosystems can work the same way, with patterns layered one on top of another as the system evolves over time.

The idea of palimpsest is evident in *Ground Cover*, one of Naomi's recent paintings. She began by pressing together two inked boards, separating them, and placing them side by side to form one long panel. She then scraped away some of the ink, more on one side than the other. She applied a transparent yellow wash on top and then, finally, a series of vertical lines in transparent red ink, allowing the organic textures to show through from below. To me the resulting pattern suggests the idea of weathering over time and evokes the mosaic pattern of a forest floor, with organically spaced verticals of trees superimposed on top.

Naomi is constantly making little diagrams and notes in her sketchbooks—not just to record ideas but as part of the process of generating them. "The phrases in my notes," she says, "are semaphores for ideas and observations." I paged through her notebooks and selected a diagram that seemed related to *Ground Cover*, showing an organic pattern beneath a sequence of variously spaced vertical lines. She explained that the question she was asking herself in this entry was something like "How does one enliven an infinite pattern?" Accompanying the diagram are notes that suggest some answers, but they are only suggestions. The artist's process is more about questioning than finding answers.

Painting, scraping down and leaving traces, painting again, and then again scraping down, more traces being left, and then more painting, again and again. The results are paintings with very strong organic form, with layers of natural patterns and ambiguity of content, that inspire the imagination, draw you in, and allow you to perceive them based on your own perspective and life experience. They express a wide spectrum of emotions, highly charged with symbolism and meaning hidden just out of reach beneath the surface.

Ground Cover, a painting by Naomi Schlinke, shows how a process including spontaneity, layering, and ordered chaos can build abstractions that evoke natural landscapes, but remain open to your own personal associations and interpretation. Photo by Naomi Schlinke.

Naomi uses a particular set of tools and techniques, brought together with great focus and concentration but not in a way that's premeditated or overly controlled. To create the work, she initiates and sustains a particular physical process that remains open to chance and spontaneity but refrains from total chaos. There is theme and variation, and a beauty that comes from balancing serendipity and control.

In developing such a technique, repetition is key—doing something over and over to gain confidence. My friend Steve Bostic, a botanist who studies ecosystems, defines art as repetition with variation. You learn a particular brushstroke by repeating it again and again. Eventually you begin to trust your own hand. When you can make marks without thinking about it too much, the magic starts to happen. When you're making the piece, the process and the poetics are fused and you are unaware of it. Then suddenly you burst through to something new, and it puts everything else in a totally new light. It's how you stay creatively engaged in your work.

"Don't think too much," Naomi told me. "When you paint you have to get out of your own way." As part of learning how to paint, you have to steep yourself in the language of natural patterns, nature's vocabulary. Use the principle of directed chaos, making spontaneous choices but following particular guidelines.

Learning from Sculptors

Alice Adams is a sculptor with major works in cities throughout the United States including Seattle, New York, Denver, and San Antonio. I met her in 1990 when I was serving on the advisory committee for Philadelphia's Percent for Art Program, and she was designing *The Roundabout*, a public artwork and plaza at Thomas Jefferson University in downtown Philadelphia. In that work, references to Jefferson as architect and botanist are layered into a landscape of earth mound and water wall reminiscent of the dams along the nearby Schuylkill River. Special gardens defined by the sloping pathways around the site are punctuated by neighborhood icons of lighted doorways and marble steps. The title *The Roundabout* came from the name Jefferson gave to the main circulation route around his home at Monticello.

Some years later, Alice asked me to join her in creating a piece at the University of Delaware. In a process similar to what she used in *The Roundabout*, we made Plasticine study models that explored various

Naomi Schlinke's sketchbooks contain brief notes and tiny diagrams, shorthand records of spontaneous ideas. Here she is investigating how to enliven an infinite pattern—by dislocation ("where"), disruption ("rupture"), or by erasure, washing out, or sanding away ("swept away").

FOUR Expanded Repertoire: Lessons from Artists 109

ways of traversing a circular site from all sides while creating stopping places of interest within the circle for rest and relaxation. We studied the typography of ancient Celtic manuscripts and scrolls and the landscape architect Marian Cruger Coffin's 1918 plan for the campus core, along with architectural motifs from the historic buildings there. We combined and overlaid these disparate elements to produce *Scroll Circle*, a unified landscape that is connected to the local sense of place and imbued with multiple levels of story and meaning.

In 1990 I collaborated with sculptor Bilgè Friedlaender on *A Sitting Path—Dialog Along the Edge*, part of "Out of the Woods," an exhibition of environmental

BELOW *Scroll Circle*, the finished environmental artwork, takes images from the historic campus core and weaves a centerpiece for a cluster of modern buildings. The name refers to the architectural scrollwork on the university's historic buildings and to the complex and beautiful lettering in ancient scrolls.

ABOVE Alice Adams taught me the value of thinking in 3-D, making Plasticine study models of the emerging design.

artworks in Philadelphia's Fairmount Park curated by Marsha Moss. Our contribution was a low wall made of stones native to the Philadelphia area, combined with other stones collected from important places in each of our lives. The wall pierced the edge between a forest and a meadow, serving as a place for sitting and meditating on the dialog that occurs along the edge between "inside" and "outside." As part of the creative process leading up to making the wall, Bilgè wrote a poem, "Edge," that was printed in the exhibition's catalog. It names some of the edges we know in life, such as the edges between night and day, ocean and shore, sleep and awakening, knowing and forgetting.

I collaborated with sculptor Bilgè Friedlaender on *A Sitting Path—Dialog Along the Edge*, a low wall made of stones collected from important places in each of our lives. Spanning the edge between a forest and a meadow, it served as a place for sitting and meditating on the dialog that occurs along the edge between "inside" and "outside."

From Landscape Design into Fine Art Photography

My friend Ronald M. Saunders started off as a landscape architect but now is also a photographic artist. Ron and I studied landscape architecture together in graduate school at the University of Pennsylvania, and his free spirit has always been an inspiration to me. In the landscape design studio, he was known for collecting all kinds of diverse ideas and throwing them together without inhibition. Over the years, nurturing our mutual love of the fine arts, we have visited many museums together to explore the intersection between art and landscape design.

When Ron began to devote more and more time to perfecting his technical photographic skills, I worried that he might lose some of his creative spontaneity, but after several years of training in the basic tools and techniques he found a way to invite the unexpected into his work as a photographer. Ron makes photograms, where objects are laid onto photographic paper and exposed directly to a light source. In this form, you never know exactly how the image will develop, and the results are often surprising.

Ron creates full-scale images of the human figure, actually laying his body down on large sheets of photographic paper, and his long, wild dreadlocks create amazing shapes and textures. Nature is still a big part of his work, and he has developed a double-exposure technique where images of plants are collaged with the human form. The resulting prints suggest a dialogue between people and nature. When the human-sized photograms are hung on a wall, you can't help but be drawn personally into the work, pondering your own relationship to the natural world.

Ironically, Ron's fine art photography is taking him

back into the physical landscape. Now he is working as a public artist, using his photographic images to create environmental artworks in the San Francisco area.

Inspirations from the Performance Arts

The great modern dancer and choreographer Merce Cunningham passed away while I was working on this book, and it gave me an opportunity to reflect upon the role of what he called "chance technologies" in the creative process. In an appreciation written for the *New York Times*, Alastair Macaulay talked about how Cunningham used various techniques for generating chance—including cards, dice, and the I Ching—as compositional tools in choreography "to determine which parts of the body would be used, which directions, how many dancers." However, he didn't let chance determine the final form of the piece or direct the dancers on the stage. "The point had nothing to do with improvisation," Macaulay wrote. "Cunningham's choreography was very precisely made. Rather, he wanted to banish predictable compositional habits."

In other words, the chance elements don't determine the final work, but they can help the design process to stay unpredictable, enabling designers to move outside their own preconceptions. Chance can keep us from being too repetitive as designers, and it is one tool for keeping us interested in what we are doing. But the artist or designer maintains a degree of control, making the important choices about content. In a garden this can include making choices about visual elements such as form, line, and color—or about more narrative components such as historical reference or symbolic meaning.

Cosmic Dancer, a double-exposure photogram by Ronald M. Saunders, superimposes plant textures onto the human form. While this form of photography does require precise technique, the results are greatly enriched by accident and spontaneity. Photo by Ronald M. Saunders.

In his journal article "Cunningham, the Impermanent Art," Fernando Puma quotes Cunningham on his use of chance in design: "Some people think it's inhuman or mechanistic to toss pennies in creating a dance instead of chewing the nails or beating the head against the wall or thumbing through old notebooks for ideas." Even in landscape design today, the prevailing attitude seems to be that the designer is the key decision maker and must work hard to create a garden. It seems we can't begin a new design without poring through every book we can find, sticking little Post-its on any page that has a photograph we think might be relevant. Instead, we could use some of these games of chance to inject ourselves immediately into the creative process. "The feeling I have when I compose this way," Cunningham said, "is that I am in touch with a natural resource far greater than my own personal inventiveness could ever be."

Landscape architect Ken Smith's installation piece *Triennial WallFlowers* was created using a chance technology not unlike one Cunningham might have used. Part of an ongoing series of WallFlower installations, it covered the façade of the Cooper-Hewitt Museum in New York during the National Design Triennial in 2006. The museum's street face was covered with a huge scrim of fluorescent orange plastic construction fencing, supporting an array of overscaled, variously shaped and colored plastic pop-art flowers. The flowers were fabricated from various kinds of erosion control fabrics that are generally manufactured in bright

Ken Smith's *Triennial WallFlowers*, a temporary installation covering the façade of the Cooper-Hewitt Museum in 2006, resulted from a design process that included organized games of chance.

colors. Working with technological materials from the landscape industry in new and innovative ways, Smith offered a commentary on engineering and utility versus whimsy and beauty.

Using an invisible grid of organizing squares, each with nine positions (four corners, four sides, center), Smith determined the placement of each flower by pulling objects out of bowls in what he called "an organized system that engages random selection." I asked him how he made the decisions about which flower type would go where. "We pulled out small squares of paper at random from the bowls," he said. "One bowl had squares of paper with flower positions, and the other bowl had squares indicating flower type." As with Cunningham's choreography, the random selection system contributed to the piece, but the artist was responsible for the overall content, meaning, and total visual effect.

I'm not well versed in the art of dance, but I've learned a lot from dancers. My friend Peggy Gould is a dancer and choreographer in New York City. One evening a few years ago while sitting in on a rehearsal of a work by choreographer Sara Rudner, I was taken with the similarities between the issues Rudner was working with as a choreographer and those I worked with as a visual artist and landscape designer. Peggy and I talked about it after the rehearsal, and the next day I recorded some thoughts from our conversation in my journal:

> I'm really glad I went to watch Peggy's rehearsal last night. I found it hypnotic, and I lost myself in pattern, space, and time. I thought a lot about connections to elements in landscape: repetition, pattern, order/disorder, spatial progression, movement, shifting points of view, the focus of attention passing from place to place over time.
>
> Peggy and I talked about some of the connections between this and my doodle books: setting down rules that play out over time into patterns, the interplay of multiple patterns over time. Tension, disorder, synchronicity, layering. Order versus chaos, serendipity versus control. Improvisation, happenstance, and chance—all played out within some sort of overarching pattern or structure.

Dance is a spatial and temporal art form, and this is part of what connects the art of dance to the art of garden making. As dancer and choreographer, Peggy is constantly enticed by spaces that suggest possibilities for extra-ordinary movement or action. At Storm King Art Center in Mountainville, New York, she found herself drawn to Israeli sculptor Manashe Kadishman's 1977 piece, *Suspended*. Its monumental steel boxes are cantilevered above the ground, creating a space beneath them that feels tense and even dangerous.

I asked Peggy what possibilities for movement were presented by this particular sculpture. "Flight, in this case," she told me. "The space created underneath the suspended steel drove me into the air. The desire to be airborne in that space was instantaneous, instinctive, appetite-driven, both for the visual picture and for the kinesthetic experience. It was a kind of graffiti. To dance there was to inscribe the space that Kadishman created with a momentary human presence. It was a dancing call in response to the sculptor."

Recently, I had the opportunity to work with Peggy and a team of diverse artists on a performance piece,

PART 1 Cultivating the Artist's Eye

From Within and Outside a Bright Room. This was part of a continuing series of pieces Peggy has created based on Tony Kushner's play *A Bright Room Called Day*, which is about the interactions among a group of friends in Berlin during the time leading up to the Holocaust. One of my creative contributions to the piece was to design costumes for the five performers. After so many years of working with plants, I was excited to have a chance to design for a different living form: the human body. I was even more delighted to be intimately involved in a new kind of artistic collaboration, and I learned more than I could have predicted from each of the participants.

The project included a full-scale production of the piece in Schenectady, New York, at the end of a weeklong residency that featured workshops with fine arts students at the local high school. Each day, the company met with the students for a couple of hours to provide them with opportunities to practice the various disciplines at work in the project. Dancer and choreographer Jules Skloot conducted an exercise about improvising with the human body while partnering with another person. Jules took everyone through a sequence of improvisations using particular parts of the body, pressing hands to hands, elbows to elbows, feet to feet, and so on. The group moved around with two feet on the floor, then two feet plus one hand, then two hands plus one foot, and finally with the front of the body pressed to the floor. Our bodies don't have too many parts for us to use—hands, feet, elbows,

At Storm King Art Center in Mountainville, New York, Peggy Gould found herself drawn to Israeli sculptor Manashe Kadishman's *Suspended*. Her instantaneous response to the piece was a desire to be airborne, to leap into the space beneath the sculpture and fill it with a fleeting human presence. Photo by Jeremy Dunn.

head—so the richness comes in choosing and combining the different parts. Thinking about garden design, I was reminded of the finite number of shapes and patterns in nature and how richness depends on the creativity with which they are combined. Sometimes combination and juxtaposition are everything.

Composer Eve Beglarian contributed a musical composition she wrote based on the Hurricane Katrina disaster and the ensuing political debacle. The piece begins with a contemporary composition by Eve, and then a Bach theme gradually emerges. She talked about holes opening up in the new theme, allowing the Bach to show through. One pattern erodes in places, she said, to reveal another pattern beneath. I noticed that she was using visual language to describe a musical composition, and her use of spatial terms reminded me of how architecture has often been called frozen music. I have always felt that the garden, made of living things and therefore dynamic, is even closer to music than architecture is. Like so many of the artists I admire, Eve works a lot with the interplay between chaos and order.

"So you've got the chaos," she said, "and then you apply an algorithm to create order. And if you don't like the outcome, you change the algorithm."

"What do you mean," I asked, "when you say 'don't like the outcome'?"

"I mean, if it's not beautiful," she replied.

I lamented that we haven't been able to openly discuss beauty in landscape architecture for many years, and Eve told me the same has been true in music. This is one thing that sometimes distinguishes landscape architects from garden designers. Talking about beauty is largely taboo in the world of licensed landscape architects. I guess once you've gone through all the trouble of taking the exam that demonstrates you have the proper training and credentials, discussing intangible or "soft" topics might be considered threatening to your official status. Beauty is not on the registration exam. Garden designers tend not to have such worries, so among them beauty is a frequent topic of discussion, and nobody feels a need to apologize when they indulge themselves in it.

Peggy also brought a writer into the *Bright Room* collaboration, Pamela Sneed. Pamela suggested a writing method where you just start writing and then keep going without stopping. She told us to get specific about details, to begin writing about something and then describe whatever came to mind—what people were wearing, the weather, anything and everything, even if it didn't seem relevant. This reminded me of the sketching exercises I do when I first encounter a site. There's no editing. I look at what's in front of me and simply jot down whatever comes to my awareness, and before I know it the creative juices are flowing.

Garden designers can learn a lot from performance artists, and we can be grateful that once our work is put in place it's relatively permanent. Performance art can be so temporal, so fleeting, and its ephemeral nature can be very challenging to an artist. A dancer works for months and months to prepare a piece, and then it passes before an audience in an hour or two. It's not necessarily gone for good. It can be repeated, but that requires attracting the resources to bring it back to the stage. Imagine having to constantly raise money to keep a garden alive, to keep it out there before the public. Gardens do require maintenance, and every now and then they may even need a total overhaul—but it's very rare for them to disappear completely after their debut.

Art and the Design Process

I visited Conrad Hamerman, my design teacher from my undergraduate years, to talk about his west Philadelphia garden, which is bordered by a painted wooden fence with angular lines that look like they emerged from an early Piet Mondriaan painting. Conrad's work illustrates the relationship between painting and garden design. We've talked a lot about abstraction over the years, and about how he paints as a way of fueling the creative process for his design work. He talked about how the early abstract painters, including Mondriaan, started with realistic images from nature and then developed layers of abstraction from them, and how their abstract paintings had much more depth than those by later painters who hadn't first done the more representational studies.

Conrad is an abstract painter, as well as a landscape architect, and I asked him if the shapes in his abstract paintings had always influenced his designs for gardens. He said no, not until the design of his own garden. The design for all previous projects was mostly a creative response to preexisting conditions: site topography, groups of trees, rock formations, views to enhance or screen, the needs of the client, and the purpose of the garden. "These are the elements," he said, "that initiate the design process and from which the designer fashions a harmonious composition." His own garden, however, offered the opportunity to work on an almost empty canvas, a flat rectangle of land that ran alongside his townhouse.

He had always imagined he would design the garden on a rectilinear Mondriaan-like model, with the vertical panels of the fence as an integral part of the design. So he stretched his tracing paper over the drafting table and, many overlays later, eventually created a composition derived not from Mondriaan but from a series of his own abstract paintings. "In these paintings," he told me, "I had recombined fractured and geometric shapes, triangles, parallelograms, and hexagons into dynamic compositions."

This process was influenced by the time he had spent in Rio with his friend and mentor, Roberto Burle Marx. "Roberto gave me a bunch of stretched canvases," he explained, "and had one of his gardeners set up a still life of exuberant tropical flowers. Starting with the still life and a realistic painting, he nudged me, canvas by canvas, into abstraction."

The design of his entire garden—more than just the fence—was inspired by a sequence of abstract paintings, with the lines of the fence continuing down and

FAR LEFT Conrad Hamerman's design process for his own garden included his painting a sequence of abstracts, beginning with this still life of flowers in his studio.

LEFT In a sequence of paintings based on the original still life, the image became more and more abstract and architectural with each iteration.

BELOW The slanting lines in the paintings were translated directly into the garden's central design motif, with diagonals extending from the fence down onto the ground plane.

across the ground plane to also define the shapes of the planting beds. Being in the garden is like being in a three-dimensional representation of an abstract modernist painting.

I once asked Conrad if beauty had anything to do with the process of abstraction he used in his designs, and why so many landscape architects today seem reluctant to talk about beauty as an essential element in their work. "The Calvinistic tradition," he answered, "tended to equate beauty and ornamentation with extravagance, vanity, and sin." When we talk about beauty in Western culture, he explained, we challenge a significant aspect of our conservative cultural roots. As designers it's necessary for us to challenge this old conservatism, because we need beauty. It is an essential creative force in our physical and spiritual lives.

Conrad's work embodies a number of principles at work in certain modern art movements, especially cubism and abstract expressionism. In the early nineteenth century, cubist painters such as Georges Braque and Pablo Picasso introduced the notion of multiple perspectives, perceiving a subject from a number of vantage points simultaneously. The various points of view come together in one integrated experience and imply movement through space over a period of time. A walk through a garden also offers multiple points of view, but more richly than painting ever could do. In the garden, the three-dimensional experience is actual, not implied. Furthermore, it is experienced with the full range of senses, not only the visual.

The abstract expressionists of the 1940s and 1950s sought to express pure emotions and feelings, using their interior selves as subject matter rather than external objects or landscapes. They painted spontaneous images that drew from their own inner worlds, transcending their physical surroundings. For me, the garden offers a similar opportunity for self-expression. It is a place where through personal creativity you can release something of your self and experience new connections and relationships with the living world.

The Cascade Garden, designed in 1992 by Burle Marx and Hamerman for one of the conservatories at Longwood Gardens, demonstrates some of the principles of cubism and abstract expressionism. It features a dramatic array of tropical plants such as earth stars (*Cryptanthus* spp.), philodendrons, and giant vriesea (*Vriesea imperialis*), and most notably includes a collection of various bromeliads with strong sculptural form. These are distributed among stone walls and the cascading waterfalls that give the garden its name. Many of the plants are epiphytes that cling to the walls at various heights, as they might cling to trees and outcrops in their natural habitats.

The design makes good use of a tall, rather confined space. Its upper and lower levels are connected by a winding pathway that presents a succession of changing perspectives. You see the plants from above and below, and from various sides, and you can choose whether to move quickly or to linger at various points along the way. The cascading waterfall provides a sense of motion, animating the display and contributing a variety of sounds that help to remove you from the outside world.

The sculptural and colorful plants are splashed about as an abstract expressionist might cast paint across a canvas. Although an element of control is clearly at work in the placement of the plants, walls, and water, the lush and exuberant growth typical of tropical plants brings in the excitement of improvisation and spontaneity. The overall feeling is one of

EAST SIDE — ELEVATION
SCALE: 1/2"=1'-0"

ABOVE Conrad Hamerman has an expressive drawing style, even in architectural drawings primarily intended to convey the technical details of a design. In this drawing of the Cascade Garden, the changes of level are shown with technical precision; the stonework and plants are rendered in all their exuberance of texture and form.

LEFT In the Cascade Garden, designed by Conrad Hamerman and Roberto Burle Marx for a Longwood Gardens conservatory, bromeliads and vrieseas, Wissahickon schist, and flowing water are arranged in an abstract expressionist composition.

delight in the rich variety of shapes, forms, and colors, yet the composition is not overly complex. The repetition of bold, vase-shaped bromeliads and vrieseas keeps the composition from becoming too confusing in all its details, creating a sense of unity throughout the design.

Even though the plant palette is entirely tropical, the designers used local Pennsylvania stone in the garden's architectural components. Conrad hand-selected the stone, Wissahickon schist, from a nearby quarry. Ironically, the most sculptural pieces were selected from a pile of stones that had been rejected as being imperfect. This material is commonly found in buildings and garden walls throughout the region, and its use in the Cascade Garden helps to make a connection between the exotic plants and the local landscape. Most visitors to Longwood know that bromeliads and other tropicals couldn't possibly survive in their gardens at home, yet the use of local materials projects a subtle sense of familiarity and brings the visitors into closer contact with these plants.

The Garden as a Unique Art Form

Bill Frederick and I once went hiking on Isle-au-Haut in Acadia National Park on the coast of Maine. Taking a break, we sat on a rustic bench by a freshwater marsh and admired the great sweeps of native blue skullcaps blooming all around us. Bill loves conversations with an interview format. Once, over the lunch table, he produced a small piece of paper from his shirt pocket and read me the question, "What is your definition of *ecstasy* and how does it relate to garden design?" I loved it. I don't remember exactly what we decided about ecstasy and garden design, but I do remember being delighted by the exchange. Sitting on the bench in Acadia seemed like a good time to talk about gardens, so I asked Bill what he thought makes the garden a unique art form.

His first reply was that gardens change over time, including the gradual shifts that occur from season to season and the longer-term changes that occur from year to year. Sometimes these changes require revising the garden's original design. Garden writer Mac Griswold has often been credited with calling the garden "the slowest of the performing arts." I think it's undeniable that no other art form requires constant human input to manage living things through their evolution over time.

The second component that makes the garden unique among all the arts is its sequential, spatial progression. You have to move through a garden to fully appreciate the relationships at work in each space, including the plants and architectural elements that support them. While some gardens can be fully experienced from a fixed point of view (the Zen meditation garden is the best example), most require movement to appreciate the full range of experiences they have to offer.

Next, we talked about engagement of multiple senses: fragrance, sound, the tactile sense as well as the visual. The simultaneity of various sensations can transport you to another dimension. Synesthesia—having one sense triggered by the stimulation of another—is sometimes described as a neurological disorder, but it also has poetic expression in the arts. "Loud colors" is one example that combines hearing and vision to describe an unpleasant sensation. "Cool green" or "warm red," combining touch and sight, are often used to describe a positive mood or feeling. Poetic expressions of synesthesia, such as "cacophony of color" or "sweet fragrance," are commonly used to describe experiences in gardens.

Climate is another unique factor in gardens. Really good gardeners know how to program certain plant combinations to achieve a desired effect from year to year, but they can't always predict the weather, either the weather on a given day or the progression of the climate from season to season. In the current age of global warming, seasonal changes seem to be getting more and more difficult to accurately predict. Annual variation in climate causes different plants to perform in different combinations from year to year, so serendipity is another essential component unique to the art of the garden. One recent spring in the Winterthur garden in Delaware, the progression of seasonal weather was such that early-blooming plants stayed in flower later than usual, and later-blooming plants flowered early. That year, in early May, I visited Winterthur's Sundial Garden and was amazed by the juxtapositions.

Finally, Bill said, what most distinguishes a garden from all other art forms is the intangible experience of being among living plants and literally breathing the same air as they do, feeling the same warm rays of the sun. No other form of art connects us so deeply to the living world.

Bill Frederick and Conrad Hamerman created this abstract composition for a forested stream at Ashland Hollow. The artificial island's clean sculptural form heightens the organic character of the surrounding trees. The prevailing mood is tranquility, with human artistry in balance with the forest's inherent beauty.

FIVE
The Garden as Fine Art: H. F. du Pont's Winterthur

The home of Henry Francis du Pont from his birth in 1880 until his death in 1969, Winterthur Museum & Country Estate combines a thousand acres of countryside, a sixty-acre woodland garden, and a house containing one of the world's most highly regarded collections of American decorative arts. In the center of the estate, adjacent to the house, is the Winterthur garden. Since 1998 I've had the good fortune to work with the staff there in the garden's restoration and ongoing development. The more familiar I become with the place, the more I realize that it is one of the greatest—and most unrecognized—examples of a twentieth-century garden created as a work of fine art.

H. F. du Pont devoted enormous resources to the Winterthur garden, employing a sophisticated and carefully articulated set of design principles over an entire lifetime of garden making. There's something magical about getting to work with the same site over a period of many years, to get to know it that intimately and to witness longer-term changes. The opportunity to study du Pont's work extensively, and to be a part of keeping his legacy alive, has inspired and deepened my own work as a designer in many ways—from the way I think about color and seasonal progression to the way I strive to incorporate the prevailing local sense of place into a finished design.

A Strong Sense of Place

Winterthur is located in the Brandywine Valley of northern Delaware and southeastern Pennsylvania, a picturesque region with a unique history and a clearly defined sense of place. Brandywine Creek meanders through fields and hedgerows, forests and meadows, historic farms and villages—all fairly well protected from the visual interruption of housing subdivisions and shopping malls that cover the landscape throughout most of the region. These modern intrusions have been kept largely to the uplands, so today it's still possible to travel through the landscape near the banks

This painting summarizes the key color theme for the Oak Hill section of the Winterthur garden, including the red of 'Firefly' azalea, lilac cultivars, and yellow *Rhododendron austrinum*.

124 PART 1 Cultivating the Artist's Eye

of the Brandywine and imagine the region as it might have appeared more than a hundred years ago.

Fine arts have always been a part of the cultural landscape there. The great American artist Howard Pyle lived near the Brandywine in the late nineteenth and early twentieth centuries. Widely considered to be the father of American illustration, he wrote and illustrated *The Merry Adventures of Robin Hood* in 1883, among other classic adventure stories. In 1903 he founded the Howard Pyle School of Illustration Art in Wilmington, Delaware, which fostered a collective of artists still known as the Brandywine school. One of his first students was N. C. Wyeth, who illustrated the first editions of Robert Louis Stevenson's *Treasure Island* in 1911 and James Fenimore Cooper's *The Last of the Mohicans* in 1919. N. C. Wyeth's son,

the painter Andrew Wyeth, cemented the reputation of the Brandywine school as one of the great movements in American art, celebrating the natural landscape and cultural heritage of the region. Adventure, romance, and natural beauty characterize the Brandywine school, along with an intense and emotional evocation of local sense of place. H. F. du Pont, himself a product of the Brandywine Valley, created the Winterthur garden as an expression of his own cultural history combined with a love of horticulture and the rural landscape in which he lived.

The du Pont family emigrated from France and set up gunpowder mills along Brandywine Creek at the beginning of the nineteenth century. One of the first family immigrants, E. I. du Pont de Nemours, described himself as a botanist on his passport. His heirs would go on to create some of the world's preeminent gardens, such as Longwood Gardens, the formal French-style Nemours Mansion and Gardens, the native woodland wildflower garden at Mount Cuba Center, and Winterthur—all in the Brandywine Valley region.

More than any other garden I know from the first half of the twentieth century, Winterthur exemplifies the garden as a work of fine art. It is actually a sequence of gardens, with many distinct destinations

FAR LEFT Hay is harvested from Winterthur's open fields, and the subtle curves are typical of the Brandywine Valley. I loved the dialogue that seemed to be going on between these two giant hay bales and the red cedar tree. Don't ask me how the tractor got up into the sky. It just did.

LEFT Shown here in a 1925 hand-colored glass slide, the Sunken Garden was often referred to by Mr. du Pont as his mother's rose garden. It was dismantled in the 1960s when the museum expanded. The columns of the rose arbor were placed in storage and found their way into the Winterthur children's garden, Enchanted Woods. Photo courtesy of the W. C. Spruance Collection, Hagley Museum & Library.

seamlessly woven together into one composition. The garden is so artfully integrated into its naturalized woodland setting that many visitors actually fail to recognize it as a designed landscape.

A Passion Brought to Life: Azalea Woods

Azalea Woods has been Winterthur's most popular spring attraction since the garden first opened to the public in the 1950s. Something about flowering azaleas always attracts a crowd. Azalea Woods has frequently been described as a masterpiece of color, harmony, and naturalistic design, and it includes a significant collection of evergreen rhododendrons and Kurume azalea cultivars.

 H. F. du Pont was a close friend of Charles Sprague Sargent, the director of the Arnold Arboretum at Harvard University from its inception in 1873 until his death in 1927. During his tenure as director, Sargent sponsored significant collecting expeditions to China and Japan, led by British plant collector and adventurer Ernest Henry Wilson. At that time, the full richness of Asian plants was just beginning to be appreciated by Western horticulturists. "Chinese" Wilson, as he was known, was responsible for a wide range of exciting new plant introductions—many of which have become staples in Western gardens today. We can thank Sargent and Wilson for the forsythia (*Forsythia japonica*), the Chinese witch hazel (*Hamamelis mollis*), and the Japanese stewartia (*Stewartia psuedocamelia*), among many others. Most important to H. F. du Pont were the Kurume azaleas, a group of azaleas Wilson first saw in 1914 at a nursery just north of Tokyo. Introduced to the United States in 1915 at the Panama–Pacific International Exposition in San Francisco, they won gold medals for their compact form, evergreen habit, and abundant flowers completely covering the shrubs with pure and lustrous colors.

 Du Pont first saw these azaleas in 1917 at one of his favorite Long Island nurseries, Cottage Gardens. He bought all seventeen Kurumes the nursery had in stock and immediately had them planted in what was soon to become known as Azalea Woods. The recent epidemic of American chestnut blight had opened up great shafts of light in the forest canopy, and along with the deep rich soils in the forest floor, this provided the perfect habitat for the Japanese azaleas. Between 1945 and 1951, du Pont began expanding the azalea collection, each spring evaluating the color combinations by carrying flowering sprigs from plant to plant. He directed his gardeners in rearranging them, moving fully mature plants at the peak of bloom. Du Pont worked in the manner of the impressionist painters, with azaleas as oils and the forest floor as his canvas.

 In other sections of the Winterthur garden, du Pont's horticultural palette extended far beyond azaleas—lilacs, viburnums, peonies, daffodils, and woodland wildflowers were among his other passions. His employees and their successors have continued his high level of horticultural achievement from his time to today. His taxonomist, Hal Bruce (who also taught horticultural writing at the University of Delaware), named *Viburnum nudum* 'Winterthur' in 1974. Selected for its superior flowering and deep red autumn color, it remains of the most popular flowering viburnums in cultivation today.

Azalea Woods was one of H. F. du Pont's first offerings in the Winterthur garden and remains one of the most popular destinations for visitors today. This collection began with a group of Kurume azaleas he acquired from a Long Island nursery in 1917, some of the first such azaleas ever imported to the United States from Japan.

A Connoisseur of Color

Du Pont is frequently quoted as saying, "Color is the thing that really counts more than any other," but his garden artistry was far more complex than that. He was an expert at the fine art of carefully putting together hues, shades, and tints of color in the garden, and he was especially concerned with how these combinations would change incrementally over time. He was a master at programming a variety of color schemes that played against each other as the seasons progressed, gradually morphing from week to week. While color combinations can easily be illustrated in photographs, the Winterthur garden must actually be visited—and with some degree of frequency—to fully appreciate du Pont's sophisticated color choreography.

It was at Winterthur, in assisting the staff with the garden's restoration and evolution, that I first came to understand the complexity of time in a garden. The experience of time in any garden is multifaceted, with different scales of time operating simultaneously. First there is the period you spend on any one visit to a garden, your own personal span of time in the place on that particular day. Within one day, the

light changes hour by hour as the sun moves across the sky. It can be a day of brilliant sunshine, or gray and cloudy with a misty rain, or a sudden downpour might be followed by a dramatic break in the clouds. The second scale of time occurs within a given year, as plants change through the seasons. Finally there is the larger sweep of time, the long-term process of plants maturing and spaces evolving year by year. Any particular moment in the garden offers a totally unique combination of these different time scales, each moment never to be repeated. A truly sophisticated garden offers an unlimited supply of experience, delight, and inspiration—and to fully understand it, you have to visit it again and again.

H. F. du Pont was as obsessed with seasonal change as he was with color theory, and he kept careful, week-by-week records of changes in the garden. He had his staff photograph the garden when he was away from home so that when he returned he could evaluate any subtle color changes that might have occurred. Du Pont was always adjusting his plant combinations in keeping with the progression of time throughout the seasons. As mentioned earlier, he even moved mature azaleas and other flowering shrubs while

The Winterthur garden is set in a mature beech and tulip poplar woodland, shown in this painting with the fall colors intensified almost to the point of abstraction.

Looking into the Winterthur garden from a terrace near the museum, many think of this view as nature untouched by human hands. Actually, it is a carefully contrived work of garden art, set beneath a preexisting canopy of mature forest trees.

FIVE The Garden as Fine Art: H. F. du Pont's Winterthur 131

fully in bloom. When situating plants in the garden, he had his gardeners stand and extend their arms as if they were trees, motioning them to move a few inches this way or that. The overall experience of the garden changed week by week, so he placed movable white wooden arrows along the pathways, directing his guests to follow the ideal sequence of horticultural events occurring at that particular time—a practice the Winterthur staff continue today.

The Sundial Garden, designed in collaboration with Marian Cruger Coffin in 1955, illustrates how complex H. F. du Pont's planting schemes can be. The spring color progression is choreographed to change gradually, week by week. In one corner of the

The Sundial Garden illustrates the complexity of H. F. du Pont's color choreography. The whites and pinks of spiraeas and flowering quince define the major color theme, with the immature flowers of Chinese snowball viburnum adding a jolt of chartreuse for contrast.

Sundial Garden, the billowing white flower sprays of garland spiraea (*Spiraea* ×*arguta*) are adjacent to a pink-flowering Japanese quince (*Chaenomeles speciosa* 'Moerloosei', formerly 'Apple Blossom'). Nearby is a *Viburnum* ×*carlcephalum*, the fragrant snowball viburnum, with pale pink flower buds opening to small white heads, intensely perfumed. Adjacent to these three shrubs is another flowering quince—an unnamed red cultivar—along with a large specimen of Chinese snowball viburnum (*Viburnum macrocephalum* 'Sterile'). The Chinese snowball viburnum is typically grown for its large white flower heads, but in this setting H. F. du Pont planted it specifically for the effect of its chartreuse immature flowers in combination with the pinks and reds of the quince. By the time the Chinese snowball viburnum flowers are fully white, the quince flowers have faded.

The March Bank and Winterhazel Walk

At Winterthur, the garden's spring display starts well before the flowering of Azalea Woods. In late February, the March Bank comes alive with giant carpets of small woodland flowers. Du Pont first planted the March Bank in 1902, when he was twenty-two years old. He began with naturalizing daffodils on the wooded slopes, eventually adding thousands of crocus, squills, snowdrops, and glory-of-the snow, creating wave upon wave of tiny flowers. The result is enormous horizontal sheets of blue, white, and yellow moving in and out among the massive verticals of mature beeches, oaks, and tulip poplars. A recent estimate of the number of bulbs on the March Bank placed the total—conservatively—at well above a million.

In early April, the Winterhazel Walk occupies center stage, with large masses of lavender Korean rhododendron (*Rhododendron mucronulatum*) interplanted with various species of pale yellow winterhazel (*Corylopsis*). Lavender and yellow was one of du Pont's favorite combinations, and the Winterhazel Walk illustrates his obsession with this motif. He explained that even though these two colors are opposites on the color wheel, they're brought closer together by the fact that these plants have a warm lavender (usually a cool color) and a cool yellow (usually warm)—a good example of a garden designer thinking like an artist. Indeed, on close inspection you can see that winterhazel's yellow is very faintly greenish, indicating just a hint of cool blue, and the lavender flowers of Korean rhododendron have a pinkish tint, leaning toward the warm end of the color spectrum. The overall effect of strong contrast is mediated by these subtle tints that bring the colors closer together along the spectrum.

Du Pont knew that you have to do more than put a purple plant next to a yellow plant and say, "Wow, look at that color combination!" It's easy to get strong contrast by combining something like a 'Crimson Sentry' Norway maple with a yellow 'Sunburst' honey locust. This is a common street tree combination in North American cities, and it is totally lacking in subtlety. In du Pont's Winterhazel Walk, the nuances of shading set up a faint vibration that makes the color combination come alive with complexity. It holds your attention beyond the initial color rush, presenting something to stop at and ponder. It's like savoring the multifaceted richness of an aged merlot or burgundy versus getting a quick buzz from a glass of cheap generic red.

More than just looking at plants, it's about being surrounded by multiple sensations. Along the Winterhazel Walk, you are completely engulfed by carpets of

Beneath mature beeches and other woodland trees on the March Bank, more than a million bulbs begin to bloom in late February, beginning with yellow winter aconite (*Eranthis hyemalis*) and white snowdrops (*Galanthus nivalis*) and ending as shown here, in solid sheets of blue squills (*Scilla* spp.) and glory-of-the-snow (*Chionodoxa* spp.).

ABOVE In the valley adjacent to the March Bank, giant sweeps of old-fashioned hostas carry the blue floral display into June, with the delicate white wands of black snakeroot (*Actaea racemosa*) rising above them.

RIGHT In one of Winterthur's most spectacular combinations of flowering shrubs, the lavender Korean rhododendron (*Rhododendron mucronulatum*) blooms simultaneously with various species of pale yellow winterhazel (*Corylopsis* spp.).

LEFT At one end of the Winterhazel Walk, a hybrid cherry (*Prunus* 'Accolade') and Korean rhododendron (*Rhododendron mucronulatum*) burst into full bloom on a warm spring day. It's a spot where visitors can relax, read a book, or simply stop for a moment, fully surrounded by flowers.

ABOVE On Sycamore Hill, April brings another expression of du Pont's favorite color combination. Rosy lavender redbuds (*Cercis canadensis*) blossom with a number of forsythia species and cultivars that are a softer yellow than most forsythia.

ABOVE The flowering season on Sycamore Hill peaks in May and June with, from front to back, *Weigela* 'Red Prince', lavender fountain butterfly bush (*Buddleia alternifolia*), and white *Deutzia* ×*magnifica*.

RIGHT Many details in the Winterthur garden are so subtle they go almost unnoticed, including the seamless integration of plants and built elements. Here, stringy stonecrop (*Sedum sarmentosum*) grows in the crevasses and on top of an old stone retaining wall, while *Hosta lancifolia* grows in a band along the wall's base.

hellebores and masses of Korean rhododendron and winterhazel, transporting you away from everything else that might have been going on in your head when you first entered the garden. You don't just stop and look at different combinations of plants along the way, you actually spend a significant period of time moving through them, with one scene followed by another. One of du Pont's basic design principles had to do with a particular way of moving through the garden, making such a subtle transition from one destination to the next that you find yourself having a new experience before you're fully aware you have left the previous one behind.

Working Relationships

The collaborative process is central to my work, and this is another area where I've learned a lot from du Pont's legacy. The most significant gardens are often the result of collaboration, and while Winterthur may have been du Pont's brainchild, he had help along the way from a number of horticulturists, designers, and craftspeople. I strive to incorporate this principle into my work at every stage of the design process. From executive directors to horticulturists, from engineers to laborers, every person involved in the making of a garden has a unique perspective to offer. Some of the most valuable lessons about a place,

and about its impact on those who spend time there, come from the most surprising sources.

Although du Pont worked largely on his own in making the Winterthur garden, he did have important assistance from a close friend, landscape architect Marian Cruger Coffin. She first visited Winterthur with her mother when she was a child, and she and H. F. du Pont became friends in the early 1900s when she was a student in the new landscape architecture program at the Massachusetts Institute of Technology and he was studying horticulture and agriculture at Harvard University's Bussey Institution. They developed an enduring friendship visiting gardens and flower shows together in New England. Du Pont inherited Winterthur when his father died in 1927, and a year later he commissioned Coffin to design a series of formal garden spaces around the house. By that time she had designed many estates in New York and Connecticut, and a few for other du Pont family members in Delaware and elsewhere. Since 1918, she had been working on the design of the Delaware College campus in Newark, which later became the University of Delaware.

Marian Coffin was largely responsible for the more architectonic garden spaces at Winterthur, while du Pont was the main designer of the naturalistic areas. Whimsical statuary and ornaments were placed at focal points in the spaces Coffin designed, becoming an important part of Winterthur's garden vocabulary and sense of place.

Du Pont had a very strong interest in artistry and craft, as demonstrated by the fine quality of stonework in the garden as well as in the surrounding estate. In the early 1900s, a wave of Italian stoneworkers immigrated to Delaware. Although they helped construct the homes of the extended du Pont family, their primary work was building the expanding industrial mills along the banks of Brandywine Creek and laboring in the quarry complex that supplied cut stone in nearby Avondale, Pennsylvania. Some of them were also trained in production horticulture and found jobs in the local cut flower industry or as estate gardeners.

I talked about this history with John Feliciani, currently Winterthur's curator of horticulture and director of the horticulture department. A member of the fourth successive generation of his family to work in the Winterthur garden, he began his employment there as a ten-year-old child at a rate of fifty cents an hour. John's ancestors emigrated from Italy in the 1920s, and his great-grandfather, Abraham Ragazzo, was a laborer on the Winterthur estate. John's grandfather, Giuseppe Feliciani, was supervisor of the cut flower gardens and was succeeded by John's father, Albert Feliciani.

The cut flower gardens covered eight acres of meticulously groomed turf pathways and flower beds, with all the plants carefully trained, deadheaded, and kept to H. F. du Pont's high standards of perfection. The whole thing was watered by a state-of-the-art, brass piston-driven irrigation system, and John recalls the sprays of water playing back and forth like ornamental fountains. As industrialists, the du Ponts were proud of their hardware. At nearby Longwood Gardens, H. F.'s cousin Pierre du Pont had one of the most extensive displays of ornamental fountains in North America, but his real pride and joy was their engineering, the elaborate system of pumps and valves that drove the display.

At Winterthur, H. F. du Pont extended his creativity beyond the artful combinations of plants and spaces

There were many engineers in the du Pont family, and H. F. du Pont was as proud of his farm infrastructure as he was of his garden. This system of weirs was constructed with the latest technology. As with many estates of the American Country Place era (late 1800s to early 1900s), distant views and vistas reflected historical European styles.

With this painting I put the weir machinery front and center. Spending time pondering this farm scene helped me understand and internalize the sense of place at Winterthur.

in the gardens, and beyond the meticulous arrangements of furnishings and decorative objects in the house, to encompass all the technological workings of the larger estate. Not only is the garden at Winterthur an expression of his love of horticulture, rooted in an innate understanding of the Brandywine Valley's unique sense of place, it is also the product of an enduring relationship with the land and—more important—with the people who worked with him there.

Continuing the Legacy: Oak Hill

At the time of his death in 1969, H. F. du Pont was experimenting with extending his favorite lavender and yellow color combination into the fall. Winterthur's horticulture staff is continuing this work today in restoring the Oak Hill section of the garden. While du Pont spent forty to fifty years perfecting the design of certain destinations at Winterthur, such as the March Bank, he had given Oak Hill just less than twenty years of attention before he died. So in a sense, we are not so much restoring the area as we are continuing its evolution. Recently a severe storm brought down several mature oak trees on the hill, so we have a much sunnier situation with which to work. A number of shrubs originally planted there have proven to be invasive in other sections of the garden, including winged euonymous (*Euonymous alatus*) and oriental photinia (*Photinia villosa*), so we're making some changes to the original plant list.

We began by taking an inventory of all the plants that had originally been installed on the hill. We then expanded the list to include plants that are available today but might not have been in the 1960s, focusing on those that would contribute to a dramatic fall display. These were evaluated in terms of their significance, which Winterthur staff defined by the following four criteria: Are they rare or unusual? Are they environmentally sustainable? Are they historic to Winterthur? Will they attract an audience?

In one section of Oak Hill, du Pont planted hardy orange (*Poncirus trifoliata*) with beautyberry (*Callicarpa dichotoma*), along with a golden-fruited variety of *Viburnum dilatatum*. As in the Winterhazel Walk, where warm lavender Korean rhododendrons are combined with cool yellow winterhazels, Oak Hill's hardy orange has slightly greenish-yellow fruits that set up a subtle vibration with the warm lavender berries of beautyberry. We've decided to extend this combination to a larger area, but the viburnum will be omitted because it has proven to be invasive elsewhere in the garden. In its place we'll be testing two cultivars of native possum haw, *Ilex decidua* 'Finch's Golden' and 'Byers Golden', both of which have showy yellow fruits and are not known to be invasive. It is a rewarding challenge to stay true to H. F. du Pont's original aesthetic principles while updating them to accommodate today's ecological concerns.

Also on Oak Hill, a drift of autumn crocus (*Colchicum autumnale*) is in fairly close proximity to a couple of tulip poplars (*Liriodendron tulipifera*). Noticing that the tulip poplars were in their yellow fall color concurrent with the lavender of the crocus flowers, I gathered a few leaves and scattered them among the crocuses to see if we wanted to make this combination a part of our plans for Oak Hill. We hope to extend the drift of crocuses so that this effect will occur naturally as the leaves fall from the trees.

An American Master of Garden Design

For more than ten years now, working at the Winterthur garden has been for me a unique experience in learning from one of the great American masters of horticulture and garden design. H. F. du Pont's carefully articulated record of his theories and principles of design, expertly interpreted by Winterthur's curatorial and horticultural staff, has allowed us to work toward gaining wider recognition for an unsung work of garden design genius. Du Pont's design principles—his sophisticated color choreography, sense of timing through seasonal change, seamless transitions from one garden experience to another, and careful attention to regional sense of place—demonstrate how the artful eye can bring garden design into the realm of the fine arts.

In the Oak Hill section of the garden, the yellow and lavender theme is expressed in the autumn fruits of hardy orange (*Poncirus trifoliata*) combined with various species of beautyberry (*Callicarpa*).

Extending a drift of autumn crocus (*Colchicum autumnale*) to bring it in closer proximity to a couple of tulip poplars (*Liriodendron tulipifera*) will ensure that as the leaves fall from the trees they will contribute to the lavender and yellow color theme so beloved by du Pont. Here I've scattered the leaves by hand to test the effect.

In the shrubs remaining on Oak Hill from H. F. du Pont's time, the lavender and yellow color theme—carried out with dwarf Korean lilac (*Syringa meyeri*) and the yellow Florida azalea (*Rhododendron austrinum*)—is jazzed up with a shot of intense red from a 'Firefly' azalea.

PART 2
Designing the Artful Garden

This is a portion of a watercolor "sense of place" study I did at the Lady Bird Johnson Wildflower Center in Austin, Texas, leading up to the design of their new children's garden.

SIX

Abstracting from Nature: Peirce's Woods at Longwood Gardens

PEIRCE'S WOODS, at Longwood Gardens in southeastern Pennsylvania, is a seven-acre woodland garden that showcases native plants in the canopy, flowering understory, shrub layer, and ground layer. Its design was inspired by studying how plants grow in their natural habitat, but it also shakes up old ideas about working with natives. The project was envisioned by Longwood's leadership as an "art-form garden that brings together the most ornamental characteristics of the Eastern Deciduous Forest." This mission was to become a major creative challenge and a valuable lesson in incorporating the local sense of place in surprising new ways. How could we go big and bold using only plants from the native landscape?

I used pencil to render this preliminary design study of the Carpinus Walk in Peirce's Woods. The design included a collection of fragrant yellow-flowering native azaleas drifted beneath a clump-and-gap arrangement of native birch (changed to native hornbeams before the design was finalized).

Unlike most native plant gardens, Peirce's Woods doesn't aim to teach about natural ecosystems but focuses instead on the pure design possibilities of working with woodland natives. Its central concept is all about abstracting patterns from nature and using native plants to create artful design compositions. This emphasis on artistic form over ecological value was a departure from what had previously defined gardens of native plants. Until the mid-1990s, most native plant gardens were based on environmental themes such as natural habitat or ecological association. They were often designed in the style of landscape architects such as Jens Jensen, who designed gardens to look like natural landscapes that emerged spontaneously from their site. A leader in the native plant movement of the early twentieth century, Jensen believed contact with native plants was necessary for human health and well-being, beyond the plants' ecological value, and that gardens of native plants should look like nature.

In Peirce's Woods, we took on the challenge of creating a large display garden exclusively with native plants, focusing on the beauty of natives and their potential for creating visually powerful works of

abstract garden design. Longwood's mission is to strive for innovation in horticulture and display, and to present the arts in a setting that brings pleasure and inspires the imagination. We designed Peirce's Woods not as Jens Jensen might have but more in the spirit of Roberto Burle Marx, considering the garden as a large-scale work of abstract art that clearly shows the mark of the human hand.

A New Destination

Longwood Gardens is known for its brilliant horticultural displays, with dramatic color combinations that change throughout the seasons. Pierre S. du Pont purchased the property in 1906, and until his death in 1954 he developed a sequence of many different garden destinations. The Flower Garden Walk was the first of many compositions he created there, and it is the experience Longwood's visitors enjoy just before they enter Peirce's Woods. Informally called the brick walk, it has floral beds arranged on either side of a six-hundred-foot-long walkway. Each season the display changes dramatically, creating a stunning succession of big blocks of colorful bulbs, annuals, and perennials. The flowers are arranged in a rainbow of color progressing along the spectrum as you walk down the brick path—from blues and lavenders to reds and pinks, to oranges and yellows, and finishing with greens and whites. With its over-the-top, intensely stimulating color combinations, it is one of the most popular destinations at Longwood.

Since visitors would reach the entrance to Peirce's Woods immediately after traversing six hundred feet of colorful and mostly nonnative ornamentals in the Flower Garden Walk, I was concerned about how we could make a similarly showy display with the subtle beauty of native woodland wildflowers. Furthermore, during most of the growing season, the dominant palette in Peirce's Woods would be shades of green, so making a strong impression after all those dramatic flowers would be an especially challenging task. Since we didn't have a wide range of color to work with, I figured we'd have to rely on other design elements, such as texture or scale, in order to make a big visual statement.

Even though we didn't want to recreate a natural woodland ecosystem, I did want to use the Eastern Deciduous Forest habitat as the primary source of inspiration. I began to study the visual characteristics of the native forest, seeking to abstract them as far as possible, to boil them down to their most essential shapes and patterns. Also, I wanted Peirce's Woods to fit in with the prevailing sense of place at Longwood Gardens, so I studied other destinations at Longwood to gain some understanding of their essential qualities as well.

The Cow Lot is the central open space at Longwood Gardens. Originally a pasture, it is now surrounded on three sides by impressive allées of white oaks, copper beeches, and paulownias. It is the first place visitors encounter when they enter the gardens, and its large scale sets the tone for their entire experience. I sketched the Cow Lot several times, at different moments of the day and in different weather. This is how I really get to know a place, inviting its subtleties to emerge but also giving big themes the opportunity to express themselves. Notes accompanying sketches I made say, "Big. Big landscape. Big forms. Very large scale. Bold contrasts." In Peirce's Woods, it was evident, small patches of ground cover would not work.

Sometimes the most obvious elements are not so obvious at first, and you have to spend a lot of time carefully studying a place to coax them out of hiding.

SIX Abstracting from Nature: Peirce's Woods at Longwood Gardens 151

Observing and sketching again and again, I eventually noticed that the Cow Lot basically had a large horizontal plane at its center, with a simple ground cover of lawn, the whole thing framed by the verticals of mature trees. My notes say, "Simple lawn panel is very important in the composition. Lawn must be very large to read as a strong form in perspective." There was a single large specimen of American elm remaining from a former allée that had succumbed to Dutch elm disease, and it stood out as unique, contrasting with the other trees in the composition. All of these elements would become important design motifs in Peirce's Woods.

The Flower Garden Walk was the first display garden Pierre du Pont created at Longwood Gardens, in 1907. Visitors walk through these brightly colored beds just before entering Peirce's Woods, so it was especially challenging to create a display of woodland natives with a similar degree of drama.

Big gutsy Paulownias.

newly planted oaks.

Big haystacks of beech soft, round, pure form, uniform.

huge old American elm alone. stately. outstanding specimen.

open lawn.

to main Conservatory

to Peirce's Woods.

TOP AND CENTER As part of coming to understand the overall sense of place, I sketched existing destinations at Longwood several times, at different times of day, in different weather, to allow the subtleties of the place to emerge. Here are sketches of the Cow Lot made on an overcast day (top) and a sunny day (center).

BOTTOM This small pencil sketch summarized the spatial qualities of the Cow Lot, helping to set a design direction for Peirce's Woods.

A Crash Course in Woodland Natives

To study woodland natives in their natural habitat, I took a springtime botanizing trip with Longwood staff to the mountains of western North Carolina and eastern Tennessee. It was nearly impossible to study the Eastern Deciduous Forest biome in the areas around Longwood, where a long history of farming, coupled with more recent suburban housing development, had eliminated the region's old-growth forests. In North Carolina and Tennessee we could study native plants in vast woodland habitats that were largely unaltered by humans. The higher elevations of the Great Smoky Mountains have plant communities similar to what might have been found a hundred years ago in southeastern Pennsylvania, so we figured this would be a good place to study the shapes and patterns of the native forest and search for ideas to inspire the design of Peirce's Woods.

Our team included Rick Darke, who was Longwood's curator of plants, and Jeff Lynch, Longwood's nursery manager and chief propagator. Rick had been appointed to head the plants committee because of his long focus on and accumulated knowledge of deciduous woodland plants and processes, and Jeff not only was talented at selecting plants for use in the garden but also had the expertise in nursery production that would ensure we'd have all the plants we needed to complete the project. This was my first time working strictly with a native plant palette, so for me it was also a crash course in native horticulture.

We found a rich source of design inspiration in the Joyce Kilmer–Slickrock Wilderness near Robbinsville, North Carolina. With more than seventeen thousand acres, it's one of the most extensive old-growth forests in the eastern United States. (Joyce Kilmer is best remembered for his 1913 poem "Trees," which almost every schoolchild knows by heart: "I think that I shall never see / A poem lovely as a tree"). The trail offers an easy walk through old-growth woodlands, with some trees more than four hundred years old. It's a prime example of a cove hardwood forest, which means the soils are rich and deep, the rainfall abundant, and the species diversity extraordinarily high. Along the Poplar Cove Trail, we found yellow poplars (*Liriodendron tulipifera*, also known as tulip poplar), that were more than a hundred feet tall, with trunks up to twenty feet in circumference.

Walking through this magnificent landscape of towering trees, we ended up learning a lot about design by looking down at the forest floor. The ground is carpeted with an especially diverse mosaic of wildflowers, ferns, and mosses. Coming upon an expanse of lady fern (*Athyrium felix-femina*) combined with common wood sorrel (*Oxalis montana*), I was reminded of a design idea that Conrad Hamerman had talked about many years earlier in an introductory landscape design class at the University of Delaware: the principle of analogy and contrast. The most pleasing combinations contain two or more plants that have some visual characteristic in common (analogy), along with another characteristic that is different (contrast). This feeds our appetite for diversity while also satisfying

154 PART 2 Designing the Artful Garden

our need for order and unity. Lady fern and wood sorrel have contrasting textures but are exactly the same shade of green, perfectly illustrating the principle.

Nearby we also found a big sweep of partridgeberry (*Mitchella repens*) combined with round-leaf violet (*Viola rotundifolia*), another expression of the analogy-and-contrast principle. They both have leaves with a circular shape, so they're drawn together by a shared pattern, but they differ in the size of their leaves and in their shades of green. In addition, the lady fern–wood sorrel and round-leaf violet–partridgeberry combinations illustrated the mosaic carpet pattern. Each species grows in clumps of varying sizes, interspersed with the other in an organic mosaic. These two simple plant combinations, living harmoniously on the native forest floor, would come to inspire other ground-cover combinations in Peirce's Woods.

Here's Jeff Lynch experiencing the huge scale of four-hundred-year-old tulip poplars in Poplar Cove at the Joyce Kilmer Memorial Forest.

At the Joyce Kilmer Memorial Forest, the forest floor offered two striking lessons in analogy and contrast. Lady fern (*Athyrium felix-femina*) and common wood sorrel (*Oxalis montana*) have contrasting texture and form but exactly the same shade of green (left). Round-leaf violet (*Viola rotundifolia*) and partridgeberry (*Mitchella repens*) have analogous round leaf shapes, but contrasting leaf sizes and shades of green (right).

We also found beautiful examples of the scattered pattern at Joyce Kilmer, with two species interspersed with each other plant-for-plant. We called them "ground-cover blends." These were most noticeable when they were in sweeps that extended for a good distance—some of them went on for a hundred feet or more. Round-leaf violet was common throughout the forest, and we saw it intermingled with a number of other species including dwarf crested iris (*Iris cristata*) and galax (*Galax rotundifolia*). My favorite ground-cover blend was Christmas fern (*Polystichum acrostichoides*) and maidenhair fern (*Adiantum pedatum*). We lifted this idea directly from the native forest floor, planting a big expanse of the blend in Peirce's Woods.

A whole collection of wildflower species had a similar compound leaf shape and texture, including black cohosh (*Cimicifuga racemosa*—genus name recently changed to *Actaea*), white baneberry (*Actaea alba*), blue cohosh (*Caulophyllum thalictroides*), common goatsbeard (*Aruncus dioicus*), and false goatsbeard (*Astilbe biternata*). We looked forward to choosing two of these to blend together in Peirce's Woods.

We hiked the Alum Cave Trail in Great Smoky Mountains National Park, which has some of the most beautiful vistas in North America. Offering a strenuous hike, the five-mile trail climbs a total of 3800 feet to a peak elevation of 6400 feet. The air gets pretty thin up there, so it's not for the faint of heart. While the big takeaway message from the Poplar Cove Trail was the carpets of woodland wildflowers, the most memorable experience along the Alum Cave Trail was tunneling through groves of yellow birch (*Betula alleghaniensis*). Dense clusters of shiny silver-yellow

The idea for this "ground-cover blend" of Christmas fern (*Polystichum acrostichoides*) and New York fern (*Thelypteris noveboracensis*) in Peirce's Woods was borrowed directly from the native ground layer in the Joyce Kilmer Memorial Forest.

TOP I made a brief watercolor sketch looking into a dense cluster of rhododendrons. In the mountains of western North Carolina, the locals call it a "rhododendron hell," because the plants are so entangled with each other you can easily get lost among them.

ABOVE An even quicker sketch in my notebook abstracts the design elements further.

LEFT I made some quick visual studies as we walked through the forest, in this example about path geometry and mood. Writing notes directly on the sketches helps me to remember the main lesson later. Jagged edges create excitement, while curved edges are more restful.

trunks lined the path on both sides, and occasionally a single specimen of pin cherry (*Prunus pensylvanica*), which has a dark reddish-brown bark, stood out in sharp contrast.

Lessons from Nurseries

In addition to exploring plants in their native habitats, we visited a number of nurseries in western North Carolina and eastern Tennessee. Meredith Clebsch was co-owner of Native Gardens and Nursery in Greenback, Tennessee. This was one of the native plant nurseries established early in the current native plant movement, providing a huge service when there was a great need for native plant sources of supply. She occasionally ran native plant rescue missions for the state of Tennessee and propagated the plants for sale in her nursery. The Tennessee Department of Transportation would contact her when they were putting new roads through wilderness areas, and she'd go in with her rescue crews and extract what she could before the bulldozers arrived. She had recently rescued a population of the purple variant of hairy alumroot (*Heuchera villosa* var. *purpurascens*). When Rick and Jeff saw them at her nursery they got very interested. I just love it when plant people get all worked up over some new discovery. They selected a group of the deepest purple ones, and Meredith shipped them back to Longwood Gardens. Within a few years Jeff had grown thousands more of them from seed, picking out those with the purplest leaves and growing them on for planting in Peirce's Woods. We placed them in big sweeps right up against great masses of the ordinary *Heuchera villosa*, which is a bright chartreuse green. It was our clearest expression of the analogy-and-contrast principle, with strongly contrasting color but exactly the same leaf shape and texture. We planted

We found a purple form of hairy alumroot (*Heuchera villosa* var. *purpurascens*) at Native Gardens and Nursery in Greenback, Tennessee. Jeff Lynch is bending down to select the most intensely purple specimens, while Rick Darke (standing) discusses their propagation with nursery owner Meredith Clebsch.

them in long curving masses, purple bands against chartreuse, representing the serpentine pattern found so often in nature and making a very intentional tribute to the modernist gardens of Roberto Burle Marx.

Magic in the Ancient Forest

After spending an afternoon and evening hiking along the Albright Grove Trail in the eastern Tennessee part of the Smokies, we headed down to the car, watching the night fall around us as a full moon rose. It was a white gravel trail that led us down out of the ancient grove. It got dark pretty quickly all around us, but the moon lit up the gravel path, so the trail was easy to navigate. We walked along in silence, marveling at the brightness of the moon, waving our arms and playing with the shadows we were casting onto the pathway. We descended into a small wooded valley,

In Peirce's Woods we planted big sweeps of both the purple and the chartreuse forms of hairy alumroot—*Heuchera villosa* and *H. villosa* var. *purpurascens*—to illustrate the serpentine pattern and express, in a very pure way, the analogy-and-contrast principle.

and then the path made a turn to parallel the stream at its center. Here the valley was darker, shaded from the moonlight by a high canopy of hemlocks. After we had been walking there for a few minutes or so, Rick touched my elbow without a word and pointed down into the darkness. We all stopped and looked, and then saw what he was pointing at: fireflies, thousands of them, tiny lights filling up the valley beside us. They floated above the stream in a long twinkling cloud. We stood there for a good while, silently immersed in this experience, and then I noticed the cloud was moving. It moved almost imperceptibly down the valley, following the trajectory of the stream. It was a river of fireflies suspended above the stream and flowing slowly through the night.

"Cold air drainage," I thought. This phenomenon, also known as katabatic flow, is common in the mountains at night. When it gets dark the air cools, and as moisture condenses the air gets heavier. Gravity pulls it downhill, slowly draining it out of the valley. As I looked down into the creek I could feel the cool moist air flowing against my cheek.

I'm not sure how long we stood there watching the levitating river of fireflies slowly floating downstream.

I thought about how this firefly river was probably flowing along to merge with others down below. I wanted an aerial view, so I imagined myself rising up into the air and looking down onto the vast landscape from a vantage point far above us. In my mind's eye, a vast network of twinkling firefly rivers stretched out below me. The rivers of fireflies joined up with each other in a huge dendritic pattern, the whole thing slowly draining its way out of the immense forest that surrounded us. It was totally magical, and the scale of the whole thing was overwhelming.

I knew there was no way we could ever recreate the depth of that experience back at Longwood Gardens. If you really want to know how it feels to be inside 520,000 acres of forest primeval with millions of fireflies twinkling all around you, you actually have to go to the Smokies and immerse yourself in it. But we'd learned a lot about design from our hikes in the mountains, more than enough to inspire our plan for Peirce's Woods. We couldn't recreate the full experience of walking through the ancient woods, but we were taking many lessons home with us that would provide plenty of references to it. We could give the visitors what Jens Jensen might have wanted us to give them, the sense of well-being that comes from the native forest's deep and nurturing well of native spirit. The essential experience of Peirce's Woods would be total immersion in the beauty of native plants.

A Sequence of Spaces

Back in Pennsylvania, loaded with ideas and information, we began figuring out how to apply all of this to our design. First we had to understand the sense of place of the existing site. Encompassing seven acres of mature native trees (and one or two nonnatives that we wanted to keep), the site had become an ad hoc repository for many shade-loving flowering plants, largely exotics. A network of pathways had been installed two years before my first visit according to a plan by prominent British landscape architect Sir Peter Shepheard (who, incidentally, had been one of my studio teachers at the University of Pennsylvania and was a longtime advisor to Longwood Gardens). While the pathways were beautifully laid out, an overall unifying planting theme had never been developed, and now Longwood's professional staff were eager to create a plan that would incorporate native woodland plants into a design that reflected Longwood's mission of horticultural display.

When I first visited the site, all of the nonnative shrubs and ground covers had already been removed. The whole place seemed pretty naked, but there was a suggestion of structure from the banks of evergreen rhododendrons that remained. I set about mapping the spaces that existed so we could then begin to modify them into a logical progression of distinct woodland rooms. I began where the visitors would enter Peirce's Woods immediately following their rich visual experience along the brick walk.

Knowing that during most of the year we wouldn't be able to rely on color for major impact, I wanted to explore what dramatic effects we could provide through other means. A curving path led through the woods to a small gazebo at the edge of the Large Lake, a focal point that would draw visitors to the next destination after Peirce's Woods, the Italian Water Garden. Heading toward the gazebo, I noticed a pool of light off to one side, pulling my attention from the main pathway into the center of the woods. I followed the path into the woods, stopping periodically along the way to make sketches and jot down some notes about the experience. These sketches are a record of what I

perceived to exist on the site, combined with a sampling of ideas I was imagining about how the garden could evolve. They're not finished presentation drawings but serve as small visual notes of what I experienced and observed during my first couple of visits to the site. I was interested in how each visual or spatial experience seemed to lead directly to the next. As it turned out, this idea became a major design motif in Peirce's Woods.

The overall concept evolved into a series of well-defined spaces connected by the existing path network, each space offering a different experience with native plants. In developing the planting design, the Longwood staff had prepared a list of possible plants to include. As one might expect from those who love plants for a living, it went on for eight typed, single-spaced pages. After much delightful discussion and deliberation, we managed to get the list down to

RIGHT Strong verticals of mature trees were an essential component of the design for Peirce's Woods. This sketch shows a large red oak, which became known as the Sentinel Oak, at the edge of the Cathedral Clearing.

OPPOSITE TOP A sequence of small oil pastel sketches describes a progression of spaces that already existed in Peirce's Woods when we began the design process. First, a pool of light drew my attention through the woods to a specimen of alternate-leaved dogwood (*Cornus alternifolia*) leaning out over the pathway.

OPPOSITE BOTTOM I walked to the pool of light and to my left was this view into a grove of sweet birch trees (*Betula lenta*).

around 130 species and cultivars. The major focus was native azaleas, including 18 species and some thirty cultivars and varieties of them. We decided this was to be a plant-focused garden, with the architectural details being subservient to the plants.

At the entrance to Peirce's Woods, we made a small plaza where you can stop and get a drink of water and sit under a canopy of Kentucky coffee trees (*Gymnocladus dioicus*). Resting for a moment after all the bright color and sunlight on the brick walk, you can shift gears and prepare yourself for the subtler beauty of the woods. In the entrance courtyard the architectural materials—stone walls, brick paving, and benches—are similar to those found elsewhere in Longwood Gardens, giving a sense of continuity and transition. The courtyard also features a collection of planted containers, in which head gardener Pandora Young finds creative and ever-changing ways to experiment with living arrangements of native plants.

ABOVE Stepping off the path and into the grove, and then turning around, I found this view across the Large Lake to the Love Temple.

RIGHT The master plan for Peirce's Woods shows a sequence of well-defined woodland rooms, enclosed by single-species masses of native shrubs, each space carpeted with a different combination of woodland wildflowers. The Carpinus Walk parallels the Large Lake.

9/20/93 (3)

main entrance to Peirce's woods and main path to Love Temple, Dr. Water Parterre.

service drive with ugly painted stripes

NO SENSE OF PLACE

PROBLEM: as soon as you pass thru the hornbeams it feels like you are in a service area. Like going some backstage + can see behind the facade.

pleached hornbeam hedge + archways

"Back Room"

large mass of ilex

GRIFFEN ROOM

Stone griffin bench

brick paving

Helen? → truck access into center space? 10/26 Condor — cherry picker w/ 4 flotation tire base.

quiet green "room" prepares visitor for transition to woodland experience.

end-terminus: focal point completes the long vista down the flower walk.

solution?

vista to huge oak in cathedral clearing

entrance plaza (to woods) overlook

Carry the fine paving across the service drive

sign

sign

11/20 Fred Roberts — eliminate the service road?

speed bumps

NEW COURTYARD ENTRANCE TO PEIRCE'S WOODS.

masses of multi stem woodland understory trees - mag. va.?

new plaza.

formal container plant

floral strip

boxwood spirit hedge?!?

the pleached hedge is a fabulous piece of garden architecture. Let people walk up close to it and inspect it carefully!

TOP LEFT If a design idea can be illustrated with a simple diagram, chances are it will be a strong idea. The top sketch describes the basic structure of the Cathedral Clearing. Below it, the entrance plaza is shown as a transitional element from the brick walk into Peirce's Woods.

LEFT This diagram illustrates the linear sequence of spaces through "rooms," as in the Carpinus Walk.

ABOVE In the entrance courtyard, Pandora Young has been experimenting with native plants in containers, often with unusual and delightful results. In the container on the left is a large sumac (*Rhus typhina* 'Tiger Eyes') with a ground cover of *Tiarella cordifolia* 'Running Tapestry' and *Geranium maculatum* 'Espresso.' The purple form of hairy alumroot (*Heuchera villosa* var. *purpurascens*) reaches out from beneath the pot.

OPPOSITE This design study for the entrance courtyard records initial impressions and possible design ideas. I noted about existing conditions: "Problem: as soon as you pass through the hornbeams (at the end of the Flower Garden Walk) it feels like you are in a service area, like you've gone backstage." As it turned out, the existing service drive was removed so the entrance courtyard could continue uninterrupted from the Flower Garden Walk into Peirce's Woods.

six Abstracting from Nature: Peirce's Woods at Longwood Gardens 167

OPPOSITE TOP LEFT An autumn meadow container garden includes a tall 'Gateway' Joe-pye weed (*Eupatorium maculatum* 'Gateway') growing with a trailing threadleaf bluestar (*Amsonia hubrichtii*), a 'Montrose Ruby' *Heuchera*, and switch grass (*Panicum virgatum*). The container on the right includes *Heuchera* 'Montrose Ruby' along with 'Golden Fleece' goldenrod (*Solidago sphacelata* 'Golden Fleece').

OPPOSITE TOP RIGHT The bold foliage of skunk cabbage (*Symplocarpus foetidus*) contributes a strong focal point in the entrance courtyard, shown here in combination with *Heuchera* 'Silver Scrolls'.

LEFT Native azaleas make great container plants, as shown by this arrangement of pinkshell azalea (*Rhododendron vaseyi*) with Allegheny foamflower (*Tiarella cordifolia*) and blue flag iris (*Iris versicolor*).

ABOVE A miniature garden of insectivorous bog plants features two species of pitcher plant—the taller one is the pale trumpet (*Sarracenia alata*) and the short bronze one is the purple pitcher plant or sidesaddle flower (*S. purpurea*)—and also includes the scouringrush horsetail (*Equisetum hyemale*) and threadleaf sundew (*Drosera filiformis*).

The Cathedral Clearing

To really get to know a place, I have to sketch it and then sketch it again, and then again—each time dropping out levels of detail and getting closer and closer to its most abstract qualities. When you first look at a landscape, it is often filled with so much detail that its basic sense of place is obscured. Drawing and then drawing again is a way of removing the unnecessary visual information and getting at the core of a place's being. These drawings don't have to be beautiful; they're not made to be works of fine art, not even necessarily made for sharing with others. On the contrary, I make them just for me, as part of my internal process of understanding a place. More often than not, however, they do become a useful tool for communicating ideas to others.

When I first started looking at Peirce's Woods, I sketched the central clearing in a good amount of detail, using my ordinary field notebook and a black felt-tip pen. The existing space was clearly defined by the surrounding verticals of mature trees, but it was cluttered with a hodgepodge of flowering trees, shrubs, and ground covers. I drew this place multiple times, dropping out levels of detail with each iteration until eventually I had a diagram that revealed the essential spatial character of the site: a simple clearing surrounded by trees, with a single specimen tree in its center and another off to one side. This reminded me of the sketching I had done earlier in the Cow Lot at the main entrance to Longwood Gardens. I believe the earlier exercise informed and influenced the observations I was now making in Peirce's Woods.

The final and most abstract of these sketches set the design direction for what became the central area in Peirce's Woods. We ended up naming this space the Cathedral Clearing because the arching canopies

9/26/93 Cloudy. Was drizzly in early morning. Now clearing a bit.

OK what have I seen today?

The most AMAZING thing is the mature _sourwood_ right in the middle of the cathedral.

This wood is a world of straight vertical trunks against wiggly horizontals of shrubs & g.c.

THEME:

That's the major theme. very simple:

VARIATION:

Then, after your your brain has recorded this pattern, off you go wandering & exploring the subtle variations on this theme.

...and suddenly you encounter one very bold wiggly stem, more wiggly - and _blacker_ - than the rest.

and later you see it again, from a different point of view

as the focal point where a path rounds a bend.

two events converge

and it's twarfed by one of the largest tulip poplars in the whole woods.

LEFT I use drawing as a way of observing a place, not making art. As this sketch records, the existing mature oaks and tulip poplars on the site all had straight trunks, but one wiggly trunk captured my attention because it was so different from all the others. On closer inspection it turned out to be a sourwood (*Oxydendrum aboreum*), providing a strong element of contrast with the surrounding trees.

ABOVE Later, walking through another part of the woods, I saw the sourwood from a different point of view, this time dwarfed in juxtaposition with a huge tulip poplar.

TOP LEFT When I first started looking at the site, I made this sketch of the main clearing at the center of Peirce's Woods. It is rather detailed and took half an hour or so to draw but helped me begin to understand what was initially present in the woods.

LEFT I sketched the same scene again and then again, drawing each iteration more quickly than the last. The process edited out layers of nonessential information until eventually I had a simple diagram that abstracted the basic spatial character.

ABOVE In the studio before developing the planting plan for the main central space, I made this oil pastel drawing as part of imagining what the finished design might feel like. It emphasized the motif of strong vertical trunks played against the horizontals of shrubs and ground covers.

ABOVE Several years after Peirce's Woods was completed, I returned and painted this image of horizontal sweeps of ground covers meandering through the verticals of trees. Coming back and painting a garden years after its completion is one way to maintain an ongoing relationship with a place and continue to learn from it.

RIGHT Jeff Lynch proposed using this combination of woodland phlox (*Phlox stolonifera* 'Sherwood Purple') and Allegheny foamflower (*Tiarella cordifolia*) after noticing that they bloomed at exactly the same time. It became the signature wildflower combination for Peirce's Woods.

of trees reminded us of the central nave of a Gothic cathedral. As it turns out, the Cathedral Clearing became the place in the woods most photographed for books and magazines. All we had to do was clear out the center, removing most of the detail, and then choose a few species to install in simple large masses.

English garden writer Nan Fairbrother, in her influential 1970 book *New Lives, New Landscapes*, promoted alternatives to what she called the "fitted-carpet complex" of covering the whole ground plane with a uniform carpet of mowed lawn that stretches from one building to another. This practice had defined landscape design in Great Britain and the United States throughout most of the twentieth century, particularly in the home garden. Even in the shade, where lawn can be difficult to maintain, most of every garden was covered with closely mowed turf. A good friend who had been in the home landscape business for many years once confessed to me, "Sometimes I think I've spent my whole life trying to grow grass in the shade for people." We wanted to offer a fitted carpet of wildflowers as an alternative to lawn, for shade as well as sun. The Cathedral Clearing seemed to be the best place to demonstrate this principle.

Longwood staff had tested a combination of woodland phlox (*Phlox stolonifera*) and Allegheny foamflower (*Tiarella cordifolia*) as a ground cover, and they seemed to perform well together, blooming at exactly the same time. I proposed a large sweep of the mix flowing through the center of the clearing. We used

Phlox stolonifera 'Sherwood Purple' in combination with the tiarella, since its deep blue provided strong contrast with the white of the foamflower. This bold and colorful mosaic carpet has become the signature plant combination for Peirce's Woods. (Maintenance note: the phlox is more aggressive than the tiarella, so it's necessary to remove big handfuls of the phlox every year to keep the two in balance.)

Parallel to this big colorful sweep, we planted a sweep of pure green native pachysandra (*Pachysandra procumbens*). Together, these two massive forms provided the garden's clearest evocation of the Burle Marx aesthetic, taking what are usually diminutive woodland wildflowers and using them to make a bold statement. The ground-cover design in the Cathedral Clearing has continued to evolve. While the tiarella and the

Coastal azalea (*Rhododendron atlanticum*) blooms in early May, just as the "fitted carpet" of foamflower and phlox reaches the peak of spring bloom. *Heuchera* 'Montrose Ruby' provides a contrasting accent.

This large serpentine sweep of foamflower, adjacent to a solid green mass of native pachysandra (*Pachysandra procumbens*), flows around the base of the Sentinel Oak. Its form was inspired by the large sweeps of tropical plants in gardens designed by Brazilian landscape architect Roberto Burle Marx.

phlox have flourished there, the native pachysandra has not done very well. For some reason that remains mysterious, after the first few years it didn't seem to want to live there anymore. Longwood's horticulturists are currently testing alternatives to provide a uniform sweep of green. Still, the overall theme has been successful, and it's gratifying to see visitors enter the woods, gasp, take a photograph, and then write down the names of the plants so they can use them at home. That's what Peirce's Woods is really all about.

Orchestrating Azaleas: The Carpinus Walk

Following our trip to the Smoky Mountains, I visited Jeff Lynch in Longwood's nursery, where they had been collecting and evaluating native azaleas. All

Separating native ground covers into large single-species masses helps to distinguish Peirce's Woods as a garden rather than a woodland ecosystem, where wildflowers tend to grow in complex mosaics.

of these are deciduous, but there is a wide variation in their flower color, bloom time, and fragrance. Jeff was growing hundreds of them, and many were in full flower at the time of my visit, with many others getting ready to bloom in the weeks ahead. Observing exactly when the different azaleas bloomed, and in what colors, allowed us to precisely choreograph the display as it would unfold week by week. I visited the nursery regularly during the main azalea season—April through June—for two successive years before developing the final planting plan. A few species don't reach their peak of bloom until July, or even into the beginning of August, so during those months Jeff would call me periodically and I would come by to take a look, attaching a tag to each one, noting its specific attributes. We had a lot to choose from, so when it came time to plant them we had the luxury of selecting only the very best.

In Pennsylvania the flowering time of the Florida azalea (*Rhododendron austrinum*) can vary by individual plant from late April to mid-May, with colors ranging from light yellow to reddish-orange. Jeff had been growing a stunning group of them, and I was overwhelmed by their dramatic display of color and perfume. Since the intensity of their sweet scent can also vary from plant to plant, I wanted to select only the ones with the strongest fragrance. And I wanted to be sure they were planted in masses large enough to give visitors the richest possible experience, so I proposed arranging them in a color progression similar to the way the flowers were being displayed on the Flower Garden Walk. We'd plant them in large masses on either side of a long pathway in such a way that visitors could experience the full gradation of color from pale yellow to deep orange, and walking along the path would take enough time that they would have ample opportunity to become immersed in the experience.

To arrange them effectively, we had to get to know the specific characteristics of each individual plant. In addition to all the natural variants of *Rhododendron austrinum*, we planted certain cultivars, including those of other azalea species, to extend the flowering time and enrich the display of colors and fragrance. Within the species *Rhododendron atlanticum*, the coastal azalea, we chose 'Yellow Delight' and 'Choptank Yellow', two intensely fragrant cultivars. We also used the flame azalea (*R. calendulaceum*), which is not fragrant but has particularly spectacular yellow to orange-red flowers. It requires a fair amount of light for good bloom, so it had to be carefully sited. The Oconee azalea (*R. flammeum*) cultivar 'Harry's Speciosum' is a reliable orange-red, but not fragrant. The hybrid 'My Mary' has fragrant flowers, bright yellow with orange tubes. This one is a hybrid between *R. austrinum* and another hybrid called 'Nacoochee', which itself is a cross between *R. atlanticum* and *R. periclymenoides*. All of this should give you some idea of just how complicated it was for the team to program this display, and even more than that, how much fun native azalea experts can have when they get together at professional meetings to discuss the complexities within the latest cultivars and varieties.

Inspired by the tunnel of birch along the Alum Cave Trail in Great Smoky Mountains National Park, I wanted to have strong vertical birch stems rising up in clusters and punctuating the masses of native azaleas, receding into space and creating a greater sense of depth. Also, the birch bark's beauty throughout the year would make up for the native azaleas' relative lack of interest outside of their flowering season. The first

178 PART 2 Designing the Artful Garden

design study showed paper birch (*Betula papyrifera*), because I thought that dense clusters of white trunks would be really dramatic. However, Jeff and Rick both expressed doubt about the ability of paper birch to thrive in southeastern Pennsylvania's summer heat. Also, a member of Longwood's advisory committee objected, pointing out that while she admired the tree, it reminded her too much of the native woods farther north, and she thought it didn't look very much like Pennsylvania.

TOP The flowers of Florida azalea (*Rhododendron austrinum*) offer a natural gradation of color from pale yellow to deep orange. This sequence of color became the major design theme in the Carpinus Walk.

ABOVE Longwood's staff had been collecting and evaluating native azaleas for several years before I joined the Peirce's Woods design team. I observed them in flower for two successive years, tagging each specimen with a serial number and making careful notes about each specimen's bloom time, flower color, and fragrance.

After a number of discussions, Jeff and Rick and I decided to go with American hornbeam, *Carpinus caroliniana*, which is native to the woods near Longwood. Their strong, muscular, silvery trunks have turned out to be even more spectacular than I had imagined those of the white birch would be. We ended up naming this part of the garden the Carpinus Walk, since even though the primary purpose was to surround the visitors with the azalea display during the spring flowering season, the hornbeams would be providing year-round beauty.

Rick frequently tells the story of the paper birch/hornbeam decision when he lectures about Peirce's Woods, because it illustrates how emblematic certain

The original design for what became the Carpinus Walk called for verticals of white birch (*Betula papyrifera*), but after Longwood staff pointed out the difficulty of growing them in southeastern Pennsylvania the proposed trees were changed to American hornbeam (*Carpinus caroliniana*). Notice the alternate-leaved dogwood leaning in from the far left over a pool of light-colored ground covers—the same view as in the preliminary sketch at the beginning of this chapter.

I painted *Carpinus Walk* to illustrate the final design concept: horizontal drifts of native azaleas moving through the verticals of silvery-barked hornbeams.

plants are of particular landscapes. While it's true that paper birch would have been no more exotic than the southeastern azaleas we were introducing, its strong association with more northern forests might have made it seem out of place in Peirce's Woods. Gardens have meaning. They are repositories of memory. When you are designing a garden to tell a particular story, you have to make sure that the vocabulary you are using will support the story as fully as possible.

We planted 150 mature native azalea specimens in clusters of 3 to 10 along a pathway more than four hundred feet long. When it came time to place the azaleas along the Carpinus Walk, I marked the precise location for each one, placing flags in the ground with serial numbers keyed to the tags on the plants in the nursery. It was a challenge to lay out the color gradation according to our plan, as well as to get the fragrant ones distributed evenly along the path. Jeff helped me keep track of which azaleas should go where, and it took quite a lot of reorganizing as we went along, moving the little flags around until the arrangement was just right. I love working in public gardens, where there is an innate understanding of how much time and careful choreography it takes to create a spectacular display—and of course, we were planting mature specimens from the nursery, so we could be sure the performance would be amazing from the very first year.

One day while taking photographs during the peak display season, I was standing at one end of the walk and saw three visitors enter from the other end. One of them had dark glasses and a white cane. The other two were so busy chatting away with each other that they were oblivious to the display on either side of them. About midway down the walk, the one with the white cane stopped the other two and said, "Wow, what is that wonderful fragrance?" The other two peered left and right, and one of them said, "I think it's all these forsythias." I loved it. The visitor who was totally blind had had the immersive experience we intended everyone to have, while the two sighted visitors had almost missed it entirely.

After the azalea season has come to an end, there is one more wildflower display along the Carpinus Walk before the whole thing goes to green for the rest of the summer. Massive sweeps of black cohosh (*Actaea racemosa*), also known as fairy candles, come into bloom in late June and early July, with hundreds of white flower wands rising as much as five feet into the air and leaning out over the pathway. I like to program as much richness into a display as possible while keeping a sense

The planting plan showed the approximate placement of each specimen, identifying them by serial number. The exact locations were determined by inserting numbered flags into the ground and then walking along the path to imagine the intended experience.

of unity and avoiding chaos. Timing events sequentially over the seasons is a good way to do this. While the azaleas are flowering, the black cohosh provides a knee-high, fine-textured ground cover, and it's not until the azaleas have gone completely out of bloom that the cohosh's tall flower spikes rise to their full height.

I also like to integrate multiple levels of detail so people with greater horticultural knowledge can have many layers of experience. Along the Carpinus Walk, the ground cover is not 100 percent black cohosh, even though to most people it all looks like the same species. Mixed in here and there is blue cohosh (*Caulophyllum thalictroides*). Its flowers are rather inconspicuous, but clusters of bright blue berries follow later in the season. This was an especially subtle expression of the analogy-and-contrast principle. Blue and black cohosh have a similar compound leaf arrangement, with the same texture but a slight variation in

TOP LEFT The area where we planted the Carpinus Walk had been filled with a hodgepodge of nonnative shrubs. When they were removed we had a virtually blank slate to work with.

LEFT It was a luxury to plant full-sized azaleas. With such a dramatic display in the very first flowering season, it was even more satisfying than putting paint directly onto canvas. In addition to being surrounded by a dramatic gradation of flower colors from pale yellow to deep orange, visitors are immersed in fragrance.

ABOVE After the native azaleas have finished flowering, the white wands of black cohosh (*Actaea racemosa*) rise up above the shrubs and carry the floral display into midsummer.

the individual leaflets. The leaflets of black cohosh are warm green and toothed, while those of blue cohosh are colored a slightly cooler green and have smoother edges. This is stuff to delight the real plant nerds as well as those who love to celebrate nature's minutiae and infinite diversity.

Make It *Real* Big

During our field trip to the Smokies, if the huge rivers of fireflies slowly draining away from the Albright Grove Trail defined the yin of our experience, later that night we experienced the yang. Down in the town of Robbinsville, in the parking lot of an ice cream stand, we witnessed a young man trying to impress his girlfriend with his customized 1960s Chevy. He sat in the driver's seat, revving up the engine, and the girlfriend stood behind the car, watching. He'd step on the gas, and big blue flames would shoot out of the tailpipes.

He'd call out, "How wuz that one, honey?"

"Oooh," she'd squeal with delight, "they wuz big, honey. They wuz *real* big!"

Carpeting the ground beneath the azaleas is a blend of black cohosh (*Actaea racemosa*) and blue cohosh (*Caulophyllum thalictroides*). Both have the same texture, and at first glance it seems like a large mass of the same plant. However, on closer inspection you notice *Actaea* has leaflets that are warm green and toothed, while *Caulophyllum* has smoother-edged leaflets that are slightly bluish green—a particularly satisfying expression of the analogy-and-contrast principle.

He'd flash a satisfied smile and then do it again.

Size is important—and in certain situations size is everything. The fireflies in the forest brought our awareness to the majesty of grand scale in nature, and the scene with the Chevy gave us the mantra: "Make it big, honey. Make it *real* big!"

Before our trip to the Smokies, I was a bit apprehensive about using woodland natives so boldly. Every native garden I had ever seen was fairly subtle and delicate. While woodland wildflowers were widely appreciated for their simple beauty, they almost never got to make a big bold splash in the world of horticultural design. It seemed to me that woodland gardens had always depended on subtle moments—a fern arching out from the base of a tree, or a little foamflower tucked between a couple of rocks. Offering an alternative to that tradition, we wanted to create a garden of wildflowers that was big, bold, and brassy. I wondered, when they name something "foamflower," aren't they thinking of waves crashing on a beach? Big sweeps of swirling foam? Two or three plants nestled between a rock and a tree trunk is very sweet, a classic moment,

Following the spring blooming season, Peirce's Woods is mostly green through the rest of the summer. By planting wildflowers in large monospecific masses, we were able to use textural variation and subtle color contrasts to make a dramatic design statement. The simple green of native pachysandra (*Pachysandra procumbens*) provides strong contrast with the brownish spent flower spikes of Allegheny foamflower (*Tiarella cordifolia*).

The central area of Peirce's Woods includes a vista made with more than one hundred thousand plugs of Allegheny foamflower (*Tiarella cordifolia*) spilling down a slope in a section of the garden we call The Waterfalls.

but a hundred thousand blossoming tiarellas cascading down a woodland slope is real *foam*. Jeff Lynch cooked up that idea and we called it The Waterfalls. It's a massive sweep of *Tiarella cordifolia* that when in bloom looks like yards and yards of fluffy white chenille, like fifty thousand fabulous bridal gowns laid side by side. This isn't just the world's largest artform display of woodland natives, it's also the world's largest native plant fashion show. I wanted wildflowers in sweeps so big you'd clutch your pearls and scream.

There was something so comically wonderful in the coming together of those two scenes—the river of tiny fireflies and the Chevy with the big blue flames. It taught us about scale. Scale is everything.

Make it big, honey. Make it *real* big.

These two paintings record the two most dramatic destinations in Peirce's Woods, the Carpinus Walk (left) and The Waterfalls (above).

SEVEN
Interpreting Sense of Place: The Tropical Mosaic Garden

I WAS ASKED TO DESIGN a small garden to help get the new Naples Botanical Garden in Naples, Florida, up and running. It was to be a "starter garden" on less than 1 acre, a place where the staff could prototype a variety of visitor activities and programs while completing the master plan for the rest of the 170-acre site. Their mission is connecting people and plants from between the 26th parallels north and south around the world, so the design program called for a wide variety of plants. In addition to having an ambitious program of use, the garden had an ambitious schedule: it had to be ready for the public in less than nine months.

The challenge would be to produce an entirely new garden that fit within south Florida's regional character while having only a short amount of time to explore the local climate, culture, and garden design history. I thought about H. F. du Pont and the luxury he had growing up in the Brandywine Valley, where he spent an entire lifetime making a garden to reflect its local sense of place. I knew we could make a garden in Naples that would reflect the rich traditions of south Florida, but we'd have to do it in a much more freewheeling manner than du Pont employed at Winterthur.

The garden's primary audience would be people from outside Florida, largely tourists and the "snowbirds" who winter in Naples, so they asked for a peak display period of October through May. Even though they weren't anticipating many visitors June through September, I wanted to design an authentic tropical garden with year-round interest, including the hot summer season. Even in the nonsummer months, it's hot in Florida, so we'd need multiple shaded sitting areas. The garden was also to serve as a setting for fund-raisers, and once the main botanical garden's attractions were in place it would ultimately become a destination rented for weddings and other private functions. We'd need a staging area for ceremonies and places for wedding photos.

Sketching tropical plants with charcoal and pastels helped me understand and internalize their rich palette of form, texture, and color. Scanning these sketches into my computer and then wildly altering them with Photoshop gave me greater license to experiment with live plants out in the garden.

The overall master plan for the Naples Botanical Garden drew heavily from the popular book by B. Joseph Pine and James H. Gilmore, *The Experience Economy: Work Is Theater and Every Business a Stage*, which is all about the added value of "themed" experiences such as those offered by Disney and Starbucks. Their theory is that combining layers of complexity with immersion in multisensory stimulation—within the context of an overarching theme supported by richness of detail—leads to a more memorable experience that will attract consumers and encourage them to return again and again. Pine and Gilmore call it the "immersive experience." At the botanical garden they called it the "wow!" experience. This is nothing new to garden designers, who were creating multisensory themed experiences long before Starbucks came along.

What Makes the Tropical Garden Unique

One of the things I love most about working in public gardens is interacting with people who know more about plants than I do. Each new project has a different plant palette, and the horticulturist in me gets really turned on. This was my first experience with tropical plants, and I was eager to start learning all about them. However, the Naples Botanical Garden was so new they didn't yet have any professional horticulturists on staff. I needed some advance training in tropical garden making, so I started searching for an expert to join me in this adventure. I didn't have to look very far. At that time I was living in Austin, Texas, where I'd recently met Scott Ogden, one of the most knowledgeable horticulturists and creative garden designers in North America. Scott's work is all about plants, romance, and creating beautiful spaces to inspire beautiful living. He agreed to join me as my plant expert, and I soon found out he also had a huge amount to contribute about tropical garden design. There was no way this project could have been a success without his collaboration.

Scott quickly generated a wish list of more than three hundred species and cultivars to use in the garden. The botanical garden staff wanted maximum species diversity, so we agreed to include as many different plants as we could. I wondered how we could do this on a small site and still have it read as a unified garden design. I hadn't spent much time in south Florida, so my first task would be learning about the region's ecosystems and garden history, including the great diversity of tropical and subtropical plants that can be grown there. The key to this whole endeavor would be to understand the prevailing sense of place, boiling that down to its essence and using it as the basis for the new garden's design.

I learned a lot from Scott about what makes the tropical garden unique. Most important, the light is different from that in the north, very intense. The sun is largely overhead. At noon on the summer solstice, buildings hardly cast a shadow, so there's no real "shady side" to speak of. The heat can be brutal in Naples, and people always want to get out of the sun, so shade has to be created by other means. At sunrise and sunset the slanting light is very dramatic, and sudden thunderstorms can produce theatrical lighting effects. In the daytime the brilliant sunlight offers excellent opportunities for working with shadows, and tropical leaves can cast beautiful patterns onto paving and walls.

Unlike gardens in more temperate regions, the tropical garden is not very much about flowers; it's more about foliage texture and structural form. Flowers

ABOVE Palm trees cast bold graphic patterns on the ground—an important part of the overall design composition, especially in tropical gardens. The drama is heightened if the ground surface is light, as with the crushed shell paving shown here in the Tropical Mosaic Garden.

LEFT For me there was a whole new set of interesting visual opportunities in the tropical landscape, including dramatic patterns of light and shade. This palm leaf had a radial pattern of blades emanating from a center point, and when the shadow from another leaf was projected onto it, a spiraling pattern emerged.

RIGHT *Caladium* 'Thai Beauty' has leaves of bright pink with green and white accents and is effective in the garden all year since it doesn't have a dormant period in winter.

BELOW In Florida you see plants growing on top of other plants, such as these Florida sword ferns colonizing India date palms. If you want to recreate this effect, be sure to use the native sword fern, *Nephrolepis exaltata*. *Nephrolepis cordifolia*, the tuberous sword fern, is often used in tropical gardens but should be avoided since it is a seriously invasive exotic that crowds out native plants in Florida ecosystems.

tend to provide speckles of color, not masses of color as they do in the north, amid overwhelming green. Broad sweeps of color can come from foliage, however, and you do get some drama from certain tropical trees that can burst into flower and make bold focal points. Nocturnal bloom, mostly white and often fragrant, creates a romantic mood after sundown.

Scott's book *The Moonlit Garden* was a great source of information on what goes on in tropical gardens after dark. To learn even more about night-blooming plants, I spoke with Peter Loewer, author of *The Evening Garden*, and was fascinated to learn that many night-blooming plants are bat-pollinated. Although I suspect that bats are fairly unpopular in Naples, since most people there don't like bugs and creepy things, they're actually gentle mammals that help to control unwanted insects—they eat lots and lots of mosquitoes. Asked about his favorite night-blooming plants, Peter says he loves almost anything belonging to the genus *Brugmansia* (formerly *Datura*), angel's trumpet, but particularly some of the newer cultivars such as 'Charles Grimaldi', which has deliciously fragrant flowers that are pale orange rather than the more common white. These are also good to grow as container plants in nontropical regions, where they just need to be moved indoors to get through the winter months. When I spoke with Peter about brugmansias, he urged me to point out one serious potential hazard of planting them in your garden: angel's trumpet has flowers, seeds, and leaves that are poisonous if ingested. I suppose the angels are looking for company. We decided not to include them in the public garden at Naples, but Peter encourages you to try them at home.

One thing that amazed me about Florida is how quickly plants grow in the tropical climate. I was delighted to find the Tropical Mosaic Garden looking fully mature just one year after it was planted. It felt like making a giant cut-flower arrangement, except that all the plants were living and more or less permanent. In his book *Tropical Garden Design*, landscape architect Made Wijaya writes, "In tropical gardening one has to consider that extra dimension of rapid growth," which can bring "quite radical change to the balance of shapes during a garden's adolescence." I'm accustomed to working in the northeastern United States, where you have to wait three years, five years, even ten years after planting before you know you've achieved your desired effect. In Florida you have the pleasure of almost instant gratification, but the downside is that the garden can quickly get out of control. Trees can quickly grow to be huge, so you have to plan ahead very carefully. Still, the superabundance can also produce wonderful effects—some flowering trees, I'm told, can carpet the ground with a layer of petals up to your ankles.

Garden as Theater

Scott says making a garden is like doing a theatrical production. The designer is the writer/director, generating the ideas that lead the whole creative team. Stage sets are designed and constructed to provide a setting for the story. And here's the thing many landscape architects don't seem to understand: the plants are the actors. The best gardens are primarily all about plants, not walls and paving patterns.

Among the plants you have many different categories of actors. You've got ordinary ones who work for scale wages, the "low-maintenance" plants everybody always asks for. These are the background actors—the extras in the cast who are necessary for a successful production but can only help to set the scene for the more important cast members. The stars are higher-

priced plants that require some maintenance and care. You need them for drama and excitement, and to carry the main plotline. And then there are the divas. Ah yes, you absolutely must have them in the garden, but they can be finicky and demand significant resources. Of course, the whole thing is pointless without an audience, and to attract an audience the story has to be great—and that's where a strong design theme comes into play.

We decided we wanted our story for the garden to be based on classical themes of elegance and romance, glamour and sophistication. We'd use traditional local materials such as colorful tiled and stuccoed walls, heirloom plants, pine straw mulch, and crushed shells for paving. We wanted an opulent "Old Florida" mood to prevail, richly detailed and complex—not the sleek modern look that recently has become popular. We definitely didn't want it to look like a photo shoot for a flashy style magazine. We were staying away from the clean lines of Cor-ten steel and brushed aluminum, taking our inspiration instead from designers like Addison Mizner, the flamboyant 1920s-era architect who adapted a Mediterranean style for the ornately decorated houses and gardens he designed in Boca Raton and Palm Beach, along Florida's southern coast.

Florida's Rich Legacy

Florida has a rich history of garden design. Many significant botanists and horticulturists have lived there since the nineteenth century, and many important ornamental plants originated there. The orchid industry would be nothing without south Florida, the setting for Susan Orlean's *The Orchid Thief: A True Story of Beauty and Obsession*, all about the quest for the rare ghost orchid, and the basis for the movie *Adaptation*. Collier County, home of the Naples Botanical Garden, has a greater diversity of native orchids than anyplace else in North America.

When I came across this small garden in front of a New Orleans apartment, with its rustic patina and organized clutter of potted plants, I felt it captured the Old World feeling we wanted for the new garden in Naples.

ABOVE We visited natural landscapes across southern Florida, such as this palmetto-pine scrubland. These endangered places have immense environmental value, including offering critical habitat to native birds and other animals.

LEFT At the historic arts-and-crafts-era Bok Tower Gardens in Lake Wales, Florida, I found these orange crotons displayed in front of a blue-tiled wall. This image had a significant influence on our design for the Naples Botanical Garden.

ABOVE While we weren't interested in using architectural elements that were actually crumbling, this balustrade at Miami's Vizcaya Museum and Gardens did illustrate the look of 1920s decadence we wanted for the Naples Botanical Garden.

RIGHT Rusticated stone, richly textured stucco, and bold foliage plants combined with just a few speckles of flowers are hallmarks of the classic Florida garden, as this vignette from Vizcaya illustrates.

We began the design process by visiting gardens and natural landscapes across south Florida—Scott, me, and Elayna Toby Singer, who was the botanical garden's vice president for guest experience. We studied the history of the region's old-style gardens, which are based on gardens from Spain, Italy, and other parts of the Mediterranean because of their similarities in climate and other environmental conditions. It felt right to borrow ideas from all across the state, since the cultural history of Florida was already replete with borrowed ideas from other places around the world.

The completed garden presents a sequence of immersive experiences that allow the visitor to explore Florida's rich legacy of horticulture and design. Each destination within the garden refers to a different classical element in the region's rich garden history and features a diverse collection of tropical ornamental plants.

Room for Spontaneity on the Fast Track

Public gardens usually require twelve to eighteen months to design, because they require careful programming, research, and discussion. I enjoy the typical process of presenting design alternatives and discussing them with a wide range of professional staff including horticulturists, educators, marketing specialists, and fund-raisers—along with various presentations to and approvals by a gardens committee or board of trustees. Usually there is plenty of time set aside in the design process for testing and refining ideas. Then the actual implementation can take up to a year. Typically, the whole process can take two or three years.

But not in this case. The Tropical Mosaic Garden had to be up and running in less than nine months. We didn't have time for testing lots of design options, and we certainly had no time for elaborate construction plans and written specifications. From the moment the design process began, a general contractor was on board helping with technical decisions, and the garden was quickly built from rather rudimentary drawings. This suited Scott and me quite well, since both of us prefer to keep the creative process going throughout the installation of plantings and built elements, right up to the moment the garden is completed. No matter how much time you have for planning, it's impossible to think of everything ahead of time—besides, some of the most satisfying details occur spontaneously as the whole composition is coming together. I'll describe some examples of that in the sections that follow about various parts of the garden.

Since we were on such a fast-track schedule, there wasn't time to prepare a detailed visual inventory to use as inspiration for design. I had to rely on a few quick sketches and paintings, just enough to get a sense of the design vocabulary that Florida's gardens and landscapes had to offer. I was delightfully overwhelmed by the huge diversity of ornamental plants that can be used in tropical gardens. Particularly fascinated by plants in the aroid family, or *Araceae*, I was especially attracted to the group of plants known as elephant ears, belonging to the genera *Alocasia*, *Xanthosoma*, and *Colocasia*.

The planting plan never made it beyond the tracing-paper stage—and I mean the flimsy stuff that many landscape architects rather disrespectfully call "trash," the stuff that gets sketched on, wadded up, and thrown away by the yard during the design process. Our tracing-paper planting plan had notes and plant lists scribbled all over it, with squiggly arrows indicating approximate locations for plant groupings.

I was attracted to the shapes, texture, and scale of tropical plants, especially those in the *Araceae*, or aroid family.

LEFT The Tropical Mosaic Garden was a super-fast-track project, so we weren't given much time for elaborate design presentations. The preliminary master plan was hastily sketched out as a six-inch pencil drawing in a little notebook.

BELOW This drawing of the finished garden design, which at ten by fourteen inches was slightly larger than the master plan sketch, was given to a local architect who then prepared more formal construction documents.

The planting plan never made it out of the flimsy tracing-paper stage. We took a photocopy of this rough drawing onto the site and refined the design by moving plants around by hand.

The actual placement of individual plants was done by hand in the garden itself. I enjoyed watching Scott work like an artist, moving plants around on the site the way a painter might move colors around on a canvas, or more accurately, the way a theatrical director might position actors on a stage.

The India Date Palm Allée

In the midst of the design process I happened to visit Barcelona, where I was totally blown away by the architecture of Antonio Gaudí. His Sagrada Familia, a fabulous cathedral the construction of which began in 1882 and continues today (Gaudí worked on it from 1883 until his death in 1926), is widely considered to be one of the world's sublime architectural wonders. The central nave is an abstraction of a forest, with columns branching like trees as they soar up to the roof. Gaudí continually received inspiration from nature. An interpretive sign at the cathedral notes that when he was asked about the source of his vision for the "forest nave," he said, "The tree next to my workshop is my master."

I found Gaudí's design for Parc Güel even more inspiring than Sagrada Familia. A work of true genius inspired by the site's natural elements and executed with whimsy and playfulness, it presents a marriage of engineering, landscape architecture, and art, all in the service of human delight. For a colonnade in the park, Gaudí created stone columns representing the trunks of palm trees, each topped with a potted agave to suggest the arching fronds. In tribute, I proposed a similar feature for Naples, rows of classical columns with potted agaves on top.

Back in Florida, Scott had found some wonderful silver India date palms (*Phoenix sylvestris*) in a nursery called Fish Branch Tree Farm in Zolfo Springs. At Fish Branch (where they refer to India date palms as "sylvesters"), their palms are ultra-carefully trimmed with very clean and precise cuts that highlight the pattern of leaves spiraling up the trunk. The trees we selected had strong architectural form with large arching fronds, just right for the central allée that would lead visitors into the garden from the new parking lot. Most India date palms have fronds more green than silver, but the people at Fish Branch allowed us to select the most silvery ones.

Scott suggested we lay out our allée with alternating pairs of palms and columns. Also at Scott's suggestion, I designed each of the columns to have spiraling lines of seashells from bottom to top, to echo and reinforce the pattern of the tree trunks. Shell-encrusted architecture is a part of Florida's garden heritage, so this motif would also make a connection to local architectural history.

I happened to visit Barcelona during the time we were designing the garden in Naples, and I found Parc Güel to be amazing. Completed in 1914 by architect Antonio Gaudí, the park includes an "allée" of architectural columns imitating palm trees, with agaves in containers on top. I knew right away we had to borrow this idea for Naples.

For the Naples allée, Scott suggested we use pairs of agave columns alternating with pairs of India date palms, and I made these pencil studies to illustrate the idea.

ABOVE LEFT After the existing parking lot was stripped of its asphalt, I mapped out the allée directly on the site. The contractors followed along behind me preparing the planting beds to receive the new palms and compacting the soil where they would be laying the new paving.

ABOVE It's always exciting when you have several different trades working on a site at once. The India date palms were being installed while we were applying the tile mosaic to the Sunrise Border Wall.

LEFT We found these India date palms at Fish Branch Tree Farm and were taken with how carefully the old leaves were trimmed off (with what is locally referred to as a Morgan cut), accentuating their beautiful spiraling arrangement on the stem.

Unlike gardens in more temperate climates, the tropical garden looks fully mature within a year after planting. It's like doing a giant cut-flower arrangement with live plants.

The Florida Sunrise Border

At Parc Güel, Gaudí's broken-tile mosaics were another source of inspiration. There, a masonry bench runs along the top of a serpentine retaining wall covered with a continuous mural of colorful tiles. The whimsical patterns have no discernible rhyme nor reason other than the pure celebration of color and creativity. The instant I saw the wall I knew we had to have one like it in Naples. Scott had introduced me to a group of yellow and orange sun-loving bromeliads, *Aechmea blanchettiana*, in cultivars with citrus names like 'Lemon' and 'Orange', so as a backdrop for them I proposed a mosaic tile wall that was mostly blue. As blue is the complementary color to orange, I knew it would bring out the rich warm tones in the bromeliads. The surface of the wall would have undulating sweeps of various shades of blue, representing the intense Florida skies, while images of mythical sea creatures and microorganisms would recall the movement and life in Florida's waters.

We had the general contractor build a concrete wall with a serpentine form, 250 feet from end to end. Its exterior, facing the street, was given a veneer of native stone, while the interior was finished in plain concrete, ready to receive the broken-tile mosaic. My first sketch for the mural was rudimentary, a rough drawing in colored pencil on tracing paper, with only a minimal suggestion of the final design. I'd never done a broken-tile mosaic before, so I didn't want to get too specific too early in the process. As it turned out, I drew the final design directly on the wall with a big black crayon—the largest drawing I've ever done. I walked quickly, moving the crayon along the wall's surface, reaching up and ducking down, with the resulting curves reflecting the scale of my body, the natural arc of my arm. Movement through space is one attribute that gardens share with dance, and I felt like a dancer moving across a stage.

To get the mosaic on the wall I worked full-time with two tile masons for four weeks. Paul and Keith, the tile guys, were lots of fun. They showed me how to use the cutting tools and attach the tiles. They brought me fish and chips from Long John Silver's because they wanted me to experience the full range of Florida's cultural offerings. They took good care of me. They called me Smitty. We talked about how much fun we were having and how cool it was to do such interesting things with other people's money.

Paul and Keith had never created a piece of art, their work being mostly limited to ordinary kitchens and bathrooms, and although I'd done a lot of different kinds of artwork, I knew nothing about how to put tiles on a wall. We learned a lot by collaborating with each other. I would affix the tiles along the edges of general shapes and curves, and then Keith and Paul would fill in the larger areas. We took turns making up

SEVEN Interpreting Sense of Place: The Tropical Mosaic Garden 209

whimsical details and placed a giant crab behind one of the benches to honor Antonio Gaudí. His astrological sign was Cancer, and he found places for the crab motif all over Parc Güel. This symbol also has local significance, since crabbing is a major commercial and recreational activity throughout Florida's salty waters.

Our wall included contributions from the local community, botanical garden members as well as neighbors, who were invited to bring broken dinnerware

ABOVE Parc Güel is full of whimsical broken-tile mosaics, including those along this serpentine bench and retaining wall. Even though I'd never made a broken-tile mosaic before, I knew immediately that we needed one in Naples.

ABOVE RIGHT I thought the strong yellows and oranges of *Aechmea blanchettiana*, a spectacular full-sun bromeliad from Brazil, would look great against a complementary blue background. These are cultivars 'Lemon', in the foreground, and 'Raspberry', behind.

BELOW AND NEXT TWO PAGES There wasn't much time for making detailed design studies, so I did a quick colored-pencil sketch to illustrate the basic idea.

and pottery from home. We smashed them into shards and put them into the mosaic, so the wall has little pieces from the lives of people that live near the garden, such as fragments of grandmother's china or bits from other family treasures.

The president of the Naples Garden Club contributed a beautiful chipped plate, which she told me was a wedding gift from her mother in 1938, part of a fine china set that she was still using. I put pieces of the decorative border from her plate into the center of the crab. Jim Rice, a local ceramicist who specializes in fish-serving platters (and whose motto is "plattery will get you everywhere"), donated some of his gorgeously glazed plates that had been broken in handling. Someone else contributed a little ceramic dish with a portrait of Abe Lincoln on it and another with a picture of the Chicago Water Tower. Naples gets a lot of visitors from Chicago, so we put these near one of the benches where they'd be easy to find. Keith said they should have a contest to guess the total number of tiles in the wall. I cut my fingers to ribbons on all the sharp edges. A really great time was had by all.

In spite of my interest in creating gardens where the plants are more important than the architecture, the tile wall attracted a huge amount of attention. Still, its primary purpose was to provide a backdrop for the bromeliads, simple theatrical staging for the real stars of the show: *Aechmia blanchettiana* 'Lemon', 'Tangerine', 'Orange', and 'Raspberry'. The pointy shapes in the tilework represent shadows cast by the bromeliads. It was early evening when I started making the drawing on the wall, and I had pulled some pots of bromeliads up against the bare concrete to see how the scale of the plants looked against their backdrop. The sun was setting and it projected shadows from the leaves up against the wall. Without thinking too much about it, I traced the shadows directly onto the wall and they became part of the design.

Serendipity is a major part of the creative process. I've learned from artists that it's often best not to figure out too many details ahead of time, but to keep your creative spirit open to new possibilities. After you've done your homework and developed an overall concept that is clear and simple, you can go with the flow and allow the unforeseen to enter the process. Once we got into the tiling, the wall seemed to take on a life of its own. One day I felt there was just too much blue. It needed some contrast, so I asked Paul and Keith where I could buy bits and pieces of other colors. They sent me to a junk shop on the other side of town, the Bass & Bass Flea Market. I went over there and found all sorts of good stuff, including a wide variety of colorful tiles left over from various home improvement projects.

I also found a whole collection of ceramic ashtrays and soap dishes, souvenirs shaped like seashells and

SEVEN Interpreting Sense of Place: The Tropical Mosaic Garden 211

glazed in pastel colors. I bought all they had. As it turned out, these weren't just any souvenirs. Bass & Bass had bought them from Sylvia's Shell Ceramics, a shop whose owner had recently closed her business and moved back up north. The fortuitous find alone was good enough, but then I was amazed to learn that the now-defunct Sylvia's Shell Ceramics had been located directly across the street from the botanical garden. These funky little objects had been made across the street from the garden and then taken to a junk shop all the way across town, and I had unwittingly brought them right back to where they were born. Now they are permanently embedded in the wall as gorgeous little pieces of Florida folk art.

ABOVE The masons had never done a broken-tile mosaic before, so to some degree all of us were learning as we went along.

ABOVE RIGHT I hadn't planned on the multifaceted layers of imagery, with the bromeliads' intense colors reflecting from the shiny surfaces of the tile wall.

FAR LEFT The curves in the wall express the natural arc of the human arm, and the colors in the wall were selected to accentuate those in the plants: the blue background contrasts with the bromeliads' dominant yellow color, while the bit of red tile brings out the complementary chartreuse overtones.

CENTER The spiral motif suggests the action of waves curling onto the beach.

LEFT The pointed shapes came from shadows that the bromeliads cast onto the wall, and the yellow circles were cut from cheap decorative plates bought in a local home-decorating store.

BOTTOM A local potter donated some fabulous broken fish platters, which were turned into serpentine sea creatures that swim among a naturalistic drift of seashell-shaped souvenir dishes and ashtrays.

Something that really disturbed me about Naples was its ultracleanliness. It seems people who live there obsessively leaf-blow and power-wash everything. The landscape seemed so disinfected it made my skin itch. There wasn't a natural microorganism to be found for miles around, and the base of the food chain didn't have a chance of survival. I don't think most of Florida's visitors could even begin to entertain the thought that tiny, invisible creatures actually rule the world. So when nobody was looking, I invented a giant microorganism, an imaginary hybrid between a paramecium and a bacterium, and quickly slipped it onto the wall. If I remember my high school biology correctly, paramecia have cilia and bacteria have flagella. This one has both. I'm pretty sure there's no such life form in the real world, but who cares? It's my own fantasy. I have been imagining giant microorganisms since I was a kid, and this one is at least sixty feet long, if you include the flagellum. It was my silent protest against living in a hand-sanitizer world, and it gives the microorganisms at least a symbolic presence in the garden.

As it turns out, the tile mural has become the most popular feature in the entire garden. The mosaic tile wall and the collection of bromeliads in front of it are called the Florida Sunrise Border, and the wall inspired the name for the entire Tropical Mosaic garden.

Disturbed by the ultraclean and sanitized commercial landscapes in and around Naples, Florida, I made this giant microorganism as a testimonial to the base of the food chain.

The Oval Lawn and the Fragrant Nocturnal Arbor

We gave the garden an open area at its center, the Oval Lawn, to be used as an outdoor meeting room for lectures and programmed activities. This area also gives the garden some breathing space, a bit of relief from the over-the-top abundance of plants surrounding it. Along one edge of the Oval Lawn is the administration and classroom building, where we created an arbor for displaying a collection of flowering vines. Situated across the Oval Lawn from the Florida Sunrise Border, the Fragrant Nocturnal Arbor in its simplicity offers a sharply contrasting experience. While the Florida Sunrise Border is out in the full sun, with plenty of light and air and lots of intense color, the Fragrant Nocturnal Arbor is up against the north side of the building, where the air is a bit cooler than in the rest of the garden, and the small amount of drainage that collects there means it's moister, too. Scott calls the fragrant plants "smelly things," and we've got more than a dozen taxa of nighttime smelly things aggregated into the same experience under the softly lit arbor, in the darkest and shadiest corner of the garden.

Scott pointed out the importance of places where people can gather after sunset. Tropical gardens need spots where you can relax and enjoy the coolness of the evening, when the air is heavy with the scent of night-blooming plants. In the collection of plants at the Fragrant Nocturnal Arbor, we emphasized white flowers that would glow in the moonlight, such as the fragrant moon vine (*Ipomoea alba*). In addition to white-flowering plants, the list of vines includes the Rangoon creeper (*Quisqualis indica*), with its clusters of red flowers and sweet fruity scent, and the variegated golden challis vine (*Solandra maxima* 'Variegata'), which has giant yellow cup-shaped flowers and purple stems supporting leaves edged in creamy white, and a fragrance reminiscent of coconut.

The Bismarckia Island

One side of the Oval Lawn is enclosed by the Bismarckia Island, a mound of soil capped with a cluster of silver Bismarck palms (*Bismarckia nobilis*). On the side facing the lawn, the palms are underplanted with a simple green swath of evergreen viburnums (*Viburnum obovatum* 'Whorled Class'—sometimes cultivar names are just too clever for words). This viburnum is grown mostly for its whorls of small lustrous dark green leaves and is useful up into the more temperate zones, actually hardy up to zone 9. If you think of the Oval Lawn as an open theater, the Bismarckia Island is one of its sidewalls, enclosing the central space without attracting a lot of attention to itself. We didn't want the plantings on the island to distract visitors from the programmed activities that would take place on the lawn, so we kept them quiet.

However, if you venture around to the other side of the island, you find yourself in a totally different place. A raucous collection of spiky cactuslike plants creates a strong shift in mood from one side of the island to the other. One way to create excitement in a garden, to keep visitors circulating from place to place, is to make a sequence of experiences with strongly contrasting character.

The spiky side of the Bismarckia Island features a great diversity of plants, including crown-of-thorns, various aloes, and the South African *Kalanchoe beharensis*, the fuzzy-leaved elephant ear kalanchoe. A real show-stopper is the red *Euphorbia tirucalli* 'Sticks on

ABOVE The Bismarckia Island forms one of the sidewalls of an open "theater" space, the Oval Lawn. To keep this side of the island quiet so as not to attract attention away from the programs conducted on the lawn, the palms are skirted with a simple band of *Viburnum obovatum* 'Whorled Class'.

RIGHT On the side of the Bismarckia Island away from the Oval Lawn, the pointy leaves of the palms set the theme for a collection of plants with thorns and spikes including a collection of desert rose (*Adenium* spp.), soap aloe (*Aloe maculata*), pachypodiums, and a selection of variously colored crown-of-thorns (*Euphorbia milii* Thai hybrids).

Fire', pencil cactus. Scott's choices for the Bismarckia Island satisfied the collector's urge for diversity, and by limiting the palette to thorny plants we also gave the island a strongly unifying theme. The design was enriched by Scott's choice of mulch—big chunks of Tamiami limestone, a native Florida stone filled with fossilized coral and seashells. The sharp edges of the stone nicely reinforce the spikiness of the plants.

The Fuchsia Wall

I wanted to have a fuchsia wall, since so many of Florida's plants have colors like tangerine, pink, and chartreuse, and these colors really spring to life when put up against an intensely colored backdrop. In her classic 1929 garden design book *Patio Gardens*, Helen Morganthau Fox wrote, "Painted walls add color to the gardens already glowing with bright flowers and tiles." On the use of bright colors—in this case magenta—she wrote, "Perhaps this color is so flamboyant, so rich and vibrating, that we are afraid of it, but as we outgrow our Puritan repressions we will gain courage and fearlessly use magenta."

At the Naples Botanical Garden I was surprised to find Puritan resistance to the fuchsia idea, and I couldn't understand why it was so difficult for us to sell them on it. And then one of the board members took me aside and informed me that Naples is on the west coast of Florida, and people who live on the west coast are very different from those who live on the east coast. I was told in no uncertain terms that Naples is not Miami, and the botanical garden's board members were more than a bit nervous about a having a wild and crazy bright pink wall in a somewhat conservative town. I pointed out that the Tropical Mosaic Garden was supposed to include themes from all of south Florida, east as well as west, so eventually they agreed to consider it.

We actually painted a big sample of fuchsia on the wall, and then they convened a special board meeting to decide what to do. We held up some potted plants against the swatch to demonstrate how thrilling they could be with a brilliant color as a backdrop. Scott and I told them all about Leonard Fuchs, a sixteenth-century tropical botanist and the namesake of *Fuchsia triphylla*, the widely appreciated garden fuchsia. (We refrained, however, from mentioning that Fuchs was also the first botanist to describe

Along the Fuchsia Wall, the dark yellow-green foliage of *Xanthosoma* 'Lime Zinger' (which has edible lateral tubers) stands out in stark contrast to its background, and also to the fuzzy pink flowers of macadamia nut (*Macadamia integrifolia*).

ABOVE A pineapple, *Ananas comosus* 'Ivory Coast', has creamy striped leaves and a spiky texture that mirrors the shadows cast on the wall by an overhead palm. The taro, on the right, is *Colocasia esculenta* 'Burgundy Stem', and a chartreuse sweet-potato vine covers the ground.

RIGHT The deep reds and lavenders of the fragrant granadilla (*Passiflora alata*) harmonize with the fuchsia background. The flowers are followed by edible fruits.

Cannabis sativa—we figured they were being asked to stretch far enough already.) I implored them to give the fuchsia wall a try, suggesting that we could always repaint it in another color if it didn't work out to their satisfaction. They took a deep breath and at last decided to go for it.

Right around that time Thomas Hecker joined the staff of the Naples Botanical Garden as the director of horticulture. Tom loved the fuchsia wall idea and suggested we broaden the teaching opportunities there by including tropical food plants along with the ornamentals. I agreed that would be a good idea, and Tom selected particular cultivars of economic plants that had high ornamental value and looked great against the fuchsia wall. The final planting included a passionflower with edible fruits, macadamia nuts, taro (one of the world's most common starchy staples), and pineapple.

When the garden opened to the public there was a big ceremony, with speeches and acknowledgments delivered from a podium set up on the Oval Lawn. I noticed that many of the people at the party were wearing some very bright outfits, with colors you'd expect to find more in Miami than in Naples. I stepped up to the podium and made an announcement, asking all those wearing bright colors to report to the Fuchsia Wall. I lined them all up and took a group photo, and settled once and for all the question about using fuchsia in the garden. Sometimes art can be a struggle—but if you are persistent, the rewards can be very satisfying.

Serpentine Fallen Logs "Hidden Valley"

relocate exist. fallen logs.

emphasize the landforms moving thru this valley

"Floating Gardens" on pond

circle theme:
- islands
- water lilies
- turtle

big floating 5' diam., 5 total containers - plastic pots
test: thickness of styrofoam, plant list,
what size pots to use

EIGHT
Collaboration Goes Wild: The New England Wild Flower Society's Garden in the Woods

GWEN STAUFFER wanted to shake things up a bit at the New England Wild Flower Society's Garden in the Woods. As executive director, she had been looking for innovative ways to attract attention to native plants and the value of environmental conservation, and she had hit upon a radical idea: they would stage a show of site-specific sculptures using native plants in ways that nobody had ever seen them used before. She thought that the native plant enthusiasts in and around Framingham, Massachusetts, where Garden in the Woods is located, could use something novel and different to talk about, and she wanted to attract a new audience to the garden with the Art Goes Wild exhibit.

Sketches were rudimentary for the Art Goes Wild project, with most of the designing done on site with the native materials we had at hand. These are the sketches I did for the Hidden Valley and the Floating Islands.

I had been looking for ways to take the creative potential of native plants beyond the level of abstraction we had used in Peirce's Woods at Longwood Gardens, to the level of the fine arts, so in 2006 when Gwen gave me a call I eagerly volunteered to combine my quest with hers. The national native plants movement could use a little shaking up, I thought, not just in suburban Massachusetts. I was getting tired of and impatient with all the earnest representations of natural ecosystems in gardens of native plants. Why not stretch the limits? We had nothing to lose, especially since the show would be up for just one growing season.

Spontaneity and Collaboration

During the fall and winter of 2006 to 2007, I made several trips to Garden in the Woods, collaborating with the Wild Flower Society's staff in cooking up some wild ideas. We decided on a sequence of sculptural installations situated in various locations throughout the garden: the Gathering of Grasses, the Beech

Colonnade, the Floating Islands, and the Hidden Valley, among others. In the spring they brought in a group of volunteers, and we all spent a week creating the show. One of the things I found most refreshing about the process was the lack of drawings and plans. I made nothing more than small rough sketches in a notebook, each one representing just a grain of an idea. Most of the creative work happened spontaneously, all of us working together, directly with the materials on the site.

The design for each installation was inspired by its natural setting and used live native plants along with materials harvested from native plants. Unlike most native plant landscapes, however, each clearly looked more like a work of human creativity than a work of nature. Working in collaboration with a talented staff of horticulturists, along with some very enthusiastic volunteers, I enjoyed the opportunity to blend our creative impulses and let our imaginations run wild.

A Gathering of Grasses

My own garden at home was full of spontaneous sculptural creations, and some of these inspired the installations we made at Garden in the Woods. For several years I had been experimenting with tightly bundled grasses and had distributed them here and there throughout our garden as isolated exclamation points. The Gathering of Grasses expanded on this idea, taking 325 bundles of native grasses and concentrating them in one area. The staff had collected a number of native grasses during the winter and hung them up to dry in a small barn, protected from the rain and snow. These included native bluestem (*Schizachyrium scoparium*), switch grass (*Panicum virgatum*), and eastern gamma grass (*Tripascum dactyloides*), among others.

Each bundle was made from a single grass plant by tying a string snugly around it every six or eight inches from the bottom to the top. We took these bundles to

We spent an early spring afternoon putting a troop of garden volunteers to work, and they proved adept at bundling the native grasses. Is it any wonder that grass bundles started showing up all around the neighborhood?

LEFT We took the grass bundles to the Garden of Rare and Endangered Plants and slipped each one over a spike we had driven into the ground. Photo courtesy of the New England Wild Flower Society.

BELOW The repetition of 325 grass bundles in a naturalistic drift (complete with clumps and gaps) brought a sense of unity to what had been a somewhat disorderly array of rocks and rare plants.

the rare and endangered plants section of the garden, which was a jumble of rocks that needed something to unify the overall design. I had proposed deploying the grass bundles to create a naturalistic drift pattern, hoping that the repetition of the simple vertical shapes would give the area some visual cohesiveness. I began by putting 325 little flags in the ground and rearranging them until an abstracted pattern covered the entire area. At each location we drove a small metal stake into the ground and then slipped one grass bundle down over the stake.

The Gathering of Grasses turned out to be very popular with the locals, judging from all the grass bundles that started showing up in neighbors' front yards that summer. They're easy to make. In addition to the grasses, all you need is some string and a slender metal or bamboo stake. The bundles need to stay vertical to make them most effective, so metal stakes are better for this. Simple steel reinforcing rods work well, and they are easy to find at any home improvement store.

The Beech Colonnade

The Gathering of Grasses was fun to make, and we had an even better time making bundles of big beech branches, a much more substantial material. Beeches are abundant at Garden in the Woods, and at the entrance is a naturalistic grove of young ones. This would also serve as the entrance to Art Goes Wild, so we made a formal allée of beech bundles, the Beech Colonnade. We installed eleven pairs of them, each bundle approximately ten feet tall and made with roughly seven or eight slender branches.

Since beeches are significantly sturdier than grasses, each cluster of branches needed to be tied in only two places. We used simple jute rope wrapped around several times. Unlike the grasses, which were fastened all the way up to the top to make a clean

RIGHT For the colonnade of beech bundles we first drove metal fence stakes into the ground and then hid each one inside a cluster of seven or eight slender beech branches tied together in two places. Photo courtesy of the New England Wild Flower Society.

FAR RIGHT The Beech Colonnade served as the main entrance to Art Goes Wild.

vertical line, the beeches were left open at the top so they would spread out in a canopy that arched over the pathway. These bundles were pretty heavy, so the central stake had to be more durable. We drove standard eight-foot metal fence stakes three feet into the ground and built each bundle around them. We first secured the beeches with temporary cord and cinched them tight, and then we wound the jute rope around them neatly. After the finished rope was in place we removed the temporary cord.

Placing the colonnade next to the naturalistic grove of beeches provided an interesting dialogue between the organic and the architectural—a provocative commentary on formal versus naturalistic design.

Floating Islands

My favorite sculpture was the Floating Islands. Garden in the Woods was home to a lovely pond, and I wanted an installation of floating circular forms to play off the shape of the water lilies that already grew there. The garden staff suggested we make the islands from a material typically used in wetland conservation, trays made of a recycled polymer mesh injected with a buoyant marine Styrofoam to keep them afloat. In ecological restoration work they are filled with wetland plants that improve the environmental quality of a pond system by extracting excess nitrogen and phosphorus, the prime culprits that wash in from overfertilized lawns, cause algae blooms, and spell the beginning of the end for healthy aquatic ecosystems. The wetland plants in the trays aerate the water

FAR LEFT The islands, each tethered to a concrete block on the bottom of the pond, float in a straight line that extends from the existing pier. They move gently back and forth in the breeze, as do the switch grass (*Panicum virgatum*), white turtlehead (*Chelone glabra*), rattlesnakemaster (*Eryngium aquaticum*), and sea oats (*Chasmanthium latifolium*) that grow on them.

LEFT Now permanent features at Garden in the Woods, the islands bloom in midsummer with a variety of wetland wildflowers, including cardinal flower (*Lobelia cardinalis*), marsh mallow (*Hibiscus mocheutos*), and blue lobelia (*Lobelia siphilitica*). Photo courtesy of the New England Wild Flower Society.

LEFT The islands offer four seasons of interest. In winter, a layer of ice occasionally locks them in place. Photo courtesy of the New England Wild Flower Society.

ABOVE LEFT Shortly after the islands were installed, a duck moved onto one of them, built a nest, and promptly began eating the greenery around her.

ABOVE Fortunately, her eggs hatched before she devoured their camouflage. Photo courtesy of the New England Wild Flower Society.

and provide habitat for micro- and macroorganisms, restoring balance to the natural wetland ecosystem.

Floating Island International of Shepherd, Montana, manufactured our islands, and although the company usually makes islands in irregular organic shapes, it crafted ours in perfect circles to mimic the existing water lilies. At first we considered arranging them in a naturalistic grouping, but I wanted to depart as much as possible from the organic form. We put them in a straight row extending out from the end of an existing pier. To me they looked like big floating stepping-stones, pulling your eye out across the surface of the pond. These ended up being so popular with the public that the Wild Flower Society has kept them as a permanent exhibit. Enriching the pond habitat, they offer definitive proof that art can actually improve environmental quality.

The local wildlife provided validation as well. A few days after the islands were planted with wetland species and set afloat, a duck moved onto one of them and set up a nest. Much to everyone's delight, she laid a few eggs—and then immediately began eating her habitat. The staff sent me regular photo updates by e-mail, and we were all holding our breath to see if her chicks would hatch before she'd devoured all their camouflage. One day I opened my in-box and was delighted to see a photo of the mother and her chicks swimming in the pond. To the mother duck, it didn't

matter whether the islands were placed in a straight row or mimicked a natural arrangement. What mattered most were food, shelter, and a place to hatch her eggs.

The ducks have returned every year, with four or five ducklings hatching in each nesting season.

The Hidden Valley

Connecting two sections of Garden in the Woods, the main visitor pathway crossed a lovely wooded valley that few people ever stopped to contemplate. This was a beautiful landform, with a steeply sloping ground plane playing against the strong verticals of mature trees. Gwen wanted to see what we could do to attract attention to the area, and she hit upon the idea of an installation in the spirit of land artist Andy Goldsworthy. Probably one of the most widely recognized environmental artists in practice today, Goldsworthy makes beautiful installations that fit harmoniously within a natural site while clearly showing a human-generated form. Gwen suggested we take all the fallen logs and branches from the forest floor and rearrange them in a pattern that would catch the visitor's eye. We decided to place them in a serpentine line that would curve up and down the valley's sides, drawing the eye in and among the trees. We named the installation the Hidden Valley.

I liked the idea of using materials from the immediate site, not having to import anything to create the artwork. I worked with two staff members and three volunteers, and it took us only half a day to complete the piece. The night after we finished it there was a good soaking rain, matting down the leaves on the forest floor, cleaning up the disturbance we'd made with our hands and feet and letting the serpentine line stand out with clear precision. The Hidden Valley was so well liked that it, too, has been kept as an ongoing feature at Garden in the Woods, where it is very gradually decomposing and vanishing into the forest floor.

Playing in Nature, Transforming Perceptions

In the Art Goes Wild exhibit, a community of grown-ups allowed themselves to play in nature as children often do. While we did employ some forethought and some prior discussion, for the most part the artworks were created with unfettered spontaneity and a freedom of spirit. There was an exciting synergy among the participants, with each installation displaying a level of creativity beyond what might have been expected of any one of us working alone.

We really did allow our imaginations to run wild with each installation; however, a set of simple constraints gave the overall show a sense of unity. Because the palette was limited to living native plants and materials harvested from native plants, the various pieces shared the same theme. Also, each specific installation responded directly to its immediate surroundings within the larger garden—the Beech Colonnade was adjacent to a natural grove of beeches, and the serpentine line in the Hidden Valley was made from fallen trunks and branches in its immediate vicinity. Art Goes Wild provided a dramatic illustration of how strong a design can be when creativity is allowed to flow freely within certain guidelines.

The whole exercise was more than simply playing in nature, because we used artists' principles to bring in a sense of order. While most of the artworks we created were ephemeral, we all knew that the way we perceive native plants in garden and landscape would be transformed permanently.

ABOVE In the Hidden Valley, the logs and branches that had fallen on the forest floor were rearranged in a serpentine line. Photo by Gwen Stauffer.

LEFT The line curves up and down the valley slopes, and the undulating horizontal lines play against the verticals of the trees. Photo courtesy of the New England Wild Flower Society.

NINE
Fantasy and Imagination: Enchanted Woods at Winterthur

FOR MANY YEARS Denise Magnani, Winterthur's director and curator of landscape from 1988 to 2005, had wanted to create a children's garden. In 1998 she asked me to join her and the rest of the staff in designing one. More than twenty years before, as a student, I had studied the great estate gardens of the Brandywine Valley and had written my senior thesis on Marian Coffin's plan for Delaware College, including notes on her relationships with members of the du Pont family. I was excited about the prospect of collaborating on a children's garden that would reflect the prevailing sense of place at Winterthur and in the Brandywine Valley. The garden staff had already chosen the theme: "a garden of fairies and woodland spirits." Within this rich regional context of art and landscape, fantasy and horticulture, we created Enchanted Woods.

Mushroom circles are common in fairy literature and also in the real world on the forest floor. Although the circles are usually formed by a single species, the circle shown in this painting includes one "oddball" mushroom—a situation almost any child can understand.

We wanted to make this addition to the Winterthur garden feel unique, to distinguish Enchanted Woods from the other children's gardens that were being created at that time all over the United States. Many children's gardens weren't really gardens at all; at best they were educational facilities that taught about horticulture or ecology, and at the least they were nothing more than playgrounds bearing little resemblance to the larger garden that surrounded them. We wanted to create a place where children could immerse themselves in reverie, beauty, and all the experiences both intangible and sensory that define a true garden, as well as connect to the rich legacy of design in the Winterthur garden.

I had already found Oak Hill, the site of the new garden, to be magical, and we all felt extremely fortunate to work with a site completely surrounded by Winterthur's beauty. Enchanted Woods would be in the midst of a gorgeous garden, which itself is surrounded by a magnificent estate. And then there was the regional landscape outside of Winterthur, the whole Brandywine Valley, breathtaking in its scale and beauty. If there are such things as fairies in the world (and a lot of

people believe there are), I wondered if it could be possible that some of them might live in Delaware. And if so, where would they live? I thought there was more than a good chance they'd come to live in Enchanted Woods.

A Child's Point of View

H. F. du Pont knew about the value of gardens to children and is often quoted: "I have always loved flowers and had a garden as a child . . . and if you have grown up with flowers and really seen them, you can't help but to have unconsciously absorbed an appreciation of proportion, color, detail, and material."

At my very first meeting with Winterthur staff, I asked them how much attention they wanted to give to all the research that has been published on various play activities for specific age groups. Denise looked at me quizzically and declared, "None. We want you to pretend you are eight years old." Oh boy, I thought, this is going to be easy. She later explained that she wanted the design to be informed but not driven by the research—she wanted us to make a work of expressive art that spoke directly to a child's emotions.

With the collaboration of a talented and diligent staff of professionals who kept things on track and pulled my head back down from the clouds from time to time, it became a dream of a project. I knew we would make a place where we could put into practice all the lessons I'd been learning from artists. We could completely immerse ourselves in the lore of fairies and woodland spirits, and then if we could set aside inhibition and give free rein to our imaginations, we'd have a good chance of creating a garden every bit as much a work of art as the rest of the Winterthur garden.

After our first meeting, I started wondering what all the quiet children were doing on the playground, and I wondered what kinds of spaces those kids might inhabit in their imaginations. I wrote in my journal:

> Enchanted Woods shouldn't be a running-around-on-high-octane kind of place. It should be for quiet play and reverie. It won't be completely quiet, but I'm hoping the hollering and screaming will be at a minimum. In Enchanted Woods, all the activities should focus the child on the surroundings, not the self. This will be a place to feel exhilaration and wonder, but also a sense of humility in the presence of nature.
>
> Bundles of interesting sticks galore! Squirts of water catching you by surprise! Damp, mossy places. Roots. Gnarly old roots extending down into the Underworld, black and slithery-shiny. Collect some real tree roots and have them cast in bronze. Put them out among rotting stumps. Stones that look like toadstools coming up out of the turf.
>
> A Faerie Circle of stone mushrooms, or maybe bronze.
>
> Hidden treasure, mirrors. An Inky Pool. Mosses and ferns. The Solar Spiral, out in the bright sun. Azalea Tunnels. Bird things. A Pool of Flat Stones. Different kinds of water: pools, sprays, spillways, drips. A Moon Gate. Wind chimes on bell pulls? Mobiles.
>
> Light. Movement. Joy.
> The wonder of discovery.
> Magic.

The magic of trees would certainly be part of the children's garden. Over the years I'd attended a number of lectures and workshops about the spiritual value of trees and the importance of finding ways to nurture

NINE Fantasy and Imagination: Enchanted Woods at Winterthur 235

our personal relationships with them. I remember a lecture on our spiritual connections to nature by Native American medicine woman Pa'Ris'Ha. She told us that the trees are eager for our attention.

In 1989 I was working with my colleagues at South Street Design Company to replace all of the trees along downtown Philadelphia's Benjamin Franklin Parkway. We'd been visiting nurseries in the rural areas outside of Philadelphia to select and tag hundreds of trees. I felt uncertain about taking them from

To help myself think about the garden from a child's point of view, I collaged various ideas and images in a series of "mood studies," including one with a lounging fairy, a mushroom, and the back of a chair from one of Winterthur's garden terraces.

TOP I began the design process by surveying the history of magic, sketching a collection of magical symbols. While this exercise generated very few images that were used directly in the design for Enchanted Woods, it did get the creative juices flowing in a good direction.

ABOVE I gave Luna, the ancient Greek and Roman goddess of the moon, the wings of a modern-day luna moth.

their beautiful surroundings and sending them to live in such a harsh urban environment. At a workshop I met Ute medicine man Joseph Rael, Beautiful Painted Arrow, and shared my concern. "The trees seek out landscape architects," he told me, "to help them bring their healing energy to people in the city." He asked if I could consider the possibility that the trees were actually selecting me. When tagging trees, he suggested, I should gently rest my hand on the trunk of each one and simply ask its permission. He assured me I would never feel refused by them.

And I never have.

"Trees are great" had been my motto for more than twenty years. With the site for Enchanted Woods nestled beneath a canopy of huge old forest trees, this would be a place where all those teachings could be put to good use, and the site on Oak Hill was small enough that it would be possible for me to get to know every tree.

Our Creation Myth

Du Pont loved decorative objects, artifacts, and antiques so much, it seems he never threw anything away. At some point during the design process, one of the garden staff told me about an old dump heap, out in the woods not far from the garden, where there was a pile of broken statuary and architectural ornaments. It was high summer when he took me there, and we found it buried beneath a dense covering of Virginia creeper vines. Rather than dig my way through the leaves, I waited until winter when the vines were naked and I could see beneath them more easily, and I found a fabulous treasure trove of artifacts. I sorted, measured, and sketched them all, thinking about how we might use them in the children's garden. Although I did photograph them, once again the act of drawing was much more useful. Spending time looking carefully at each object presented the opportunity for them to sink into my own creative unconscious,

H. F. du Pont never threw anything away, so we had access to a stockpile of broken architectural and garden ornaments.

to mix in with all the other ideas we were developing for the garden. All the sketches and photos went into a catalog of treasures that we could use in Enchanted Woods.

The theme of fairies and woodland spirits was compelling, and it connected well with the history of the Brandywine Valley, especially the Brandywine school tradition of illustrating children's literature, which is always full of adventure and fantasy. But I wasn't convinced that the fairy theme was connected specifically enough to the existing estate and garden, and I was worried that it might prove difficult to create a design in the Winterthur spirit that would also be attractive to children. The Winterthur experience was all about a bucolic rural landscape, a fine garden, and a distinctive collection of American antiques. Adults loved it, but too many children found the whole thing boring.

On Oak Hill there had once been a swing set, back when H. F. du Pont's children were young and played in the garden. Inspired by this history, Brian Phiel, the gardener who would eventually be caring for Enchanted Woods, invented a creation myth for the project. I remember him telling his story to all of us at a staff meeting with the enthusiasm of a child. And this wouldn't be the last time on the project that we'd find a full-grown adult acting like a little kid. Each one of us would have what I called an "eight-year-old moment" at one point or another, and some of us didn't seem to be able to stop having them. It was part of the magic we all experienced in making Enchanted Woods.

As Brian's story goes, there once was a time at Winterthur when the fairies played with the du Pont children, happy and contented beneath the trees on Oak Hill. But then the children grew up and moved away, and the Winterthur estate became home to a museum of antiques and a collection of plants. Most kids didn't care about decorative arts, and they certainly were not interested in the highest levels of professional horticultural and garden design. So children stopped playing in the Winterthur garden, and the fairies were sad and lonely. Then one day, the fairies found a pile of old broken statues and garden ornaments, and they came up with a brilliant idea. They enchanted all these pieces and levitated them into the air, flying them across the estate to Oak Hill, where they wove them into a fantastical garden meant to attract the children back to Winterthur.

We'd found our connection between fairies and the Winterthur garden, and it really did bring the children back to Winterthur.

Finding the Fairy World

Right around the time Brian conceived our creation myth, there was a show of Victorian fairy paintings at the Frick Collection in New York. Because fantasy illustration had always been a part of Brandywine Valley culture and because fairies were our theme, I went to the Frick seeking inspiration. What I found was a wealth of imagery illustrating the lives of fairies, elves, and gnomes. These were tiny paintings, hardly bigger than postcards yet meticulously detailed. They looked like they'd been painted using brushes with maybe four or five bristles. Many of them showed fairies dancing and singing, but not all of these sprites were so friendly. Some were doing mean and nasty things like hunting down mice with thorny sticks.

At the entrance to the gallery was a basket of magnifying lenses, the big round ones that a detective like Sherlock Holmes would use, and I was amused to see all these serious art lovers hunched up against the walls, peering at miniature paintings as if they

were forensics experts looking for fingerprints. Several paintings showed fairy cottages, so I knew we'd need one of those in Enchanted Woods. I was particularly attracted to a painting of the king and queen of the fairies sitting inside a hummingbird's nest. This painting even had a frame made of woven, gilded sticks. As soon as I laid eyes on it I knew we had to have a fairies' nest in Enchanted Woods, and although we couldn't shrink the kids to the size of hummingbirds, I thought maybe we could make a nest big enough for the kids to go inside and pretend.

At that time, I didn't have any idea that a hummingbird's nest figured in H. F. du Pont's childhood, forming part of his early passion for Winterthur. But then in Denise Magnani's book *The Winterthur Garden: Henry Francis du Pont's Romance with the Land*, I read:

> When Harry (H. F.) du Pont was eighty-two years old, an interviewer asked him about the source of his love for Winterthur. His answer was an evocative image called up from a childhood idyll: "We had a big oak tree in front of the house. It's not there any longer and I remember the time I found a hummingbird's nest on a branch. It was quite near the ground, of course—a big branch and a little bit of a thing."

Enchanted Woods was to be a garden for children beneath a grove of giant oak trees, and it was affirming to read that H. F. du Pont had been so profoundly influenced as a child by a tiny hummingbird nest in a big oak tree. This was only the first of much magical serendipity to unfold.

I knew I'd need to do many different kinds of drawing and creating all at once, and I let all the ideas mingle without editing anything too fast. Now obsessed with fairies, I scoured the grounds at Winterthur on an imaginary fairy hunt. I wandered around the garden, pretending to find them beneath the beautyberries and winterhazels, sketching whatever my imagination brought to my attention. I made studies of the gates, seats, and architectural details already in the garden, blending them in with the fairy sketches that were beginning to show up in my sketchbooks.

I studied the history of magical symbols, finding ideas and imagery to use in Enchanted Woods. I read classical fairy tales, always sketching and painting so the stories would enter into my unconscious mind. A strong mood began to emerge, one of levity and playfulness but with a dark underside. I learned about whimsy and delight, but I also discovered the darker side of magic and mythology. The old fairy tales were filled with horror and grotesquerie. The Brothers Grimm were, well, grim. I wanted to keep the darkness to a minor theme, but along with the birds and butterflies I made room for toads and snakes. Beneath the bright colors and lights of blooming flowers, there would be a dark place where a fungus oozed from a rotting stump. Even though Enchanted Woods was to be a place of gaiety and sparkling playfulness, I knew we'd have to put a little bit of scariness in there for balance—we certainly didn't want to risk the fairies doing it for us.

As a designer, my main pleasure is creating places that vibrate with the joy of nature. The very life force that fuels creation is the energy of delight. There's nothing more joyful than a flower unfolding, nothing more hopeful than the sprouting of a seed. But the creation of new life does require death—the decomposition of dead things makes rich, nutritious soil that supports the living ones. Decay is a necessary ingredient in rebirth. Anyone who has spent even a little time

in the woods knows about this ongoing cycle of life. Robert Frost knew it, and I've always loved his poem "In Hardwood Groves," where he describes the cycle of birth, death, and decay in the native forest. After the leaves have fallen from the trees, he says, "They must go down into the dark decayed." There, they are "pierced by flowers" and feed the growth of new plants.

For me, painting and drawing is a way to get immersed in a particular theme or mood, and the design process for Enchanted Woods was no exception. I did a whole suite of paintings focusing on fairies and the things in their world, and the more I painted, the more connected I felt to the magic that lives within the forest, the magic expressed in the imaginary world of woodland spirits. Studying the history of fairy literature was a helpful jumping-off place, but I also wanted to bring fairy culture up to date, to make it more relevant for kids today. One day, the "extreme fairies" showed up in my painting studio. They soared through the sky on skateboards made of leaves, flying high above the fields and forests of the Winterthur estate.

As I immersed myself in hunting for fairies at Winterthur, I imagined finding them in flowers. My "extreme fairies" wore T-shirts and baggy jeans, and soared through the air on skateboards made of leaves.

Playing with Fantasy

Eventually Enchanted Woods began to really get a grip on me, and I couldn't stop thinking about it. I began to feel like it was designing itself in my head when I wasn't even paying attention. Some of the best ideas were the ones that seemed to appear as I was sleeping. In the mornings I'd go right to the studio and start sketching to see what the fairy spirits inside my head had been working on all night long.

During the time I was working on the design for Enchanted Woods, I was also taking a printmaking class at the Pennsylvania Academy of Fine Arts, working with fantasy images in a medium that was new to me: monoprinting. In this process, water-based inks are painted onto a simple Plexiglas plate. A piece of paper is laid on top and then they're sent through a printing press together. The process makes only one image, and then you can put more paint on the plastic plate and send it through again with a fresh sheet of paper. Serendipity and accident are a big part of this process, so there's none of the perfectionism required for other kinds of prints such as etchings or lithographs.

Always a fan of collage as a spontaneous medium, I started taking shapes cut from paper, collaging them onto the Plexiglas plates, then painting over them and removing the shapes to reveal a void that didn't have any color. Then I'd fill in that void with other colors, and while the paint was still wet I'd blot it with textured paper to create patterns. Even a cheap paper towel made an interesting pattern. I bought some little cutout metal shapes at a craft store—stars, moons, carrots, trees, a beehive, tiny houses, a picket fence. These got collaged onto the plates, too. I made a whole sequence of prints, not thinking too much, just throwing on some color, printing the plate, and then collaging again. After I'd made a number of prints, I laid them on a table and started shuffling them around until they suggested a story. What eventually emerged was "Carrot Moon," a poem-story about a mythical adventure in the night.

Carrot Moon.

In the blur of twilight, out in the garden,
 I spied an awakening moon
 silhouetting Grandmother's teapot
 holding secrets on the windowsill.

She'd call it a Carrot Moon,
 the moon of roots lengthening.
 "Beehive gets to buzzin' in the night," she told me.
 "Carrot Moon's gonna fall."

Deep dark night wind
 shook the houses and the trees.
 "Go to the forest," Grandmother said.
 "You got to catch her and put her back into the sky."

First a star fell, a big one,
 and then fell Carrot Moon.
 I caught her in my hand,
 held her gently for just a moment.

She leapt from my hand
 and flew back into the sky
 up above the deepest ancient woods.
 There in the warmth of a predawn glow,
 she slept again.

Carrot Moon.

I was playing with fantasy in our garden at home, too. Late in the fall season, the Pumpkin Girls appeared and started having their own adventures,

ABOVE "She'd call it a Carrot Moon,/the moon of roots lengthening."

LEFT "She leapt from my hand/and flew back into the sky/up above the deepest ancient woods."

working their magic all around them. I picked these up at the craft store the same day I bought the little cutouts for my printmaking class. They were four little half-dolls, just torsos with arms and heads, attached to wooden picks. I wrapped some little purple organza sashes around their waists and stuck them in a pumpkin, facing each other in a circle around the top. Then I set the pumpkin in a perennial border near the house.

One day a hard freeze turned their pumpkin into mush. Then they were attacked in the night by a wild animal. In the morning I found the Pumpkin Girls—along with mashed pumpkin flesh—scattered all over the garden bed. It was carnage. But the Pumpkin Girls were hardier than the pumpkin, and they survived the attack. I scooped them up and put them in a bubble bath out in the garden, in some good sudsy water in a mixing bowl from the kitchen. And then they were ready for their next adventure.

My friends were fairly forgiving about the Pumpkin Girls right up until the bubble bath. Until then they figured, hey, he's working on a fairy garden. He's doing some research, so let's cut him some slack. But the bubble bath seemed to push them over the edge, and they began to worry about my sanity. I didn't care. Enchanted Woods had pulled me into another world, and I intended to stay there until the garden was completed.

Making Choices

The overall plan for Enchanted Woods was coming together in a process similar to how "Carrot Moon" came to be. Without getting caught up in the practicalities of how to actually build anything, we stayed as

The Pumpkin Girls came from the craft store one day, and I inserted them into a pumpkin and placed it in a perennial border near the house.

I found them more than a bit disheveled after a hard freeze and a visit from a raccoon.

NINE Fantasy and Imagination: Enchanted Woods at Winterthur 243

long as we could in the world of fantasy, dreaming up whimsical ideas to keep the creative juices freely flowing. But eventually it came time to stop fooling around with ideas and make some choices about which ones would be in the final design. I met with the Winterthur staff to make some decisions.

Some of my favorite design ideas were rejected, but I didn't mind too much—that's just part of the process. I figure if you don't generate more ideas than you can use, you're not working hard enough. Still, there were a couple of ideas I had a hard time letting go of. The Fountain Mask, which would have had water squirting out of every possible orifice in a timed sequence, was one of them. The Winterthur staff didn't share my attachment to this guy, so he didn't make it into the final design.

And how could my Narcissus Pool have been rejected? Narcissus is the beautiful young man from Greek mythology who falls in love with his own reflection in a pool; in one version of the story, he eventually tumbles in and drowns. The flower *Narcissus* was named for him, and it has an important place in Winterthur's history, with big drifts of daffodils among the first of H. F. du Pont's plantings in the garden. The Narcissus Pool was designed as a quiet reflecting pool with

After a bubble bath, they were ready for their next adventure.

If you don't generate more ideas than you can use, you're not working hard enough. The Fountain Mask would have had water squirting out of every possible orifice, but this idea ended up on the shelf.

244 PART 2 Designing the Artful Garden

The idea for the Narcissus Pool included a daffodil-shaped stone where you could kneel while gazing at your reflection in the water. But this idea will have to wait for another garden.

a stone coping, including a giant daffodil-shaped stone that you could kneel on while gazing at your reflection in the water. Like the Fountain Mask, it's going to have to wait until another garden, another time.

We had made our choices about which features to put into the final design, and now it was my job to weave them all together into an overall plan. I knew that there was a comprehensive image of what this garden was to become stored up in my head somewhere. It had been forming itself gradually over time, starting to gel, and now it was going to reveal itself. The garden of fairies and woodland spirits was beginning to knit itself together inside my imagination. Now I had to find a way to bring the whole vision into a form that others could see, too.

Finally, a Master Plan

It was time to bring the whole thing together into a unified garden plan, but I found it difficult to sit myself down and start drafting one. I kept getting distracted by other creative pursuits, and days went by with zero progress. The days turned into weeks. I wrote in my journal:

> I'm in high painting-production mode, just when I need to be in high garden-design-production mode. I must, must, must start some serious work on drawing up the Enchanted Woods master plan. Oh, I'm working on it all the time—talking with staff about it, thinking about it, visiting it in my dreams. I have no shortage of attention for Enchanted Woods. It's everything to me right now. But I've got too many distractions, and I've got to produce an actual plan for the garden. Soon.

NINE Fantasy and Imagination: Enchanted Woods at Winterthur 245

A trip to the U.S. National Gallery in Washington DC furnished ideas and images for fantasy paintings, but I had to get myself out of the fantasy-painting world and start drafting a master plan for Enchanted Woods.

Finally, I remembered a lesson I'd learned from artists: drawings are only lines on paper. If you don't like what you've drawn, toss it away and draw again. All you have to do is get out some pencils and tracing paper, start the process, and one thing will follow another. Almost immediately, the pressure of producing a final plan was lifted, and I began to draft a preliminary one. It helped to think that rather than making a finished design, all I was really doing was making a map of our ideas. Once I started mapping, I could begin to imagine Enchanted Woods from the aerial view. I spent an afternoon and evening sketching a plan, throwing the sketch away, and sketching again. The next day I wrote in my journal: "There is something inherently satisfying about map making. Last night I sat down and sketched out a plan for Enchanted Woods. It ended up looking not so much like the plan of a garden as a close-up view of the innards of fruits."

Even when a final plan is being drawn, the design process can continue. New ideas can emerge even as you finalize the overall design. I find that the creativity

continues to flow if you let the drawing take on its own particular character—one that reflects the essential spirit of the place you are imagining. I knew that Enchanted Woods would be largely green but also alive with color and full of wiggles and squiggles, so the drawing remained somewhat cacophonous, pulsating with the energy of life, and it kept some of the playful energy of the previous sketch with all the fruits. Once the overall plan was in place, I met with Winterthur staff and we made a few adjustments, refining and improving the relationships between one space and another. Having spent so much of their lives working in the Winterthur garden, the staff had an inherent sense of how to make Enchanted Woods fit within its setting, within the prevailing sense of place.

The overall design for Enchanted Woods followed the principles so meticulously recorded in the writings of H. F. du Pont, as well as those evident in the Winterthur garden itself. The first guiding principle was spatial progression, each destination leading seamlessly into the next. There would be no primary colors or unnatural materials. There would be no interpretive or educational display panels to read, no directional signage more intrusive than the small white arrows du Pont had used to guide his guests through the Winterthur garden. We wouldn't enclose Enchanted Woods with fences but would make subtle transitions to the neighboring sections of the larger garden, except along one boundary where a safety fence would be required to separate the woods from the Garden Drive where the tram tour passes by.

The master plan for Enchanted Woods included many separate destinations, all woven into one garden experience.

The design evolved as a sequence of many small destinations, each inspired by a different story or image from fairy literature and from the world of magic. But there are no specific fairy tales told in Enchanted Woods. The point of the whole thing is for kids to invent their own stories, to inspire their imaginations to take them wherever they might choose to go, not just to Jack and the Beanstalk, or Cinderella, but to stories they make up on their own. Adults call it reverie when they give free rein to their creative selves. Kids call it make-believe. It's the same thing.

The Bird's Nest

Even with the master plan completed, there was still a lot of designing left to do. We entered that magical time where everything gets named—every single imaginable detail has to be described. The Bird's Nest was no longer just a fanciful idea from a painting at the Frick Collection but a real feature. Technical drawings and written specifications had to be prepared to direct a contractor in how to build it. The frame was to be made of powder-coated stainless steel of a certain cross-section and gauge, and of a particular color. The concrete foundation had to be made a certain way. The floor and the access ramp had to be designed in very specific detail.

But before that, I went out to the site with Brian Phiel and with Randy Fisher, who at that time was Winterthur's staff arborist, to make a full-scale mockup, a test nest. Jim Smith, a lifelong horticulturist at Winterthur who simply knows how to get things done, joined us. We drove metal reinforcing rods into the ground in a circle, and we wove sticks and vines through them. We wanted to be sure before committing to a final design that we had the perfect diameter, the perfect height and slope to the walls, and the

ABOVE Enchanted Woods has a wheelchair-accessible Bird's Nest. Randy Fisher used his chain saw carving bit to make some wooden eggs.

RIGHT The Bird's Nest has permanent steel uprights, and every two years Winterthur's arborist, John Salata, reweaves the sides with beech branches and vines.

NINE Fantasy and Imagination: Enchanted Woods at Winterthur 249

perfect spacing for weaving in and out between the upright stakes. We knew we'd need a structural engineer—in fact, we were about to interact with engineers of many different kinds.

The Bird's Nest has a permanent structure of steel upright spokes surrounding a wooden floor, elevated above the ground on a central steel pole, two-and-a-half feet above the surrounding grade. There's an entrance ramp leading up through the azaleas that surround it, accessible to wheelchairs and baby strollers. Every two years Winterthur's arborist cuts fresh, pliable beech branches and weaves them through the spokes, augmenting them with vines and other woody plants. To use the terminology of basket making, it has a metal warp and a beech-branch weft. I don't know of any arborist-training programs that offer instruction in basketry—arborists tend to be too macho for that—but Winterthur's arborist has become an expert on nest weaving.

The Bird's Nest is one of the features most central to the Enchanted Woods story. It's a tribute to H. F. du Pont's childhood encounter with the hummingbird nest in the giant oak tree, which he credited as the source of his love for Winterthur.

The Tulip Tree House

The University of Delaware's library has a fine collection of historical works on garden architecture, and I spent some time there studying eighteenth- and nineteenth-century garden ornaments and looking for inspiration for Enchanted Woods. I came across an image of a garden pavilion designed to look like an old hollow tree, and I thought it would be fun to make a small house out of a real hollow tree. But where would we find one? Two weeks later, Randy Fisher asked if I had any use for a hollow tree. I was floored. He took me out to an open field on the outskirts of the estate and showed me a giant old tulip popular that had been struck by lightning many years before. It had become dangerously hollow and had to be taken down. I couldn't believe our good fortune.

Randy removed the top of the tree and then carefully cut off the lower section at the ground. It was lifted with a crane onto a flatbed truck and transported across the estate to a barn. With the carving bit on his chain saw, Randy removed all the rotted wood from the tree's interior.

Meanwhile, I started sketching, figuring out how to turn this into a little fairy house. The tree was six feet around at its base, and it had two open archways in it, one of which I thought would be good for a window and the other for a door. It also had one strange

A very old hollow tulip tree had to be cut down, so we had the opportunity to use it in Enchanted Woods.

Hollow Tulip Tree - Study for Doors + Windows
WGsmith 7/22/99

TOP LEFT A color sketch showed how the Tulip Tree House might look in its final setting.

FAR LEFT I designed a door and a window to fit the tree's cavities.

LEFT A painting by elementary school student Compton Little, *Dancing with the Flowers in Enchanted Woods*, shows the Tulip Tree House surrounded by flowers.

ABOVE I love it when the final result looks exactly like the drawings. In the foreground is a gateway made from two stone console brackets matching those on the Winterthur Museum's windows.

little eyeball hole above the door opening. I designed a simple wooden door to fit the irregular shape of the opening, and a rustic metal grate for the window. A thatched roof sounded like fun, but I discarded that idea because there was no local thatching trade and someone would have to be brought in from far away every time the roof needed repair. However, the Winterthur team lobbied hard for a thatched roof, and then they actually found a local thatcher—an Irishman who lived on a farm not fifty miles away, where he even grew his own Irish thatching straw. So in the end, the Tulip Tree House got its thatched roof after all.

Be Careful What You Wish For

Once we had settled on the basic master plan for Enchanted Woods, we brought in a team of architects and engineers to help us figure out how to build everything. We had structural engineers to make sure things wouldn't fall down, electrical and plumbing engineers to lay out the power and water lines, and civil engineers and surveyors for grading and drainage. The architects advised on the built elements and put together the final construction drawings and specifications. This was turning into a complex project that would require many different trades and craftspeople, including stone carvers and masons, woodworkers, metalworkers, furniture makers, lighting specialists—the list went on and on. To get all the consultants on board with the project, I took the whole team out to Oak Hill and showed them around the site.

I had placed markers on the ground to show the intended location for each feature, and we visited them one by one to discuss what kind of technical support each one would need. These guys were serious engineers, all men. I explained that this was to be a garden that looked like it had been designed by fairies and woodland spirits. "And you, gentlemen," I told them, "are the fairies." I was trying to break the ice, but it just made them all look nervous. When we got to the place where the Forbidden Fairy Ring would be, I asked to see a show of hands of those who had engineered a fairy ring before. No one moved. "Okay," I said, "I see we're dealing with a bunch of rookies here."

They laughed a little. The ice was being broken. A little.

We were on the edge of the site near Garden Lane, where the tram tour passes by, and I was concerned about children running out onto the road. We didn't want to have any fences in Enchanted Woods, in keeping with H. F. du Pont's design principle of each section of the garden blending into the next without interruption, but we needed one here for safety. Since the hollow tree had come along, we were beginning to suspect that there might really be fairies helping us with this project, so I looked up and spoke into the tops of the oak trees.

"Fairies? We need some fencing right here, okay? And a gate, twenty-two feet wide."

The engineers exchanged worried looks, and I felt the ice begin to close over again. Oh well, I figured, sooner or later they'll understand what's going on around here. Not two weeks later I was rooting around in one of the barns out on the estate, and I saw some old doors leaning up against a wall. I began to move them out into the middle of the room to see if they might be something we could use in Enchanted Woods. Behind them I found a stack of antique metal hairpin fencing—including a gate exactly twenty-two

feet wide. I had learned by then that when you ask the fairies for something, it pays to be as specific as possible.

We placed an old stone wishing well in the center of Enchanted Woods, and on the granite plinth that supports the well the masons carved what had become our motto: "Be careful what you wish for."

S-s-s-serpentine Path

The main walkway into Enchanted Woods is the S-s-s-serpentine Path, with a friendly snake worked into the paving pattern. The serpent may be one of the most potent mythological figures in human history, but it's also a much-loved figure from my own childhood. I've been drawing pictures of the friendly snake since I was a little kid, when I was the proud owner of an imaginary farm with all kinds of animals that lived in circus wagons. Some were ordinary farm animals like cows, chickens, and pigs, but there were also lions, bears, and giraffes—as well as big colorful snakes. I played a game with my family where I would recite all the different animal names, one by one, and

The S-s-s-serpentine Path was made in the likeness of the imaginary friendly snake from my own childhood.

eventually I'd say "Snakes!" Everyone would scream because snakes are so scary, but then I'd rush to add, "But mine are friendly snakes." In a way, the S-s-s-serpentine Path is my personal signature in Enchanted Woods, a gift from my own childhood fantasy world.

The Gathering Green

In the middle of Enchanted Woods is a circular lawn called the Gathering Green, surrounded by swinging benches, with a maypole in the middle. It is enclosed by banks of hydrangeas and encircled with redbud trees, which recall the plantings in other areas of the Winterthur garden and help to connect Enchanted Woods with its surroundings. More than any other design element, the planting recommendations made by Winterthur's assistant director of horticulture, Linda Eirhart, make Enchanted Woods feel like the rest of the Winterthur garden.

NINE Fantasy and Imagination: Enchanted Woods at Winterthur 255

A wisteria arbor from H. F. du Pont's mother's rose garden (also known as the Sunken Garden) had been dismantled and put into storage in the 1960s when an addition was built onto the museum. The arbor's classical cast-concrete columns, along with two ornate cast-concrete benches also in storage, were ours to use in Enchanted Woods. While six of the columns from Mrs. du Pont's wisteria arbor went to another location, the rest went to the Gathering Green as supports for the swinging benches. I had seen a photo of a bench swinging between two granite posts in Polly Hill's garden (now the Polly Hill Arboretum) on Martha's Vineyard, and I'd always wanted to put one of these into a garden. Now the Gathering Green is surrounded by five of them.

Kids from a nearby school perform a maypole dance on the Gathering Green every year when Winterthur hosts its Enchanted Summer Day, which is on

The Gathering Green is the centerpiece of Enchanted Woods. Encircled by banks of hybrid hydrangea 'Preziosa' and native redbud trees, it has strong horticultural ties to the surrounding Winterthur garden.

256 PART 2 Designing the Artful Garden

or near Father's Day, although I like to think it's on the summer solstice. The top of the maypole has a rotating finial where the ribbons for the maypole dance are attached. It's an ornate little object, and on the design sketch it's called a floral sunburst hook attachment. In history, the maypole symbolizes the male generative force in nature, and the wriggling lines moving out from the center of the finial bring the energy of renewal to the garden.

Joe Swarter was the metalworker who fabricated a number of details for Enchanted Woods, and he made the floral sunburst for the maypole. In Wilmington, where metalworkers spend much of their time repairing fire escapes or fabricating security grates to bolt over windows, there is little opportunity for fine craftsmanship and detail. One day I was meeting with Joe in his shop, and he was running the last few specifics by me, eager to start building the thing. "Oh boy," he said, "I'm looking forward to making this. It's like a toy!"

ABOVE When Winterthur's Sunken Garden was dismantled in the 1960s, the wisteria arbor's columns were placed in storage, where they remained until we retrieved them for reuse in Enchanted Woods. Now they support the swinging benches that surround the Gathering Green.

RIGHT Quite a few of the decorative artifacts we had at our disposal were used in the Faerie Cottage, as shown in this design study for one of the interior walls.

The Faerie Cottage

The Faerie Cottage is at the center of Enchanted Woods, adjacent to the Gathering Green. The University of Delaware's rare book collection again provided inspiration, and I started to design a cottage "folly" for Enchanted Woods. We made it look like a ruin that the fairies had fixed up for the children, and this became a prime opportunity to integrate many of the broken garden ornaments we'd found piled up in the woods, along with the ornate benches from Mrs. du Pont's wisteria arbor. An arm was broken on one of them, so I had the masons embed that end of the bench in one of the walls. And of course, now that we had our own thatcher, I knew what material we'd use in making the roof.

The stonemasons were great fun to work with. The foreman was Italian, and his son was the apprentice. There's a long history of Italian stonemasons working in the Brandywine Valley, including at Winterthur. They pride themselves on the high quality of their work, their skill in getting stones to line up with great precision. But for the Faerie Cottage I wanted them to make the stones all crazy and sticking out at strange angles, as unskilled fairies might do. The foreman had a hard time forcing himself to follow the fairy aesthetic, but his son was eager to break the rules. Several mornings in a row I came in and found the masonry all neat and clean, and I asked the masons to go back and yank this or that stone out of alignment. Then one day I came in to find the apprentice calling

the shots. The foreman took me aside and proudly gestured toward his son.

"My son's in charge of this job now," he said.

I went over to talk to him. "Hey," I said, "I hear you get to be the boss."

"Yeah," he said, "on this job I get to use my creativity. Usually I'm just putting up one stone after the other, and they're all the same. Here, I get to choose every stone individually—a big one, a small one, a light one, a dark one—whatever I want."

This was exactly the spirit we wanted to encourage in Enchanted Woods. The son could provide the whimsy, while his dad would make sure each stone was secure and that the whole thing was structurally sound. I was particularly concerned about how the broken ornaments were placed around the fireplace, and I made a sketch that showed a very specific arrangement. The son told me to place the stones down on the ground exactly how I wanted them in the walls, and he'd just pick them up and put them into place. I was in masonry heaven.

The finished stonework is inspiring to the imagination. The Winterthur staff told me that one small boy who regularly visits Enchanted Woods goes each time to the Faerie Cottage to push on every stone, certain that one of them will be the key that unlocks a secret passage. That idea never crossed my mind as I was designing the Faerie Cottage, but it is a delightful example of the kind of imaginative play we hoped to encourage in Enchanted Woods.

After the masons had finished the stonework, it was time to lay the pavers on the floor of the Faerie Cottage. I'd designed a "hearth rug" for the area in front of the fireplace, a giant acorn made from variously

RIGHT The stonemasons asked me to arrange the pieces on the lawn just as I wanted them to appear around the fireplace.

FAR RIGHT The masons were true collaborators, placing the various components where I suggested but adjusting their locations so the whole thing would be structurally sound. Photo by Jeannette Lindvig.

NINE Fantasy and Imagination: Enchanted Woods at Winterthur 259

colored concrete pavers. This required a trade different from stonework, so a new craftsman was added to the cast of characters. Unlike the walls of the Faerie Cottage, the hearth rug required meticulous care to create the acorn exactly as it was designed. It turned out the concrete-paver mason was just right for the job. He brought a range of red, brown, and tan pavers to the site and asked me to direct the placement of every piece. I was amazed.

"Are you out of your mind?" I asked. "Do you really want me hanging over every single paver?"

"That's the way to get it done right," he said. "You bring the beer or whatever you need to get us through it."

It was another peak moment in Enchanted Woods. Here's a passage from my journal about laying the hearth rug:

> I was in the Faerie Cottage yesterday when the acorn paver guy was smitten with his moment of Enchanted Woods magic. He'd spent about five hours crouched over a five-by-eight-foot rectangle and had laid about eighty percent of the mosaic. Suddenly, the image of a giant

ABOVE In the Faerie Cottage, architectural artifacts from the Winterthur estate are embedded within fairy-style masonry, with stones sticking out at crazy angles.

RIGHT A big sweep of azaleas (*Rhododendron kaempferi*) makes a visual connection between the Faerie Cottage and other places at Winterthur. Photo by Jeannette Lindvig.

acorn was taking shape, emerging from the floor. He sat back on his heels and smiled.

He spread out his arms and said, "I get it. It's like this house is lived in by someone really important, like the King, and this acorn is his symbol, and it's on the flags and banners that he carries into combat."

"You got it," I agreed. "That's exactly right."

He had just the right body language—arms wide, chest high, heart opened up. The body knows. It's the expansiveness you feel when you know you are in just the right place at just the right time. It's how it feels to be really in a groove, when the creativity flows out from you and is fully welcomed into the world.

The floor of the Faerie Cottage has a "hearth rug" of cast concrete pavers arranged in an acorn motif, as shown in this design study.

The Fairy Flower Labyrinth

The Fairy Flower Labyrinth was made with off-the-shelf concrete stepping-stones, simple twelve-inch squares. Twenty-two of them were customized with fairy flower images etched into the surface. Flowers and plants are important symbols in fairy stories throughout history. The nodding heads of bluebells, for example, symbolize humility and gratitude. The five-petaled flower of the rowan (known in the United States as mountain ash) forms a pentagram, a symbol of protection against black magic. Oaks symbolize strength and durability, while lily-of-the-valley represents sweetness and light. The apple also figures prominently in fairy stories. The fruit is an object of enchantment, and the stories warn that those who linger too long beneath an apple tree could be carried away to fairyland.

Other stones in the Fairy Flower Labyrinth carry the text adapted from a popular Navajo meditation:

> In beauty may I walk
> With beauty before me
> With beauty behind me
> With beauty above me
> With beauty all around me
> May I walk.

The labyrinth has a classical seven-circuit design with a single unicursal path winding back and forth from the edge to the center and then back out again. This ancient graphic form occurs in many places around the world, including Great Britain, Egypt, India, Afghanistan, and the American Southwest. It is found embedded on the ground, etched into the walls of caves, and imprinted on coins.

The labyrinth in Enchanted Woods includes 750 stepping-stones all together, and the fairy flower

stones are spaced so that they fall on every thirteenth stone as you walk the path. Thirteen is considered by some to be an unlucky number, but in some cultures it is the opposite. It figures in many rituals and acts of magic, and it is at age thirteen that a child becomes a teenager. In Enchanted Woods I've seen some people walking the labyrinth in silent meditation and others running through it with gay abandon.

The Fairy Flower Labyrinth is a place for meditative walking or for dancing with the fairies.

The Story Stones

In 1967, H. F. du Pont acquired a collection of historic stone artifacts from a Long Island estate called Hobby Stones. In his 1968 gardens report, Gordon Tyrrell, then the director of the Winterthur garden, wrote:

> Thanks to the kindness of Mrs. H. H. Brown, Hampton Bays, New York, we were the recipients of some twenty-five stones. Utilitarian stones, such as skate stones, mill stones, sinks, well heads, and grind stones. All of which had been collected by her husband and were in the garden at Hampton Bays. Negotiations had been going on for quite a while for these stones, and at long last we were given them in December. A great deal of work was involved. To go up to Long Island, dig, load, and transport these stones back into the garden here.

When we began designing Enchanted Woods, these stones were being stored in one of the farmyards out in the estate, and they were available for our use. We knew where almost every stone had come from and had some idea of what its original purpose had been, so each one had a particular story to tell. My Corn Heart collaborator Annie Hawkins had taught me the value of narrative in the landscape, so it made sense to create a storytelling space with them in Enchanted Woods. We arranged them in a sculptural spiral, and

I measured and drew to scale each of the story stones, and then made a small sketch of each one to suggest how it might be integrated into the overall design.

on some of them we engraved passages from literature. One of my favorites was from Shakespeare: "Tongues in trees, books in running brooks, sermons in stones, and good in everything." From the popular nursery rhyme, and also the title of a Lewis Carroll poem, we have "Life is but a dream," each word etched into a broken piece of curving limestone that must have once been joined into a circle. We wanted them to be at the midpoint of the spiral, with the world "dream" at very center of the whole thing. However, the words were accidentally carved upside down and because the stones were curved a certain way, the resulting quotation reads, "Dream a but is life"—which doesn't make any sense, but somehow I like it even better.

I always try to program layers of meaning into a design, and the Story Stones are a good example of a design that functions on many levels: as a collection of historical artifacts, as a storytelling arena, as a sculptural installation, as a reference to classical literature, and as a simply delightful place where you can run around and play.

The Story Stones can be alive with people during a performance on a warm spring day, or stark and dramatic on a cold winter afternoon.

The Forbidden Fairy Ring

Mushroom circles occur naturally when mycelia—rootlike structures—grow outward from a center point and a circle of mushrooms springs up at the perimeter. In the old stories they're called fairy rings, and they're not always a happy place for humans. When you step into one you are taken away to another land. In some legends, it's a place where the little people dance and sing, and when you join them inside the circle you begin to dance, too. It's a joyous dance until you find you can't stop yourself. Then, with fairies laughing and singing and dancing all around you, you keep dancing and dancing until you die. Since my original intention was to include an occasional nod to the darker side of the fairy world, I thought it would be fun to have a fairy ring in Enchanted Woods.

The Winterthur staff and I had visited other children's gardens, and we were turned off by all the primary paint colors and high-tech animated, motorized features. We vowed to avoid such things because the places that used them felt more like playgrounds than gardens. However, in one of them we'd fallen in love

266 PART 2 Designing the Artful Garden

with a fog machine, and we thought we could bend the rules a bit and use one of those in Enchanted Woods. We decided to have a circle of mushrooms surrounding a cloud of fog. As a result, the Forbidden Fairy Ring turned out to be one of our most technically complex features, requiring the full range of talent within our team of engineers and contractors.

Randy finished carving out the interior of the Tulip Tree House and then turned his chain saw to crafting the mushrooms. He made thirteen of them, each the height of a stool for sitting on, and we put them in a big circle. At the base of each one we installed a tiny atomizing jet. When you step inside the ring, a hidden motion sensor turns on the fog machine, and you're engulfed in a cloud of fog. I've seen a two-year-old completely disappear. Next to the Forbidden Fairy Ring is one of the few instructional signs we've allowed in Enchanted Woods. It warns: "Never, ever

Children can't seem to get enough of the Forbidden Fairy Ring. A timer had to be installed to shut it off from time to time because the azaleas surrounding it were getting overwatered.

step inside a fairy ring." But kids do it anyway, all the time. In fact, they do it so much that the nearby azaleas were getting overwatered, and a timer had to be installed to shut down the fog from time to time.

I wrote this in my journal shortly after the garden opened to the public in 2001:

> I was in the mushroom circle with five or six girls and boys, lots of different sizes of kids, and we really kicked up an awesome cloud of fog. The smallest kids, nearest to the ground, completely disappeared in the fog—they totally vanished! Parents were staging photo sequences: first, a snapshot of the child standing in the fairy ring; second, the child enveloped in fog; and third, the empty circle—poof! The child's been whisked away to live with the fairies! I love that the fund-raising brochure for the Forbidden Fairy Ring said, "The child will be engulfed in a warm mist." It's actually a chilling fog. You stand there long enough and you're chilled to the bone. It's creepy. Kids love it.

The Forbidden Fairy Ring is the most popular feature in Enchanted Woods, reminding us that mushrooms do have a prominent place in local history. The Italian immigrants who brought their masonry skills to build the du Pont family estates in the early 1900s were also highly skilled at production horticulture, including mushroom growing. The local mushroom industry began when workers in the cut flower business started growing them beneath the benches in their employers' greenhouses. By the 1930s they had begun to establish their own farms dedicated to mushroom production. Kennett Square, Pennsylvania—not far from Winterthur—soon became known as the Mushroom Capital of the World.

The Upside-Down Tree

One of my very first ideas for Enchanted Woods was to make an upside-down tree. I thought we could take a big old tree, slice off the top ten feet or so above the first branching point, cut it off near the base, and then turn it upside down and set it on the ground so you could walk beneath the archways of its branches. I did a sketch of it on the second page of my Enchanted Woods sketchbook—the same page that has a sketch of a fairy ring on it, another of my first ideas for the garden. I don't know where this idea came from, but I had second thoughts about it almost immediately. Even though there were thousands of trees on the Winterthur estate, it seemed disrespectful to chop down a healthy one and turn it on its head just to have some fun with it. Fearing that somebody might take a liking to this idea and try to make it happen, I decided not to show my sketch of the upside-down tree to anyone and kept it secret.

That was in 1998. In late 2005, John Salata, Winterthur's arborist, came to me with an idea. Out in the woods near one of the farm complexes, there was a mature oak that was diseased and had to be taken down. He thought we should take a look at it because it might be something we could add to Enchanted Woods. It had been five years since Enchanted Woods had opened to the public, and garden curator Linda Eirhart agreed that maybe it was time to introduce a new feature to the garden. John and I drove out to take a look.

I couldn't believe what John showed me. It was the tree from the upside-down tree sketch I had done

nearly eight years earlier—the very same tree, with a main trunk that branched into four large branches. It even had a small cavity in one of the branches, exactly where I had imagined a little fairy door. I happened to have my laptop with me, so I turned it on and found the sketch to show John, and he was totally amazed. I showed the sketch to the rest of the staff, and everyone agreed that not only was this a good idea, it was meant to be. There was no doubt about it. We had to do it.

I started working on fleshing out the design, and the whole Enchanted Woods team joined in the process. In early 2008, we all gathered in the woods to watch John take down the tree. A crane held it up as he sliced off the trunk beneath the crotch, and then it was put on a flatbed truck and taken to a barn. As I watched the crane lift the tree from the truck and hoist it over a wall into the courtyard where we'd be working on it, I couldn't help but think of Brian's creation myth for Enchanted Woods, with the fairies levitating all the objects across the estate and into the garden. I measured the cavity so I could begin designing the door, and we found a second cavity in another branch where we could install a little window, too.

As the design evolved, the design team grew. In

One of my very first sketches for Enchanted Woods included a fairy ring and an upside-down tree. I never showed this sketch to anyone because I had second thoughts about cutting off a tree and turning it upside down.

When John Salata took me to see the oak tree he was cutting down, I couldn't believe how much it resembled the upside-down tree in my sketchbook.

addition to the garden staff we had a structural engineer, a carpenter, a metalsmith, stonemasons, and electricians. The Upside-Down Tree would require every trade but plumbing. Randy Fisher—Winterthur's former arborist, the one who had hollowed out the Tulip Tree House and carved the mushrooms for the Forbidden Fairy Ring—was brought back to clean out all the rotted wood inside the tree, remove the bark, and treat the wood with natural preservatives. We called him the Artist Formerly Known as the Arborist.

I wanted the door to open into a little room where kids could place a small stone or other object, but for structural reasons a metal column was needed in the cavity, so we couldn't have the little room. We brought the whole group together to figure out what to do, and someone came up with the idea of putting a mirror behind the door so that when you opened it, you'd look inside and see your own reflection looking back out at you. Perfect. For the other cavity, I suggested we put a little kitchen table and chair behind the window with a teacup on the table and the chair pushed back so it looked like a fairy had made a quick exit when she saw someone looking in.

Randy finished his work on the tree in spring

John cut the tree beneath the crotch, and a crane hoisted it through the air and onto a truck.

Once Randy Fisher had hollowed out all the rotted wood, the cavity was bigger than I expected, so we had Winterthur's masons fill the space with miniature stonework.

2009, and it was moved into Enchanted Woods. I was pleased to see that the scale of the tree perfectly fit its surroundings. The cavity where the door would go turned out to be much larger that I had expected, so we had the staff stonemasons build a wall of fairy-sized stones to surround the wooden fairy door. There is a local tradition in the Brandywine Valley of filling tree cavities with stonework, so this seemed like the right thing to do. The masons had great fun doing a miniature version of the other stonework that was found throughout the Winterthur estate. For the window opening, we covered the cavity with little strips of wood clapboard, and the window frame was painted to match H. F. du Pont's favorite color combination, winterhazel yellow and Korean rhododendron lavender.

The Upside-Down Tree premiered on Father's Day 2009, Enchanted Summer Day, to great acclaim.

A Garden for All Ages

It was hugely fun collaborating with the many different craftspeople on Enchanted Woods. They all knew that they were working in a place that housed one of the world's great collections of American decorative arts, so they all gave it their most creative effort. I'd visit the site in the evenings and find the contractors there with their spouses and kids, proudly showing off their work. And the Winterthur staff were fine collaborators. Their horticultural and technical skill, and their creativity, are evident throughout the garden. Everyone seemed to be able to think like an eight-year-old without even trying.

People often ask me what age group we targeted when we designed Enchanted Woods. I always like to say thirty-five and up. If the garden was not engaging to adults as well as children, we figured, the parents would get bored and want to leave before the children did. Once when I was visiting there and taking photographs, I saw a mother sitting on a bench, reading a book while her three small children played nearby. I stopped and said hello, and asked if her kids liked it there. She replied, "This is the third time we've been here this week," and she seemed quite content to sit and read as long as the kids wanted to play. I took that as a sign of success.

Gardens can trigger memories from early in life. On a recent visit to Chicago, out to dinner with some friends, I overheard someone at the next table talking about how he had spent the day. He had visited the Lincoln Park Conservatory for the first time, and he said the smells there had instantly transported him back to his early childhood in Seattle. He talked about playing in the woods near his home and recalled the smell of the trees and mosses that grew there. That's one key thing that plants and gardens can do for us. They can bring us back to enjoy a time early in our childhood, back before we knew how complicated the world could be.

I'm hoping that the kids who are playing in Enchanted Woods today will grow up and no matter where they are will have their memory triggered now and then, and be taken right back to the time they played among the fairies on Oak Hill at Winterthur.

One gorgeous April evening, the setting sun made a golden backdrop for the Tulip Tree House, the Faerie Cottage, and the Fairy Flower Labyrinth. The lilacs are in the Sundial Garden adjacent to Enchanted Woods.

TEN
The Artist's Eye in the Garden

CONSTANTLY STUDYING and discussing our relationship to the natural world keeps this connection fresh, relevant, and present in human consciousness. Artists help with this, turning to nature again and again as a source of ideas and inspiration. Environmental art questions us, provides opportunities for meaningful readjustment to the world around us, and not only stands as a record of how humans have interacted with nature across the centuries but also serves as a laboratory for testing whole new ways of relating to it. It's all about the continuous rekindling of our relationship to planet Earth.

One pitfall of the environmental movement has been that it tries to make us feel guilty or ashamed for screwing up the planet. Recently, I saw a reusable grocery bag at a natural foods store, printed with the message "I'm saving the planet—What are you doing?" I think there's been too much finger wagging, posturing, and politicking. At its most admonishing, the environmental movement is about curtailing excess, requiring sacrifice and suffering. Environmental awareness is necessary for our survival as a species, and we do need to make significant adjustments in our attitudes and activities, but we also need to lighten up and have more fun. We need more art, especially the kind that celebrates the joy, wonder, and beauty of nature.

Between Art and Ecology

In garden design, the recent focus on native plants has fostered broader ecological understanding. However, somewhere along the way the profession of horticulture acquired a bad reputation among environmentalists, to the degree that even the word *horticulture* can get some of them riled up. I once had an argument with an ecological planner who refused to use the word in a report he was writing for an arboretum's master plan. He refused to acknowledge that ecological restoration and design would be nothing without horticultural

In the Azalea Walk at the Southern Highlands Reserve in the mountains of western North Carolina, nature provided the flame azaleas and carpet of ferns. We only had to add the serpentine path.

skills. All the technologies of plant production and establishment—the practices of horticulture—make it possible for us to establish new ecosystems as well as to nurture the existing ones that require our protection and care.

Garden designers and horticulturists, uniquely poised between art and ecology, can make a real contribution here. Those who work with native plants—or who practice integrating native and nonnative plants in ecologically sustainable landscapes—know a lot about ecology and maintaining the health of growing things. Following the principles of art, they are skilled at working with shape, texture, and form (and it seems that most of them are totally obsessed with color). They know how to create plant combinations that grab your attention and make you think about gardens—and nature—in new ways. Garden designers know about the power of plants to uplift the human spirit and inspire imagination, and they can provide leadership in integrating ecology into garden design.

Sometimes a moment of simple delight in flowers and plants is enough to begin rekindling our relationship with the natural world. I love to visit gardens and be surrounded by beauty, to indulge my senses in reverie and joy. In the evolution of human culture, it may be true that agriculture—the sowing of seeds as crops—has been much more necessary for survival than growing flowers to cut and arrange in pretty vases, but every culture in human history also has had some kind of reverence for flowers. Their shapes and forms are woven into the humblest fabrics, and images of flowers decorate everyday objects around the world.

Fresh, live flowers have always been grown as a source of beauty, pride, and hope, even in the midst of

British environmental artist Neville Gabie's contribution to a sculpture exhibition at the Royal Botanical Gardens in Hamilton, Ontario, is called $V=B_0+B_1*D\hat{\;}B_2+B_3*D\hat{\;}B_4*H\hat{\;}B_5$, which he says is the formula used to compute the total cubic feet of lumber in a tree before harvesting. An entire red oak (killed by gypsy moths) was cut into cubes and packed into a solid block. Gabie used abstraction and craft, along with an ironic sense of elegant beauty, to highlight an important environmental concern in northern Canada: deforestation.

dire poverty. In the United States, all across the rural South during the 1930s, the time of the Great Depression, plants and flowers were passed along from neighbor to neighbor to bring some measure of cheer and goodwill in a vast region devastated by poverty. Many of these "passalong plants" still grow there today, continuing to be shared from house to house, neighborhood to neighborhood. Flowers share one important purpose with art: they might not put food on the table but can lift up our spirits, and we really can't live joyfully without them in our lives.

A former water-harvesting area at the Desert Botanical Garden in Phoenix, Arizona, designed by Ten Eyck Landscape Architects, collected precious rainwater along a spiraling wall of native stone.

At the Denver Botanic Gardens, in a composition with just a few species and cultivars of drought-tolerant plants, beauty is created by the repetition of simple plant forms in a naturalistic drift pattern.

At Longwood Gardens, Peirce's Woods abstracts the beauty of the Eastern Deciduous Forest biome, including the design theme of verticals and horizontals. In reddish bronze fall color, a horizontal mass of Virginia sweetspire (*Itea virginica* 'Henry's Garnet') is seen behind the strong verticals of pond cypress (*Taxodium ascendens* 'Prairie Sentinel').

From Art into Gardening

I sat down one day to talk about gardening and art with Lisa Roper and Laurel Voran, two designers and gardeners at Chanticleer. In college Laurel majored in art and environmental science, an excellent background for gardening, and her training in both the fine arts and ecology shows in her work. She cares for the Ruin Garden at Chanticleer. Designed with help from landscape architect Mara Baird, the Ruin Garden looks at first glance like unruly weeds reclaiming the ruins of an old stone house but on closer inspection reveals itself to be a meticulously maintained and sophisticated work of garden design. Even more than a work of design, it is a work of living art that continues to evolve over time. Its ongoing success requires a gardener's skilled hands working in concert with an artist's trained eye.

As an art student Laurel focused on monotype printing, enjoying the spontaneity that comes with that art form. She also studied photography, she tells me, but found it frustrating because there was so much equipment in the way between her and the final product. Eventually, she found her way into gardening.

I like to hang out in the Ruin Garden and eavesdrop on the visitors as they explore the crumbling remnants of its rooms, invaded by weeds and open to the sky. The nonhorticulturists focus on the architecture, while the plant lovers also enjoy the array of unusual trees, shrubs, perennials, and grasses. Everyone loves the beautiful stonework and the richness of sculptural detail. In what appears to have been the library is a collection of sculptural books, carved from stone and strewn about the floor. In what seems to have been the dining room is a long "table," actually a raised black pool of dark, reflective water, inky and still. The dining room floor is bluestone paving incised with serpentine lines that were crafted from what appear to be slate tiles salvaged from the former roof.

The Ruin Garden is full of mystery and invites a lot of questions. Were these dining room tiles really on the roof once upon a time? Was the whole thing made from scratch to resemble a ruin, or is this an actual stone house that has fallen apart? The sculptural elements suggest fantasy—you know the library didn't really have stone books in it—but maybe this was once a real house, and the sculptures were added after it fell apart. In fact there once was a house on the site. The original idea was to partially dismantle the house and turn it into a ruin, but for safety reasons the entire structure was razed and only its foundation and part of its stone flooring remain.

The garden sits at the top of a hill. A long, curving stairway leads up to it, with wide stone treads threaded through a scraggy meadow of tousled grasses and perennials. Although at first the whole thing looks deserted, when you study it carefully you realize that it is in fact carefully tended, and that some very detailed gardening goes into maintaining its abandoned appearance. The site is dry and gravely, but most of the plants there are well adapted to these conditions. Many of them can be rather invasive, and they have to be aggressively weeded out each year to keep them from taking over. Laurel calls this practice "the editing of self-sown plants."

There is an open-ended quality in the whole design, with the plant combinations shifting and changing over time. The gardener and the plants have an intimate relationship, and the mark of the human hand becomes evident when you study the design closely. Laurel says the process involves "going through and pulling out what doesn't feel right." She doesn't have a plan about what to weed out and what to leave

in but just notices what bugs her and needs some attention.

Most gardeners know that feeling very well. When I'm sitting on my patio reading the newspaper in the morning, inevitably I see something that irks me—maybe a flowerpot that needs to be rotated a quarter turn—and I have to get up and make the adjustment so it feels just right. Laurel does this in the meadow on a large scale, and unlike in most public gardens where volunteers help with much of the routine weeding, she does almost all of the work herself. Jackson Pollack couldn't train volunteers to fling paint onto a canvas,

It seems that weeds engulf the architecture in the Ruin Garden at Chanticleer. But these aren't weeds, they're horticultural treasures. A Chinese elm (*Ulmus parvifolia* 'Frosty') has one branch trained to grow along a low stone wall. Big bluestem (*Andropogon gerardii*) seems also to engulf the wall, with two clumps growing behind it and one carelessly falling forward from the front. Growing up the edge of the wall in the middle ground is Asian bellflower (*Codonopsis clematidea*), and on the wall in the background is wooly Dutchman's pipe (*Aristolochia tomentosa*).

ABOVE This unkempt look is in fact highly contrived. In summer, the white flowers of American feverfew (*Parthenium integrifolium*), white blazing star (*Liatris spicata* 'Floristan Weiss'), and flowering tobacco (*Nicotiana sylvestris* 'Only the Lonely') bloom along with the rosy pink blossoms of *Agastache rupestris*. Mexican feather grass (*Nassella tenuissima*) crowds the pathway, while big bluestem (*Andropogon gerardii*) provides height.

LEFT The Ruin Garden provides an elegant example of the analogy-and-contrast principle. While these two grasses have similar textures, the dark green backdrop of variegated hakone grass (*Hakonechloa macra* 'Albovariegata') strongly contrasts with the focal point of a chartreuse Japanese rush (*Acorus gramineus* 'Ogon').

ABOVE In the Ruin Garden's meadow area, the horizontal lines of stone risers contrast with the strong verticals of columnar red cedar (*Juniperus virginiana* 'Emerald Sentinel') and feather reed grass (*Calamagrostis* ×*acutiflora* 'Karl Foerster'). Fragrant white *Dianthus* 'Greystone' flowers in late spring, while aromatic aster (*Aster oblongifolius*) will bloom in the fall. Mexican feather grass harmonizes with the feather reed grass, and culinary thyme fills in the spaces between the stones. *Agave americana* is not hardy in Pennsylvania, so it is treated as a seasonal plant.

and Laurel can't have volunteers making plant-by-plant decisions about what gets to stay and what must go.

The meadow changes through the seasons. Color is provided by a number of flowering perennials including muscari, narcissus, and tulips in early spring, dianthus and thyme in late spring and early summer, lavender and butterflyweed later in the summer, and asters in the fall.

Lisa Roper designs and gardens in Chanticleer's Asian Woods, where she draws on her own training as an artist. She studied painting, photography, and printmaking at Cooper Union. Although printmaking requires precision, Lisa found a way to bring spontaneity into the exacting techniques of drypoint and etching. She practiced the art of chincolet, where you laminate pieces of paper or pictures to the print as it is fed into the press. The result always includes a bit of the unexpected. She also studied the art of batik, a textile-dying technique in which melted wax is applied to fabric, colored inks are then applied, and the wax is removed to leave uncolored areas in the fabric. The process is repeated several times with different colors, and rich patterns emerge. "Batik has layers," Lisa says, "like gardening does."

In addition to her work as a fine artist, Lisa is skilled at making things with a practical purpose—benches and chairs, small patios where you can sit and contemplate the garden—and their organic quality comes from her immersion in nature and the garden. In a little clearing covered with moss, across the path from a small stream that runs through a section of the Asian Woods, Lisa placed a small sculpture—a shallow bowl

When Laurel Voran came upon this broken container in another section of the Chanticleer garden, she knew it would contribute to the character of the Ruin Garden. *Agave americana* is a focal point, with its bluish green foliage offset by the contrasting yellow-green of *Sedum rupestre* 'Angelina'. A jolt of maroon comes from a succulent stonecrop (*Aeonium arboreum* 'Atropurpureum'). A gray creeping germander (*Teucrium aroanium*) harmonizes with the agave, as do some small tufts of gray fescue (*Festuca glauca* 'Seeigel').

In the Asian Woods at Chanticleer, a pathway borders a moss lawn, moving through big clumps of 'Blue Angel' hosta. On the left, the wine-colored flowers of Raulston allspice (×*Sinocalycanthus raulstonii* 'Hartlage Wine') bloom for several weeks in late spring. White-flowering *Rhododendron* 'Snow', a Kurume azalea, blooms in the background. The sculptural focal point in the moss lawn is a basin Lisa Roper carved into a natural stone. Photo by Lisa Roper.

Lisa made this bench out of the wood of osage orange (*Maclura pomifera*). "It's the hardest wood imaginable," she says, "and it will last for ages." On the bank to the left of the bench is Japanese hakone grass (*Hakonechloa macra*) growing with *Hosta montana* 'Aureomarginata'. To the right of the bench is a grouping of vase-shaped *Hosta* 'Krossa Regal'. Lisa says it's a popular spot for lovers to sit and enjoy the view of Bells Run, the creek. Photo by Lisa Roper.

carved into a stone. This piece was inspired by a visit to Ricketts Glen, a Pennsylvania state park, where she saw a stone basin that had been carved by a waterfall over more years than we could guess. She keeps the bowl filled with water and floats flowers there, changing them with the seasons. She added this sculpture, she tells me, because she wanted to get a bit of water on the other side of the walk from the stream, and she wanted to bring a little bit of Ricketts Glen into the Asian Woods. This is how a garden evolves over time. You make a place, you live with it, and then over time you add layers to enrich your personal relationship with it.

One day in early summer I visited the Asian Woods and found some florets of 'Blue Wave' hydrangea floating in the basin, along with a couple of leaflets from a Tokyo wood fern (*Dryopteris tokyoensis*). They were moving very slightly in the breeze, and this little bit of animation provided a nice counterpoint to the solidity of the rock. During another visit later that summer I found a few leaves of a hardy Asian impatiens (*Impatiens omeiana*) and a few yellow ragwort flowers (*Ligularia* ×*palmatiloba*) from a drift of them growing nearby. The stone basin made a connection not only to the stream on the other side of the path but also to the flowers growing elsewhere in the Asian Woods.

Floating in the stone basin are flowers and foliage collected from the surrounding Asian Woods, seasonally changed. In July (left) I found 'Blue Wave' hydrangea and Tokyo wood fern (*Dryopteris tokyoensis*). In August (right) I found yellow ragwort (*Ligularia* ×*palmatiloba*) along with a couple of leaves from the hardy impatiens (*Impatiens omeiana*).

A Place for Story and Memory

The garden is so much more than a place of beauty or a collection of favorite plants. It's an expression of your personal relationship to the particular piece of land on which you live, a place for creative expression of memory and personal story. Peirce's Woods brings the spirit and beauty of the Eastern Deciduous Forest into a form that people can delight in and be inspired by—and they write down the names of plants and recreate parts of that experience in their gardens at home. The Tropical Mosaic Garden is a blend of beautiful plants and cultural history from across south Florida. They say people are attracted to the tile wall in the Florida Sunrise Border for its color and whimsy, but I think the real attraction comes from the bits and pieces of story that are collaged into it. Visitors are invited to choose which ones have personal meaning and to indulge themselves in fantasy and storytelling.

H. F. du Pont never threw anything interesting away, and more than thirty years after his death we had a treasure trove of architectural fragments and broken garden ornaments to weave together into a place that has meaning for children and their families. (And just in case you don't think there is magic in the real world, I was writing these words in my head as I drove down the interstate from Santa Fe to Albuquerque, listening to classical music on the radio. Just as I composed the sentence about Enchanted Woods, I heard the announcer say, "And that lovely tune was Ravel's 'The Fairy Garden' from his *Daphnis et Chloe*

Texas garden designer Jill Nokes created this "reliquary" arch in her own garden, its design inspired by a bell tower on a local 1930s-era church. The various artifacts came from clients' percolation tests, or road trips, or they were given to Jill by a friend at a nearby quarry. Neighbors contributed odds and ends as the wall was being built, so it became a bit of a community reliquary as well.

ABOVE Evidence of story is everywhere you look in this private garden in the American Southwest. An old-fashioned arbor of heirloom roses blends with fields of lavender, the little café chair invokes at least the idea of pause, and the time-tempered watering can suggests that real gardening has gone on here for quite some time.

LEFT At the home of Heather Spencer and Charles Murray in Asheville, North Carolina, this mobile of wheelbarrows is more than a humorous statement about gardening. These are wheelbarrows that have been successively worn out over the couple's many years of working hard together in the garden.

Suite No. 1." Lifted by joy, I laughed until I cried. They don't call New Mexico the Land of Enchantment for nothing.)

Thinking Like an Artist

Thinking like an artist means suspending rational thought and stepping boldly outside the mindset that focuses on how to make things or how they are to be maintained. It's not dreaming, but a more informed and focused state of being. It is going with the flow, but in a way that is directed or influenced by your own interests or desires.

When Annie Hawkins hit upon the Corn Heart idea, it was spontaneous, but it was informed by her knowledge of the place. She knew we had a big open field to work with, sloping so you could see it from the field on the other side of the valley, and that we'd have it for one full season. She knew that we were in Chester County, Pennsylvania, and having grown up there, she was infused with the culture and history of that place. Out there in the field that day, the idea came to her as if it had been sitting there waiting for her all along. If you're connected to a place, and your mind has just the right level of attention, readiness, and openness, the idea will come to you. The image of the heart-shaped cornfield came first, in a flash, and then the various stories and associations followed over time, revealing themselves to us and to visitors depending upon our readiness at any given moment.

One of the most satisfying things in making art is finding all the ways it connects to other people as time goes by. It can have layers of meaning, deep layers you never could have fathomed as the work was being conceived. This applies to the garden as well as to a work of art. In your own garden, if you're thinking like an artist, there should be no inhibitions to your creativity. If you are going with the flow while keeping open your own personal artist's eye, surprising things will happen to enrich the design beyond what you could have imagined.

Thinking like an artist takes practice, but it doesn't have to be difficult. The first step is learning to see like an artist. Look for shapes and patterns that are repeated in nature, in the garden, or in other places you visit throughout the course of a normal day. Once you've developed your own vocabulary of shapes, patterns, and forms, you will start to notice them everywhere. It will sharpen your perception of your world and begin to inform the choices you make as a designer, and you will find unlimited ways to bring this personal language into the garden.

Practice sketching, drawing, collage, painting—any way of making art that is comfortable for you. And remember, you don't have to worry about making perfect, finished works of art. You're simply taking visual notes, using these techniques to record your perceptions of the world around you. Allow yourself to make mistakes, and don't worry about how beautiful your artwork is, just keep sketching and recording visual information. With practice, you will become more comfortable with the materials you are using, and before you know it, the images will become more and more enjoyable to create. You'll probably even find yourself creating works of art you'll want to share with others.

Pay attention to sense of place. If you're making a garden, look first at the regional landscape and think about the lessons there that you might use in your design. Spend time observing a place, using drawing and sketching as a way of seeing what's in front of you. Notice what attracts you and record it in your sketchbook. Allow the elements of a place to come to your

attention, inviting a relationship to evolve between you and the landscape.

Play with materials. Make collages or throw paint around on paper or canvas. Have fun outdoors with weeds, sticks, or rocks. Make temporary installations of environmental art, and free yourself from the pressure of coming up with a permanent "solution" to a given design problem. Don't rush to complete a garden in its ultimate form, because if you do, there might not be room for the spontaneous creative ideas that show up along the way. Keep the design process open so additional layers of meaning can accrue over time.

Fantasize. Indulge yourself in myth making. Invite the entire history of myth and symbol into the making of gardens. Human history provides a rich repository of meaningful images, all of which are there for

For a new retaining wall in the conservatory gardens at the John A. Sibley Horticultural Center, part of Callaway Gardens in Pine Mountain, Georgia, I used stones from a former wall, along with chunks of concrete recycled from the former pathways. Hosting a collection of succulent and Mediterranean-climate plants, the new retaining wall demonstrates the creative use of recycled materials harvested directly from the site.

The High Line, a New York City park designed by James Corner Field Operations and Diller Scofidio + Renfro, runs along Manhattan's west side from the Meatpacking District to 34th Street. Built on a historic elevated freight train line, it is now a public park that incorporates the old steel rails as a reference to its former days.

you to use and explore. Even if they don't end up being included in the completed garden, they can play a part in the evolution of its design. In fact, the most engaging gardens begin with an overabundance of ideas during the design process. Collect as many symbols as you can and copy them in your creative efforts, including sketching or painting them as well as making sculptural installations with natural materials in the landscape. Incorporate them into the garden by editing everything down to only those images that move you the most.

Steal ideas. Why not? Labyrinths, for example, have been made for tens of thousands of years in cultures around the world. Some people think they are cliché in landscape design today, but if you practice the art of not caring about what others think, you can easily allow yourself to pull in symbols from anyplace you want. I've put more than half a dozen labyrinths in gardens I've designed, and every one is unique. They've been different sizes, been made of different materials, and served different functions. Just because something has been done before doesn't mean you can't do it again. Actually, I find it liberating to assume that *everything* has been done before, and that total originality is not required to make a successful work of art or design. What makes a garden unique is not the collection of individual images and ideas that went into the design process, but the creativity and ingenuity with which they were combined or juxtaposed.

Go ahead and call yourself an artist. As Cathy Malchiodi said, an artist is not a special kind of person, but every person is a special kind of artist. Anyone can learn to work like an artist. All it takes is practice and commitment. You don't need a license to think like an artist or to bring the artist's creative processes into garden making. Just do it. If you allow yourself the freedom to think like an artist, you will not only be amazed at the results but also find yourself creating gardens—and more—beyond what you could have imagined.

Remember Annie Hawkins' words to me in the bucket of the arborist's Hi-Ranger as we soared high up into the air above the Corn Heart: "See, I told you, art takes you places you never knew you'd go."

Bibliography

Abbott, Edwin A. *Flatland: A Romance of Many Dimensions*. London: Seeley & Company, 1884. Reprint, New York: HarperCollins, 1983; with a foreword by Isaac Asimov.

Ackerman, Diane. *An Alchemy of Mind: The Marvel and Mystery of the Brain*. New York: Scribners, 2004.

Bye, A. E. *Art into Landscape, Landscape into Art*. Mesa, AZ: PDA, 1983.

Chödrön, Pema. *Start Where You Are: A Guide to Compassionate Living*. Boston: Shambhala, 1994.

Codrington, Andrea. "Keith's Kids." www.haring.com, reprinted from *Sphere* magazine, 1997.

Fairbrother, Nan. *New Lives, New Landscapes: Planning for the 21st Century*. New York: Random House, 1970.

Fox, Helen Morganthau. *Patio Gardens*. New York: Macmillan, 1929.

Frederick, William H., Jr. *The Exuberant Garden and the Controlling Hand*. Boston: Little, Brown, 1992.

Gablik, Suzi. *The Reenchantment of Art*. New York: Thames & Hudson, 1991.

Loewer, Peter. *The Evening Garden*. Portland, OR: Timber Press, 1992.

Macaulay, Alastair. "Merce Cunningham, Dance Visionary, Dies." *New York Times*, 28 July 2009, p. A1.

Magnani, Denise, and Carol Betsch. *The Winterthur Garden: Henry Francis du Pont's Romance with the Land*. New York: Harry N. Abrams, 2004.

Malchiodi, Cathy A. *The Soul's Palette: Drawing on Art's Transformative Powers*. Boston: Shambhala, 2002.

McHarg, Ian. *Design with Nature*. Garden City, NY: Published for the American Museum of Natural History by the Natural History Press, 1969.

Ogden, Scott. *Garden Bulbs for the South*. Portland, OR: Timber Press, 2007.

———. *The Moonlit Garden*. Boulder, CO: Taylor Trade Publishing, 1998.

Orlean, Susan. *The Orchid Thief: A True Story of Beauty and Obsession*. New York: Random House, 1988.

Pine, B. Joseph, and James H. Gilmore. *The Experience Economy: Work Is Theater and Every Business a Stage*. Boston: Harvard Business School Press, 1999.

Puma, Fernando. "Cunningham, the Impermanent Art." *7 Arts*, No. 3. Colorado: Falcon's Wing Press, 1955. Reprinted in David Vaughan and Melissa Harris (eds.), *Merce Cunningham: Fifty Years*. New York: Aperture, 1997, p. 71.

Schulz, Peggie. *Growing Plants Under Artificial Light*. New York: M. Barrows, 1955.

Wijaya, Made. *Tropical Garden Design*. London: Thames & Hudson, 1999.

Acknowledgments

I offer many thanks to Annie, Bill, Conrad, Gwen, Linda, Rick, two Scotts, and all the other friends and colleagues who reviewed text. I do fantasize for a living, so the reality checks were most welcome. David, thank you for your unwavering support for this and so many other projects. Sophia, your assistance and leadership with the manuscript were just the best. Many thanks to those at Timber Press who made this book a reality, especially Tom, Eve, Susan, and Lorraine.

And to all of my clients and collaborators, I live my life in gratitude for you.

Index

Aalto, Alvar, 105
Abbott, Edwin A., 32
Abramovic, Marina, 100
abstraction, 116–118
Ackerman, Diane, 35
Acorus gramineus 'Ogon', 281
Actaea alba, 155
Actaea racemosa, 134, 155, 181, 183
Adams, Alice, 108–109
Adenium spp., 216
Adiantum pedatum, 155
Aechmea blanchettiana, 208, 209
Aeonium arboreum 'Atropurpureum', 282
Agastache rupestris, 280
Agave americana, 44, 281, 282
Allegheny foamflower, 167, 173–176, 185, 187, 188
Allium christophii, 54, 71
Allium 'Purple Sensation', 61
Alocasia, 199
Aloe maculata, 216
alternate-leaved dogwood, 160
American feverfew, 280
American hornbeam, 179
Amsonia hubrichtii, 167
analogy-and-contrast principle, 153, 157, 183–184, 280
Ananas comosus 'Ivory Coast', 218

Andropogon gerardii, 279, 280
angel's trumpet, 195
Araceae, 199
Aristolochia tomentosa, 279
Arnold, Patrick Ross, 104–105, 106
aromatic aster, 281
Art Goes Wild (at Garden in the Woods), 221–222, 230
Aruncus dioicus, 155
Asian bellflower, 279
Asian Woods (at Chanticleer), 282–285
Asimov, Isaac, 32
Aster oblongifolius, 281
Astilbe biternata, 155
Athyrium felix-femina, 153
autumn crocus, 143, 144
Azalea Woods (at Winterthur), 126, 127

Baird, Mara, 278
beauty, 115, 118
beautyberry, 143, 144
Beech Colonnade (at Garden in the Woods), 224–225
Beglarian, Eve, 115
Benarcik, Dan, 10
Betula alleghaniensis, 155
Betula lenta, 160

Betula papyrifera, 178
big bluestem, 279, 280
Bird's Nest (at Enchanted Woods), 247–249
Bismarckia Island (at Naples Botanical Garden), 215–217
Bismarckia nobilis, 215
Bismarck palms, 215
black cohosh, 155, 181, 183–184
black snakeroot, 134
blazing star, 280
'Blue Angel' hosta. See *Hosta sieboldiana* var. *elegans*
blue cohosh, 155, 183–184
blue flag iris, 167
blue lobelia, 227
blue myrtle spurge, 71
'Blue Wave' hydrangea. See *Hydrangea macrophylla* 'Mariesii Perfecta'
Bostic, Steve, 108
"Boy Who Loved Hearts" (Hawkins), 26
Brandywine school, 124–125, 237
Brandywine Valley, 19, 123–125, 233, 237, 257
Braque, Georges, 105–106
bromeliads, 118, 119, 208, 209, 210
Browning, Armistead, 19–20
Bruce, Hal, 126

Brugmansia, 195
Brugmansia 'Charles Grimaldi', 195
Buckley's yucca, 44
Buddleia alternifolia, 138
Burle Marx, Roberto, 18–19, 116, 118, 119
Bye, A. E., 19–20

Caladium 'Thai Beauty', 194
Calamagrostis ×*acutiflora* 'Karl Foerster', 281
Callicarpa dichotoma, 143
cardinal flower, 227
Carpinus caroliniana, 179
Carpinus Walk (at Peirce's Woods), 176–184
"Carrot Moon," 240, 241
Cascade Garden (at Longwood Gardens), 118–120
Cathedral Clearing (at Peirce's Woods), 167–176
Caulophyllum thalictroides, 155, 183
Cercis canadensis, 137
Chaenomeles speciosa 'Moerloosei', 132
chance, as a design tool, 111–113
Chanticleer garden (Wayne, Pennsylvania), 10, 61, 278–285
Chasmanthium latifolium, 227
Chelone glabra, 227
children's gardens, 233–234
Chinese elm, 279
Chinese snowball viburnum, 131, 132
Chinese witch hazel, 126
Chionodoxa spp., 133
Chödrön, Pema, 104
Christmas fern, 155
Cimicifuga racemosa. See *Actaea racemosa*
Clebsch, Meredith, 157
coastal azalea, 174

Codonopsis clematidea, 279
Coffin, Marian Cruger, 109, 131, 140
Colchicum autumnale, 143, 144
collaboration, 97, 139–140
collage, 68–70, 240
Colocasia, 199, 218
Colocasia esculenta 'Burgundy Stem', 218
color choreography, 128–132
common goatsbeard, 155
common wood sorrel, 153–154
Corn Heart, 23–24, 26–28, 27, 28
Cornus alternifolia, 160
Corylopsis, 132, 135
Cow Lot (at Longwood Gardens), 150–152
creeping germander, 282
crown-of-thorns, 216
Cryptanthus spp., 118
Cunningham, Merce, 111–112

dance, 113–115
Darke, Rick, 153, 157, 158, 178–179
Datura. See *Brugmansia*
Desert Botanical Garden (Phoenix, Arizona), 275
desert rose, 216
Design with Nature (McHarg), 20
Deutzia ×*magnifica*, 138
Dianthus 'Greystone', 281
doodling, 13, 92–95
drawing and sketching, 73–81, 82–92, 167–172, 236–237
Drosera filiformis, 167
Dryopteris tokyoensis, 285
du Pont, H. F., 123, 125, 126, 128–132, 139–144, 234, 238, 247, 286
du Pont, Pierre S., 140, 150
dwarf crested iris, 155
dwarf Korean lilac, 145

earth stars, 118
Eastern Deciduous Forest, 149, 150
eastern gamma grass, 222
Easton, Valerie, 29
Echinocactus grusonii, 59
ego, 65–67
Eirhart, Linda, 254, 267
elephant ear kalanchoe, 215
elephant ears, 199
Enchanted Woods (at Winterthur), design of, 233–236, 244–247, 270
environmental art, 98–102, 273
Equisetum hyemale, 167
Eranthis hyemalis, 133
Eryngium aquaticum, 227
Eupatorium maculatum 'Gateway', 167
Euonymous alatus, 143
Euphorbia milii Thai hybrids, 216
Euphorbia myrsinites, 71
Euphorbia tirucalli 'Sticks on Fire', 215–216

Faerie Cottage (at Enchanted Woods), 257–261
Fairbrother, Nan, 173
fairy candles. See black cohosh
Fairy Flower Labyrinth (at Enchanted Woods), 261–262
false goatsbeard, 155
feather reed grass, 281
Feliciani, John, 140
Festuca glauca 'Elija Blue', 54
Festuca glauca 'Seeigel', 282
Fibonacci sequence, 52
Filipendula ulmaria 'Aurea', 71
'Firefly' azalea. See *Rhododendron* 'Hexe'
Fisher, Randy, 247, 249, 266, 269
Flatland (Abbott), 32
Floating Islands (at Art Goes Wild), 226–230

Florida azalea, 145, 177, 178
Florida Sunrise Border (at Naples Botanical Garden), 208–214
Florida sword fern, 194
Flower Garden Walk (at Longwood Gardens), 150, 151
flowering tobacco, 280
Forbidden Fairy Ring (at Enchanted Woods), 265–267
forsythia, 126, 137
Forsythia japonica, 126
fountain butterfly bush, 138
Fox, Helen Morganthau, 217
fragrant granadilla, 217
Fragrant Nocturnal Arbor (at Naples Botanical Garden), 214
fragrant snowball, 132
Frederick, William H., Jr. 10, 104, 120–121
Friedlaender, Bilgè, 109–110
From Within and Outside a Bright Room (Gould), 113–115
Frost, Robert, 239
Fuchs, Leonard, 217
Fuchsia Wall (at Naples Botanical Garden), 217–219

Gabie, Neville, 274
Gablik, Suzi, 99
Galanthus nivalis, 133
galax, 155
Galax rotundifolia, 155
Garden in the Woods (at New England Wild Flower Society), 221
garland spiraea, 132
Gathering Green (at Enchanted Woods), 254–256
Gathering of Grasses (at Art Goes Wild), 222–224
Gaudí, Antonio, 203, 208, 209

Geranium maculatum 'Espresso', 165
giant vriesea, 118
Gibbens, Wayne and Beth, 45–46
Gilmore, James H., 192
glory-of-the-snow, 133
golden challis vine, 215
'Golden Fleece' goldenrod, 167
Goldsworthy, Andy, 101, 230
Gould, Peggy, 113–114
gray fescue, 282
Great Cleansing of the Rio Grande River (Mazeaud), 99
Greene, Isabelle, 60
Griswold, Mac, 120
Ground Cover (Schlinke), 107
Group of Seven, 98
Growing Plants Under Artificial Light (Schulz),
Gustafson Guthrie Nichol Ltd., 40
Gymnocladus dioicus, 162

hairy alumroot, 157, 158, 165
Hakonechloa macra, 284
Hakonechloa macra 'Albovariegata', 281
hakone grass, 281, 284
Hamamelis mollis, 126
Hamerman, Conrad, 18, 116–120, 121, 153
hardy Asian impatiens, 285
hardy orange, 143, 144
Haring, Keith, 22–23
Hawkins, Annie, 23, 26, 28, 288, 291
Hecker, Thomas, 219
Heuchera 'Montrose Ruby', 167, 174
Heuchera 'Silver Scrolls', 167
Heuchera villosa, 157, 158
Heuchera villosa 'Caramel', 71, 73
Heuchera villosa var. *purpurascens*, 157, 158
Hibiscus mocheutos, 226

Hidden Valley (at Art Goes Wild), 230, 231
High Line park (New York City), 290
Hogarth, William, 45
Hosta 'Krossa Regal', 284
Hosta lancifolia, 139
Hosta montana 'Aureomarginata', 284
Hosta 'Orange Marmalade', 73
Hosta sieboldiana var. *elegans*, 283
Hosta 'Touch of Class', 73
Hudson River school, 97–98
hybrid cherry, 136
Hydrangea macrophylla 'Mariesii Perfecta', 285
Hydrangea 'Preziosa', 255

Ilex decidua 'Byers Golden', 143
Ilex decidua 'Finch's Golden', 143
"immersive experience," 192
Impatiens omeiana, 285
India date palm, 203, 204, 205
India Date Palm Allée (at Naples Botanical Garden), 203–207
"In Hardwood Groves" (Frost), 239
Ipomoea alba, 215
Iris cristata, 155
Iris versicolor, 167
Israel, Robert, 40
Itea virginica 'Henry's Garnet', 71, 277,

Japanese quince, 132
Japanese rush, 281
Japanese stewartia, 126
Jaudon, Valerie, 21
Jensen, Jens, 53, 149
Joyce Kilmer–Slickrock Wilderness, 153
Juniperus virginiana 'Emerald Sentinel', 281

Kadishman, Manashe, 113, 114

kaempferi azalea, 260
Kalanchoe beharensis, 215
Kentucky coffee tree, 162
Korean rhododendron, 132, 135, 136
Kurume azaleas, 126
Kykuit, 52

labyrinths, 291
Lady Bird Johnson Wildflower Center, 50–52
lady fern, 153–154
Lager, Anita Toby, 20
Larson, Eve, 29
Laura Smith Porter Plains Garden, 39
lavender redbuds, 137
Lenni Lenape, 20
Levy, Stacy, 98–99
Liatris spicata 'Floristan Weiss', 280
Ligularia ×*palmatiloba*, 285
Liriodendron tulipifera, 143, 144, 153
Little, Compton, 251
Lobelia cardinalis, 6, 227
Lobelia siphilitica, 6, 227
Loewer, Peter, 195
Long, Richard, 100–101
Longwood Gardens (Kennett Square, Pennsylvania), 15
Love Dreaming (Ross), 52
Lurie Garden (Chicago), 40
Lynch, Jeff, 153, 154, 157, 176–177, 178–179, 181

Macadamia integrifolia, 217
macadamia nut, 217, 219
Macaulay, Alastair, 111
Maclura pomifera, 284
Magnani, Denise, 233, 234, 238
maidenhair fern, 155
Malchiodi, Cathy, 29, 291
mangroves, 90–92

March Bank (at Winterthur), 132, 133, 134
marsh mallow, 227
Maypole (at Enchanted Woods), 255–256
Mazeaud, Dominique, 98–100
McHarg, Ian, 9, 20, 24
memory, 286
Mexican feather grass, 280, 281
Midnight Wine weigela, 71
Mitchell, Joni, 68
Mitchella repens, 154
Mizner, Addison, 196
Morrison, Darrel, 75, 79
mosaic, 31, 208–214
Mondriaan, Piet, 116
moon vine, 215
Murray, Charles, 286
music, 115
'My Mary' rhododendron, 177
myth making, 236–237

'Nacoochee' rhododendron, 177
Nairn, Michael, 20
Naples Botanical Garden, 191–192
Nassella tenuissima, 280
native plants, 149-150, 153, 157, 221–222, 273
Nephrolepis cordifolia, 194
Nephrolepis exaltata, 194
New England Wild Flower Society, 221
New York fern, 155
Nicotiana sylvestris 'Only the Lonely', 280
Nokes, Jill, 286

Oak Hill (at Winterthur), 143, 144
Oconee azalea. See *Rhododendron flammeum* 'Harry's Speciosum'
Ogden, Lauren Springer, 38

Ogden, Scott, 192, 193, 195–196, 199, 203, 215, 217
O'Keeffe, Georgia, 81
One Thousand Arms of Compassion (Mazeaud), 100
oriental photinia, 143
osage orange, 284
Oudolf, Piet, 63
Oval Lawn (at Naples Botanical Garden), 215
Oxalis montana, 153
Oxydendrum aboreum, 169

pachypodium, 216
pachysandra, 174–176, 185
Pachysandra procumbens, 174–176, 185
painting, 70, 104–106, 239
Panicum virgatum, 167, 222, 227
paper birch, 178
Parc Güel (Barcelona), 193, 208, 209
Pa'Ris'Ha, 235
Parthenium integrifolium, 280
partridgeberry, 154
Passiflora alata, 218
patterns
 circle, 52–53
 dendritic, 54–57
 fractured, 57
 mosaic, 35–40, 154
 naturalistic drift, 41–44
 radial, 54
 scattered, 34–35,
 serpentine, 20–21, 45–49, 230
 spiral, 49–52
 use in design, 58–62
Peirce's Woods, design of, 149–150, 159–165
performance art, 113–115
Phiel, Brian, 237, 247
Phlox stolonifera, 173–176

Phlox stolonifera 'Sherwood Purple', 172, 174
Phoenix sylvestris, 203
Photinia villosa, 143
photography, 110-111
pin cherry, 157
pineapple, 218, 219
Pine, B. Joseph, 192
pinkshell azalea, 167
Planned Parenthood of Southeastern Pennsylvania, garden at, 20–22
poke weed, 101–102, 103
Polystichum acrostichoides, 155
Poncirus trifoliata, 143, 144
pond cypress, 277
Porter's sunflower, 53
possumhaw, 143
printmaking, 240
Prunus 'Accolade', 136
Prunus pensylvanica, 157
Pumpkin Girls, 240–242
purple pitcher plant, 167
Pyle, Howard, 124

Quercus buckleyi, 44
Quisqualis indica, 215

Radiant Baby (Haring), 22, 23
Rael, Joseph (Beautiful Painted Arrow), 236
Rangoon creeper, 215
rattlesnakemaster, 227
Raulston allspice, 283
red cedar, 41, 42, 281
Rhododendron atlanticum, 174, 177
Rhododendron atlanticum 'Choptank Yellow', 177
Rhododendron atlanticum 'Yellow Delight', 177
Rhododendron austrinum, 145, 177, 178

Rhodendron calendulaceum, 177
Rhododendron flammeum 'Harry's Speciosum', 177
Rhododendron 'Hexe', 145
Rhododendron kaempferi, 260
Rhododendron mucronulatum, 132, 137
Rhododendron 'Snow', 283
Rhododendron vaseyi, 167
Rhus typhina 'Tiger Eyes', 165
Rice, Jim, 210
River Eyelash (Levy), 98–99
Roads Water-Smart Garden (at Denver Botanic Gardens), 38
Roper, Lisa, 278, 282–285
Ross, Maggie Napaljarri, 52
The Roundabout (Adams), 108–109
round-leaf violet, 154, 155
Ruin Garden (at Chanticleer), 278–282

Salata, John, 248, 267, 268
Salvia officinalis 'Purpurascens', 71
Sargent, Charles Sprague, 126
Sarracenia alata, 167
Sarracenia purpurea, 167
Saunders, Ronald M., 110–111
Schlinke, Naomi, 106–108
Scilla spp., 133
Schizachyrium scoparium, 222
Schulz, Peggie, 16, 17
Scroll Circle (Adams and Smith), 109
Sedum rupestre 'Angelina', 282
Sedum sarmentosum, 139
Sedum telephium 'Matrona', 54
Shea, Mary, 70, 71
Shepheard, Sir Peter, 159
Silver Garden (Longwood Gardens), 60
Simon, Marjorie, 73
Singer, Elayna Toby, 199
×*Sinocalycanthus raulstonii* 'Hartlage Wine', 283

Sitting Path—Dialog Along the Edge, A (Friedlaender and Smith), 109–110
Skloot, Jules, 114
Smith, Jim, 247
Smith, Ken, 112–113
Sneed, Pamela, 115
Solandra maxima 'Variegata', 215
Solidago sphacelata 'Golden Fleece', 167
sourwood, 169
Spencer, Heather, 286
Spiraea ×*arguta*, 132
Spiraea japonica 'Magic Carpet', 71
S-s-s-serpentine Path (at Enchanted Woods), 253–254
star of Persia, 71
Stauffer, Gwen, 221, 230
Stewartia psuedocamelia, 126
stonecrop, 282
story, 22, 286, 287
Story Stones (at Enchanted Woods), 262–264
stringy stonecrop, 139
sumac, 165
Sundial Garden (at Winterthur), 131–132
Sunken Garden (at Winterthur), 125, 255, 256
Suspended (Kadishman), 113, 114
Swarter, Joe, 256
sweet birch, 160
switch grass, 167, 222, 227
Sycamore Hill (at Winterthur), 137, 138
Symplocarpus foetidus, 167
Syringa meyeri, 145

taro, 218, 219
Taxodium ascendens 'Prairie Sentinel', 277

Ten Eyck Landscape Architects, 275
Teucrium aroanium, 282
Texas red oak, 44
Thelypteris noveboracensis, 155
The Waterfalls (in Peirce's Woods), 188
threadleaf bluestar, 167
threadleaf sundew, 167
Tiarella cordifolia, 167, 173–176, 185, 187
Tiarella cordifolia 'Running Tapestry', 165
time scales, 128–131
Tokyo wood fern, 285
Toronto Botanical Garden, 54, 63
Triennial Wallflowers (Smith), 112–113
Tripascum dactyloides, 222
tropical gardens, 192–195
Tropical Mosaic Garden (at Naples Botanical Garden), design of, 191–192, 196–203
tuberous sword fern, 194
tulip poplar, 143, 144, 153
Tulip Tree House (at Enchanted Woods), 249–252
Tyrrell, Gordon, 263

Ulay, 100
Ulmus parvifolia 'Frosty', 279
University of Delaware, 9, 17–19, 140
University of Pennsylvania, 9, 19
Upside-Down Tree (at Enchanted Woods), 267–270

variegated hakone grass, 281
Viburnum ×*carlcephalum*, 132
Viburnum dilatatum, 143
Viburnum macrocephalum 'Sterile', 132
Viburnum nudum 'Winterthur', 126
Viburnum obovatum 'Whorled Class', 215, 216
Viola rotundifolia, 154
Virginia sweetspire, 277
Voran, Laurel, 278–282
Vriesea imperialis, 118

Water-Smart Garden (at Denver Botanic Gardens), 38
Weigela florida 'Elvera', 71
Weigela 'Red Prince', 138
Wentz, Harriet, 23
white baneberry, 155

white turtlehead, 227
Wijaya, Made, 195
Wilson, Ernest Henry, 126
winged euonymous, 143
winter aconite, 133
winterhazel, 132, 135
Winterhazel Walk (at Winterthur), 132, 136
Winterthur Museum & Country Estate, 123, 125–126
Wissahickon Creek, 20
woodland phlox, 173–176
wooly Dutchman's pipe, 279
Wyeth, Andrew, 125
Wyeth, N. C., 124

Xanthosoma, 199, 217
Xanthosoma 'Lime Zinger', 217

yellow birch, 155
yellow poplar. See tulip poplar
yellow ragwort, 285
Young, Pandora, 162, 165
Yucca constricta, 44